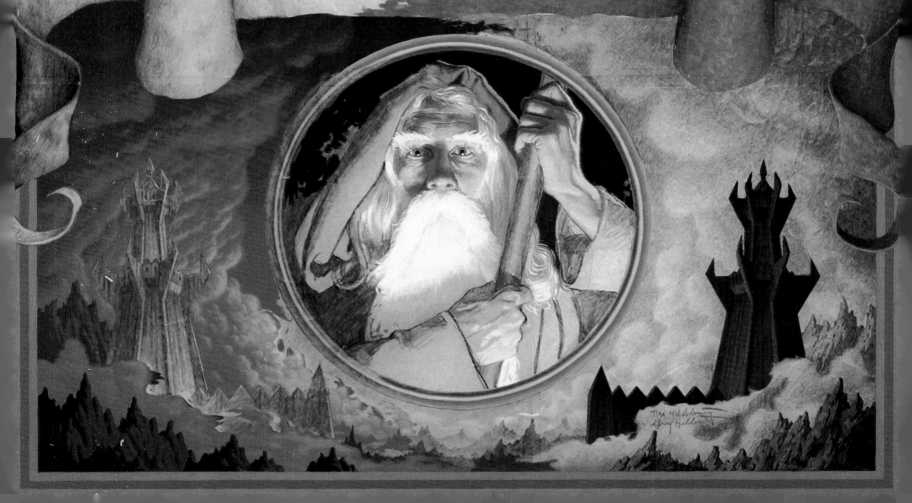

# The Tolkien Years
## of
# The Brothers Hildebrandt

I dedicate this book to the memory of my daughter, Laura, and my brother, Tim.

Both who left us too soon. But never to be forgotten. You are both always in my heart.

Sincerely,

Tim passed away in June of 2006. All of his quotes in this book were done prior to his passing.

# Greg and Tim Hildebrandt

Text by Gregory Hildebrandt, Jr.
Edited by Glenn Herdling
Concept and Design by Spiderwebart

Published By

Dynamite Entertainment / New Jersey

Greg and Tim in the 1970s

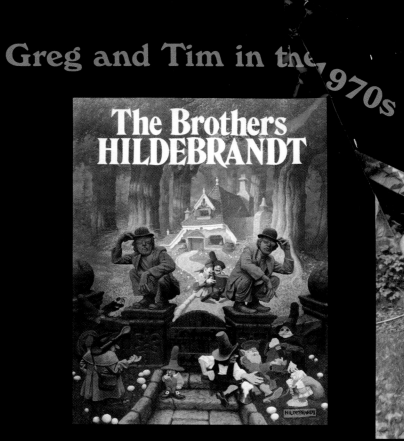

The Brothers HILDEBRANDT

2006

DYNAMITE ENTERTAINMENT

NICK BARRUCCI - PRESIDENT
JUAN COLLADO - CHIEF OPERATING OFFICER
JOSEPH RYBANDT - EDITOR
JOSH JOHNSON - CREATIVE DIRECTOR
JASON ULLMEYER - SENIOR DESIGNER
RICH YOUNG - BUSINESS DEVELOPMENT
JOSH GREEN - TRAFFIC COORDINATOR
CHRIS CANIANO - PRODUCTION ASSISTANT

SPIDI

JEAN SCR
GLEN HERD
SPIDERWEB.
THOMAS BON

THE TOLKIEN YEARS OF THE BROTHERS HILDE

First printing:
Published by Dynamite Entertainment. 113 Gaither Drive Suite 205, Mt. L
Text Copyright © 2001 - 2012 Spiderwebart.
Design ©2001 - 2012 Spiderwebart.
Art copyright © 1975 - 2012 Greg and or Greg & Tim Hildebran

For information regarding press, media rights, foreign rights, licensing,
promotions, and advertising e-mail: marketing@dynamite.net

Set in Windsor BT and DaVinci Forward
Printed in the Canada

First Printing
ISBN-10: 1-60690-349-7 ISBN-13: 978-1-60690-349-0
10 9 8 7 6 5 4 3 2 1

DYNAMITE® ENTERTAINMENT
www.dynamite.net

To find a comic shop in your area, call
the comic shop locator service toll-free
1-888-266-4226

# Introduction

I t was a snowy February day, 1975. I was busy putting the finishing touches on the June book covers when Reneé, the receptionist, buzzed in. "Ian, there are some men out here to see you." I knew there were no appointments for the day. I told her to tell them to come back another time. "Ian. You've got to see this."

I trusted Reneé and came out of my office, which some people referred to as the aviary because of the cage filled with parakeets that a designer gave me as a Christmas gift. In the reception area stood a pair of identical twins, bearded, wet, with paint-covered jeans, thick eyeglasses, and a kind of endearing attitude. I searched for their portfolios. There were only two dark-green plastic garbage bags in a corner, seemingly left behind by the night crew.

I suggested they come back when they had their portfolios with them and to make an appointment. One of them said (or maybe they said it in unison as I would later learn they were prone to do), "Hey man. Pictures. Tolkien pictures. We make 'em."

Each reached for a garbage bag and emptied it onto the reception room floor. Greg was on his knees smoothing out crumpled pieces of vellum with exquisite pencil drawings based on *The Lord of the Rings*. I was enthralled. One might say my jaw dropped. I had been searching for unique artists to create the Tolkien Calendars. I knew I had found them.

I whisked the brothers into my aviary and called Judy-Lynn and Lester del Rey, the science fiction and fantasy editors of Ballantine Books, and publisher Ron Busch. Within a week, papers were signed and I had commissioned the brothers to create fourteen paintings for the *1976 Tolkien Calendar*.

The entire art department rejoiced whenever Tim and Greg brought in their fantastic illustrations (usually on Friday afternoons, because the twins knew we served red wine and pizza at the end of the week). The delivery of each painting was an event. The artwork was created on large sheets of masonite in an acrylic technique that was refined by the twins. They would create a finished piece of art every two or three weeks.

In between their visits to New York, I would visit the artists at Greg's barn in West Orange, New Jersey. This was always an event. There were costumes, children, music, sometimes people playing guitars or recorders. There were

*Farewell to Lothlórien, 2000*

*"Ian Summers was one of the best art directors I've ever worked with. He gave artists a freedom to express themselves without over-art-directing."—Greg*

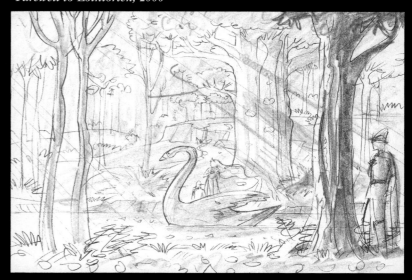

*"During the time we painted the Tolkien Calendars, we also worked with Ian on science fiction and western book covers. He was unique in not forcing us to stay in one genre."—Tim*

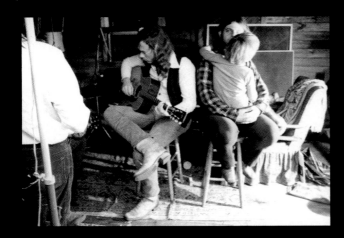

STUNNING WORLDS OF WONDER AND DELIGHT FROM THE BRILLIANT YOUNG MASTERS OF FANTASY
with text by
IAN SUMMERS

Polaroids of costumed neighbors and friends wearing outfits designed by Greg and Tim and made by Tim's wife Rita. There were references, including works by Maxfield Parrish, N.C. Wyeth, Howard Pyle, and the great Disney animators, who were the twins' heroes. The brothers were conjuring imagery from other worlds, and the studio was indeed otherworldly.

The calendar went to press in August and proofs were delivered in early September. To celebrate, we had a luncheon at La Magnette, a classy Italian restaurant next door to Random House on East Fiftieth Street. The restaurant had a street café. There was a commotion, and when I looked up, there were Greg and Tim wearing capes and top hats with feathers. They were handing out the proofs to passersby and, with Renaissance flourish, were chanting, "Howdy do you, Howdy do you." Everyone sang to some kind of Hildebrandt version of Handel's *Messiah*. We laughed for hours. Laughter and outrageousness characterized our relationship.

The *1976 Tolkien Calendar* got more publishing attention than we ever imagined. It quickly became the world's best-selling calendar. We immediately commissioned the brothers to create two more calendars. Each was better than the last—and the first was a masterpiece. I arranged for an exhibition of the brothers' work at the Cornell Club and at the Society of Illustrators. People still fondly remember the works almost twenty-five years later, and among illustrators and fans they are highly esteemed collectibles.

The fan mail was extensive. Most was filled with praise, but there were also long letters of criticism. To some, the Hildebrandt renditions did not resemble their own visualization of Tolkien's words. This is because readers are able to fantasize what each character and location looks like in their mind's eye. The Hildebrandts stirred the Tolkien fans' soup, and we all enjoyed watching what bubbled to the top.

In 1978, I left Random House and founded Summers Books. Judy-Lynn del Rey commissioned me to write and design *The Art of the Brothers Hildebrandt*, a monograph of their science fiction and fantasy paintings. It was a chance to contribute to the legend that was growing around Tim and Greg.

Summers Books' first authors were identical twins who had yet to write a single word, and their good friend Jerry Nichols, from Detroit. But they were superb storytellers. I encouraged Tim and Greg to create an illustrated novel. They disappeared for half a year and came back with over 700 magic marker and pencil storyboard frames. We mounted slides into carousel trays and made presentations to the largest paperback publishers in New York.

In darkened boardrooms, I read a narrative while Greg, Tim and Jerry made sound effects. Publishers did not know what to make of us. Somehow we had the courage to offer the book at auction. *Urshurak* was bought by Bantam Books. And yet another odyssey began.

Jerry Nichols was the writer. I designed the book. The brothers made dozens of pencil sketches and more than a handful of full-color paintings. It was a well- publicized publishing event. And off we went to Los Angeles to show the project to film directors and to attend the American Bookseller Association's annual exposition.

On the plane, we all shared our fantasies. Mine was to have a genuine, no-holds-barred pie-in-the-face fight. Jerry and I shared a room in the fancy Beverly Hills Hotel. At 3 AM, we were awakened by a knock on the door. The first pie caught Jerry in the face. I stared at him in amazement and, suddenly, felt fluffy whipped cream smashing on my face. Needless to say, we left a large tip for the hotel maids. This is another example of how the brothers' creative energy manifested itself. The six years of my life that I spent working with Greg and Tim were truly magical.

Twelve years ago, I developed a theory for creating what became the cornerstone of my next company, Ian Summers' Heartstorming Workshops. I saw that creating and problem-solving were the antithesis of each other. Problem-solving is

about making something go away. Creating is about causing what you love or what matters to come into being.

Tim and Greg are creators at the very highest levels. They do what they love and love what they do. Their paintings are evidence of this. These are pieces of the story I am allowed to tell. There is more. Use your imagination. You can be sure we will.

Ian Summers

*In 1977 Greg and Tim created the cover for tihs Tolkien biography for Running Press.*

*"By the time we started the third calendar we wanted to get The Lord of the Rings made into a film. We found out that Ralph Bakshi already had the rights. So we came up with our own fantasy, Urshurak, to see if we could sell it to Hollywood."—Tim*

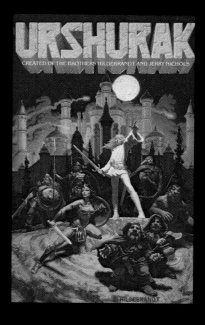

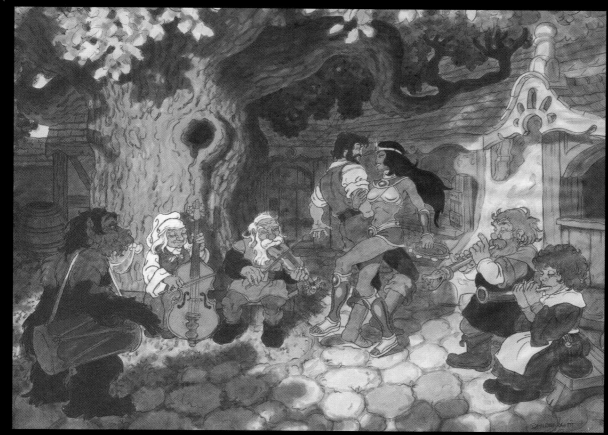

*Hugh Oxine, Zyra, Oolu, and the Dwarfs from Greg and Tim's animation presentation.*

*"I am eternally grateful to Ian Summers, Judy-Lynn and Lester del Rey for giving us the opportunity to illustrate The Lord of the Rings, and for the impact it had on our careers."—Greg*

# Preface

**W**hen my father's business manager first brought up the idea for this book, I thought, "What? That was over twenty-five years ago!" I'm all grown up now (or at least that's what I've been able to fool people into believing).

I was scared. Freaked out. I hadn't taken any notes or photographs. I mean, come on, I was only five at the time the events unfolded. Give me a break.

Then I sat down and locked myself in a room, and I journeyed back in time. A flood of memories washed over me from the childhood that I thought I had.

Let me repeat, "the childhood that I thought I had." I realize now that the childhood I lived, one that I believed to be real, was more fantasy than reality.

Or was it?

To this day I can't remember any differently.

As I put words to paper and opened the deep, cavernous recesses of my foggy memories, it soon became clear that a house filled with trolls, wizards, and hobbits sculpted my childhood.

This narrative and visual journey on which you and I are about to embark spans only three short years of my life with my dad and my uncle. A very brief time in print, but a very, very significant time of transition for all those directly and indirectly involved.

My dad and uncle were always on a journey of exploration. For them, it was always about what's around the next corner. The thrill of discovery is what drove them forward. Even today, my Dad says that he is never fully satisfied with his knowledge of art. My dad approaches learning with the spirit of a child. As he says, "Everything is grist for the mill."

Still working quietly out of a small studio in New Jersey, Greg Hildebrandt, dad spends most of his time working on art. He exists in a world that he creates, and continues to do what he does, not because he has to, but because he wants to.

*Gregory Hildebrandt, Jr., 1975 and 2012*

*"As a hobbit or a full-grown man, I am extremely proud of my son and his accomplishments. Here's custard in your eye, kid!"—Greg*

*Greg and Tim—a hard day at the office, 1975*

The Journey Begins...

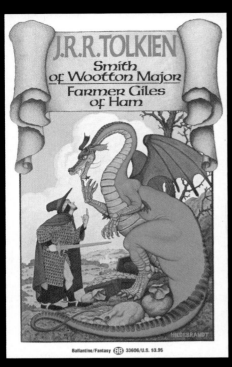

"This was the real beginning. Judy-Lynn del Rey gave us this cover job as a test. We did it, she saw it, she loved it and we were on our way to Middle-Earth."
— Greg

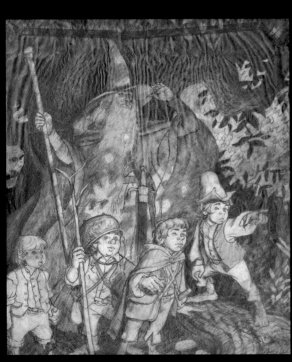

*Early character sketch, 1975*

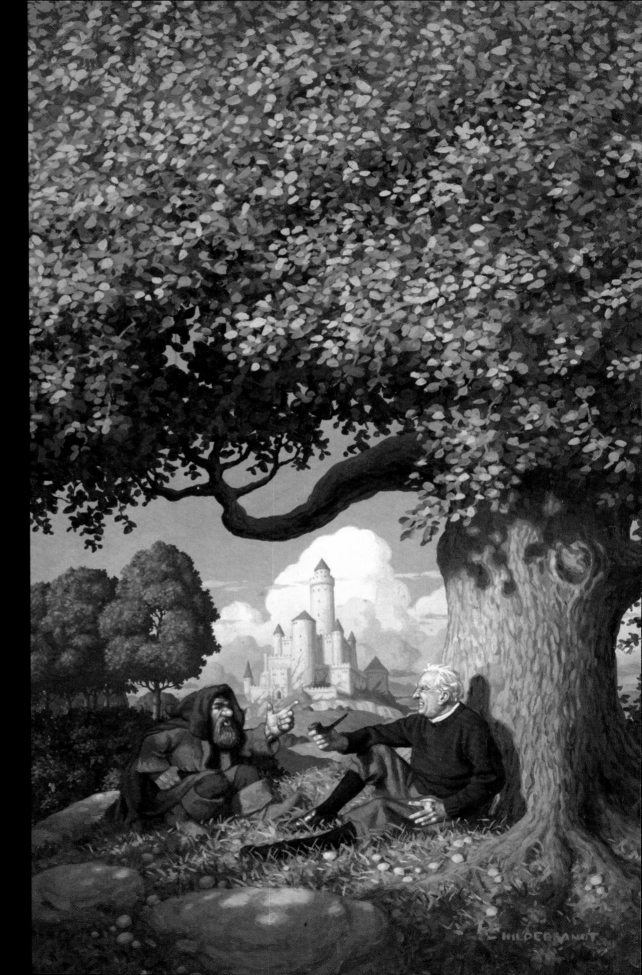

1976

J.R.R. TOLKIEN CALENDAR

ILUSTRATIONS by THE BROTHERS HILDEBRANDT

HILDEBRANDT

*"The first calendar was printed and shipped into the stores before anyone noticed that the word 'illustration' was spelled wrong. Given that it was our first Tolkien calendar, Greg and I were really happy that it wasn't our names that were misspelled!"—Tim*

The time had come to make my move. I tightened my grip on the short sword strapped at my side. The menacing roar of the grass eating monster was silent. It was finally asleep.

I gazed into the afternoon sun as it hung lazily overhead, its warm rays falling through the shifting pine trees like a silent shower.

Taking several deep breaths, I bolted from the shadows of the pines, cut across the river of stones, and sought refuge atop the small grassy knoll that lay on the other side.

I looked back, the metallic beast was still silent.

I pressed forward and cleared the hill. I climbed the stairs to the only place that would protect me from the monster. Shutting the door behind me, I let out a long sigh of relief, I was home, safe inside my kitchen.

The lawnmower was no longer a threat.

The year was 1975, and I was five years old. My home was an old Victorian house, built way before my time, which still stands in the small town of West Orange, New Jersey.

It was there, hidden within the walls of this house, that the enchanting world of J.R.R. Tolkien's Middle-earth was brought to life. And I was there.

January 1976 Calendar, Ballantine Books

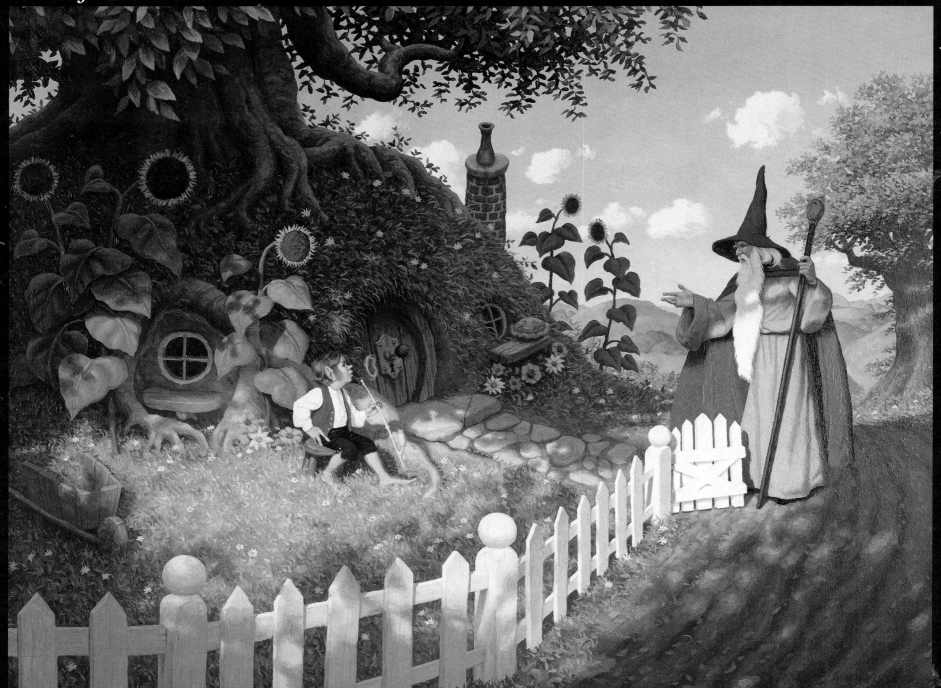

I grew up in the glow of my father, Greg, and my uncle, Tim, as they teetered on the brink of a new era of artistry.

Ascending the back stairs from the kitchen, I made my way to the second floor, where a dark hallway loomed before me. As I grabbed the old doorknob to my left, it turned with a clunk.

I stepped through the doorway into a corner room above the kitchen. I was in my dad's disheveled art studio where my dad and uncle, or the Brothers Hildebrandt, as the world would come to know them, worked most of the time.

Sneaking across the floor as silently as I could, I stepped on piles of sketches that crackled like dry leaves beneath my feet.

Drawing after drawing littered the floor. My presence was immediately detected—I was caught!

My father turned and stared eagerly at me. His long hair and thick beard were wild and untamed, obviously a remnant of the sixties.

"Good, we were looking for a hobbit!" he shouted.

I was thrown into a set of hobbit clothes and the photo lights flashed to life. I stood alone, the wood floor rough beneath my bare feet. My body saturated in hot lights, it was difficult to see into the inky blackness that lay just beyond.

Sporadically, a hand would dart out of the darkness and grab my shirt. A fold was out of place and had to be fixed. The voices of my father and uncle danced around me as they adjusted this and moved that.

I sat on a pile of books, which acted as a tree stump. In my hand I held an old pipe. I was now Bilbo Baggins, a hobbit who was smoking just outside his house.

As my father and uncle talked, they nervously spat out incomplete sentences, each finishing the other's thoughts. With fourteen paintings to do in less than six months, their photo sessions were sometimes frantic and fast-paced. An air of tension prevailed.

The camera clicked away as I sat there impatiently. I was waiting for Gandalf, the greatest wizard that ever lived, who possessed the power to banish evil with a single wave of his staff. I couldn't help but wonder why I was sitting around waiting for such a person.

As soon as my dad took the last shot, he and my uncle sat down on the floor. They surrounded themselves in a clutter of rough thumbnail sketches of Gandalf. They studied each one intently, trying to decide on which pose they wanted to shoot when Gandalf arrived.

Their thumbnail sketches are actually the first step in the process. They are called "thumbnails" because they're only a couple of inches tall. The second step is photographing a model to conform to the tiny sketch.

Later, I answered a knock at the door. Looking up, I stared into the smiling eyes of a tall man. His long hair was pulled back into a ponytail and his beard was overgrown, but uniformly shaped on his face.

He leaned down, a smile radiating from his lips. "Hey, Gorgo, is your father here?" Gorgo, a nickname given to me long before I could remember, was only known to the closest of friends.

Suddenly, my father's voice boomed. "Hey Man!"

The two friends embraced, with me caught in the middle. Squirming away, I watched as they talked.

"Hey, man, thanks for coming," my father said with a smile. "I need you to pose as Gandalf."

"That's cool," said the tall beared man.

I looked at him in amazement. I had heard my father talk of the great wizard who fought dragons and defeated evil with a swipe of his magic staff. And now, here he was, standing before me. His faded blue jeans and stained white shirt was not the disguise I would expect such a powerful wizard to wear. Then again, I wouldn't expect to find a troll living in the dark void of my basement either, but that's where my dad tells me they live.

Back upstairs, the wizard changed into his robes. Only then did it become clear. My father and uncle were in league with the greatest wizard of all time, safeguarding his robes and his magic staff from the forces of evil.

*Tim posed for the first rough sketch for this painting. But Mike had the perfect face and long hair for Gandalf.*

"When reading Tolkien's text Greg and I questioned what it would look like if Gandalf's eyebrows stuck out past his hat. We decided not to follow his text literally because his description of Gandalf's eyebrows would have made them almost a foot long." —Tim

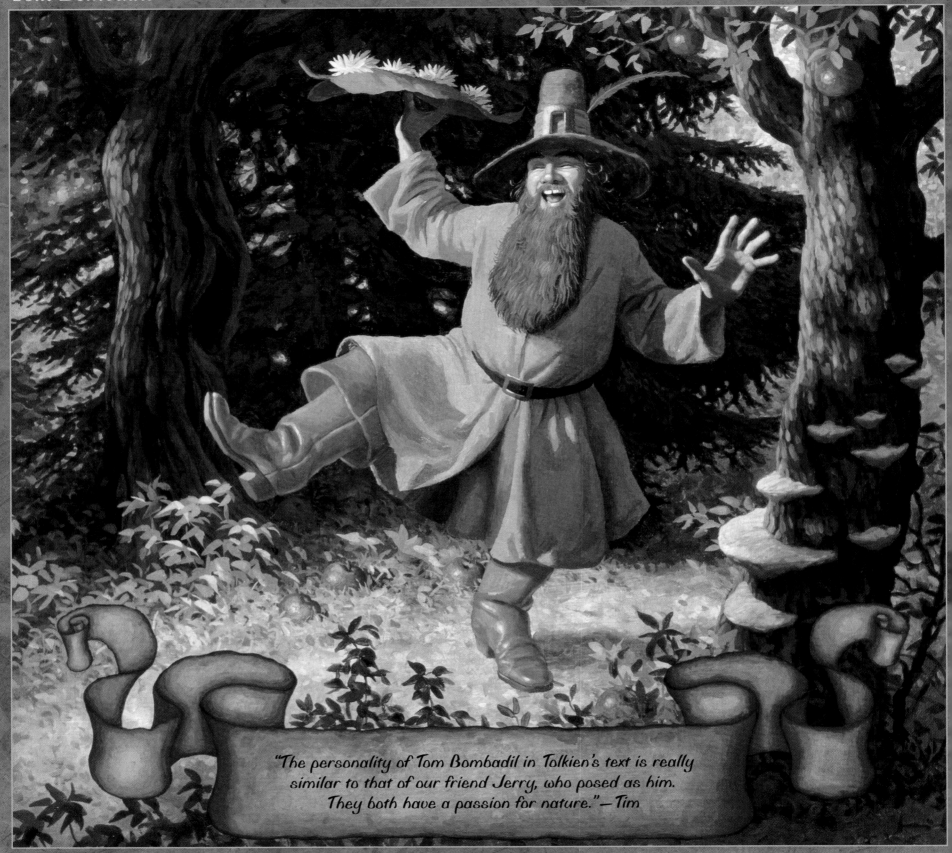

"The personality of Tom Bombadil in Tolkien's text is really similar to that of our friend Jerry, who posed as him. They both have a passion for nature." —Tim

I kept a firm grasp on the tree limb with one hand. With my other hand I scratched my nose. A calm breeze caused the giant pine tree to sway back and forth. As I looked up, I felt as if I could touch the sky. When I looked down, my heart skipped a beat. It was a long fall.

Most of the trees in our backyard were good climbing trees, just right for a small foot and hand.

Noises in the yard below caught my attention. Through the swaying branches I spied a man dressed in a white bathrobe, dancing around by himself.

My eyes fixated on the dancing man, despite the swaying branches that randomly blocked my view. Who was he? Where did he come from?

Then I saw my dad and uncle, camera in hand, shouting orders. "Kick your foot up higher, Jerry!" my dad yelled. "Raise your hand," said my uncle.

Suddenly, I realized it was Jerry Nichols, a friend from their childhood, who was visiting from Detroit, Michigan, my dad and uncle's hometown.

Trying to catch up with them I climbed down from the tree and made my way into the studio where I found my dad, uncle and Jerry. They were laughing and having a beer.

Eagerly, I asked, "Why was Jerry dancing around outside in a bathrobe?"

"That's Tom Bombadil, the dancing man," said my uncle Tim. "Tom is the master of the forest. He is always happy and loves the earth. He watches over the trees and grass, keeping evil away."

My dad leaned forward. "You'll never see him again, but he is always there. Watching over you and his forest."

You see, you have to understand something about my dad and uncle. They really believe there is a master of the forest, and fairies, and elves, and trolls, and gnomes, and giants, and dragons, and wizards.

My grandparents taught them to believe in fantasy and fairy tales, to love nature and to use their imaginations.

My dad taught me this too. So my creativity was a flame my dad would never stifle, even when this involved my interest in pretend-battles and destruction, which were against his philosophy.

As a child, I would tear up sections of the lawn to build miniature army bases for my little green plastic army, and he would encourage my efforts. The base grew, and grew, and grew some more. I would build small cities and then destroy them in a flashflood from an oversized garbage container.

I spent the next several days looking for the dancing man known as Tom Bombadil, only to return disappointed to the studio.

*"The bathrobe that Jerry posed in for Tom Bombadil was the very robe that the model posing for Luke Skywalker would wear a few years later for our original Star Wars poster."—Greg*

I watched as my dad and uncle used the photos of Jerry to bring Tom Bombadil to life on paper.

Along with the photos of Jerry were numerous pictures of trees and plants scattered about the studio. Even today, the mass of reference material my dad uses is a constant presence. Magazines and books are everywhere.

When the drawing of Tom Bombadil was finished, I watched as they cut a piece of masonite to the size they wanted and applied several layers of gesso, coating the brown board white. After it was dry, they sanded it to give it a smooth surface. My dad and uncle prefered the hard surface of board to the pliable surface of canvas.

Then they taped the finished drawing onto it, inserted a piece of carbon paper beneath it, and traced the drawing, transferring it to the board.

Over the next week I watched in awe as my dad and uncle swirled globs of paint over the surface. They filled the white spaces until the image of Tom Bombadil appeared.

It was him, the dancing man, captured by the magic wands of my dad and uncle.

March 1976 Calendar, Ballantine Books

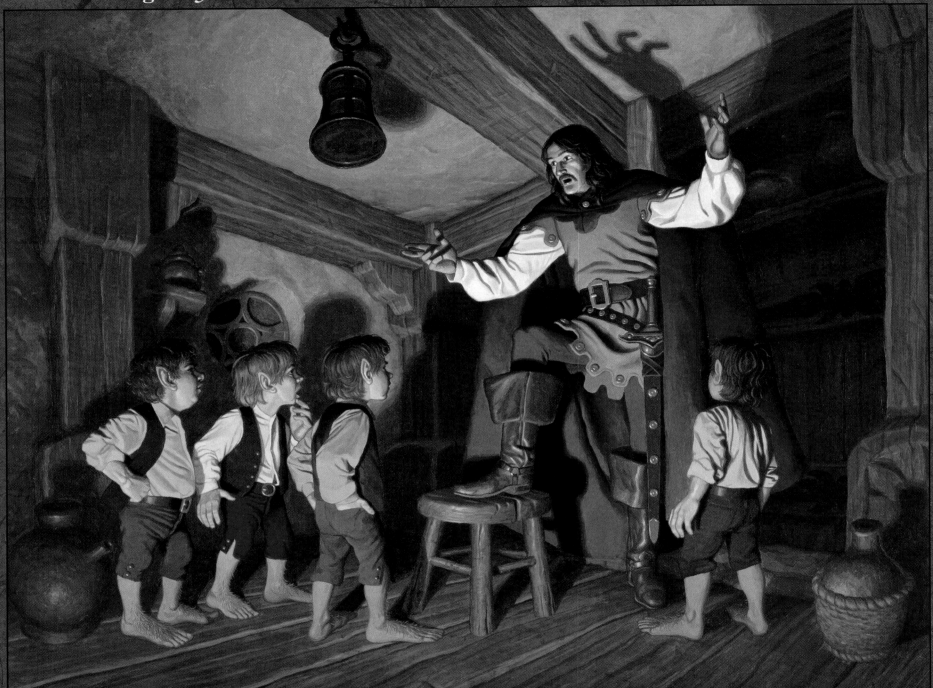

I entered the great foyer of my house. It was lined with dark wood. A massive, smooth stone fireplace protruded from one wall. A wide staircase ascended to a landing where a two-story-high, stained glass window glimmered in the sun.

Cascading colors showered through the tall window onto a second set of steps that rose to the next floor.

When I reached the top of the second flight, a pair of hands reached out and grabbed me around my waist, lifting me high into the air. Taking me into the studio, my dad transformed me into a hobbit once more.

There was my uncle, dressed in long johns, boots, and an old blanket tied around his neck as a cape. "This is Strider, or he will be by the time we're finished." my father said to me.

My dad and uncle would occasionally use each other as models and find other people to pose for the faces later.

Right now, I was a hobbit at the Prancing Pony Inn, located in the small village of Bree, listening to tales of Middle-earth. The camera clicked, punctuating bits of conversation between my dad and uncle.

"Your uncle is Strider, who has traveled here to the Prancing Pony Inn to meet with the hobbit ring-bearer, Frodo Baggins, that's you." my father explained, while adjusting the photo lights.

"I'm ready," said Uncle Tim. "Let's get moving!"

The stress of the deadline to get the first calendar done was evident in their tone of voice.

My dad put a light low on the floor, casting Strider's shadow against the back wall and over the ceiling.

"Gregory," my father said. "Pretend you are listening to Strider as he talks."

Although it was my uncle who stood before me, my dad referred to him as the character in the scene.

This is something they do whenever a model steps in front of their camera. That person transforms into the character of his pose.

The light was hot on my face. But if Strider wasn't complaining, I certainly wasn't going to. After what seemed like hours, the photo lights were clicked off and they were done. With no time to waste, they quickly took the Polaroids to their drawing tables and began to sketch.

Today, most of the clothes we wore when posing for the Tolkien calendars still exist: stitched blankets, cut-up shirts, leather belts, and sheaths.

The sheaths were nothing more than pieces of cardboard folded around a real sword then taped together. A piece of brown leather was cut and wrapped around the cardboard and either taped or stapled on the side facing the leg. A few extra buttons and a couple of paint strokes later, a worn leather sheath was at the ready. Crude, but effective. I'm still amazed at how much time was spent on creating the outfits and gear. Sometimes days would go by while my father and uncle worked on the costuming. This was something that

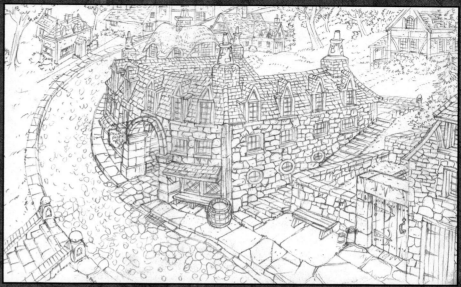

*Tim originally created this long shot of the Prancing Pony in 1975 to establish the exterior before he could design the interior. This is a recreation of the original sketch, which was damaged.*

they began doing as kids, creating everything from Frankenstein to Batman to Alien costumes.

They photographed the top floor of our old horse barn for the interior of the Prancing Pony. The circular window in our attic turned up on one of its walls.

There was more to my house than I had realized.

It was actually because of my uncle, having read *The Lord of the Rings*, several years earlier, that my dad and he were knee-deep in all these costumes and photographs. My uncle wanted to illustrate Tolkien's *Ring* badly. He had been given a 1975 Tolkien calendar by my aunt Rita, which was illustrated by U.S. artist Tim Kirk. In 1974 a Tolkien calendar had been published for the first time. It was created using J.R.R. Tolkien's illustrations. Almost instantly, he immersed himself in rereading the trilogy.

At that time, my dad was concentrating on painting his own imagry with a desire to have a show in a New York City gallery. He wanted to break away from illustrating someone elses ideas.

It was after my dad finally read Tolkien's trilogy on the insistence of my uncle, that he became interested in it. For the next three years, my father would put aside his desire for a gallery show and immerse himself in a world of hobbits, wizards, dwarves, and elves.

*"The use of low light to cast dramatic shadows was first obvious to me when I saw the witch dipping the apple into the cauldron in Disney's Snow White."* —Greg

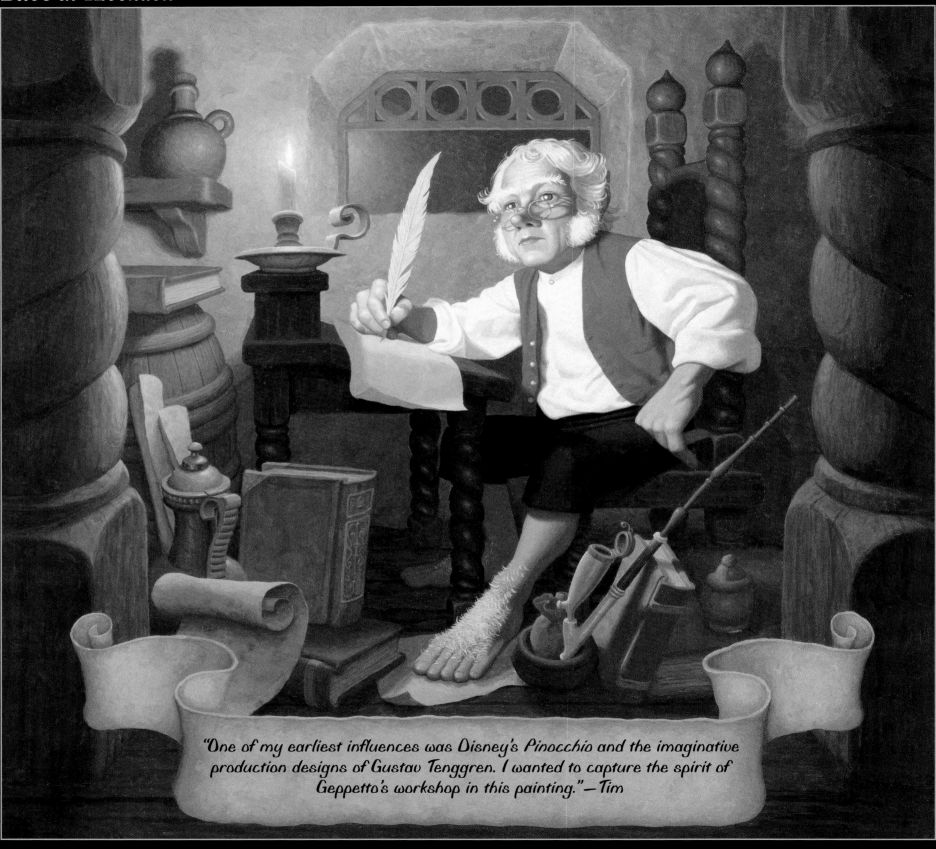

"One of my earliest influences was Disney's *Pinocchio* and the imaginative production designs of Gustav Tenggren. I wanted to capture the spirit of Geppetto's workshop in this painting." —Tim

Feeling safe and not the least bit tired, I quietly slipped from my room. I made my way down the long, dark hall. The old wooden floor creaked with every step. The stained glass window that had bathed the stairs with soothing light was dark.

My older sisters, Mary and Laura, had warned me about the dangers lurking in the night. They said that creatures crawl up from the damp basement and search the house for food. And little kids were their favorite dish. A flickering light at the end of the hall caught my eye. It was coming from my dad's studio. Did he leave a light on? Was he still working? Then I heard voices.

I continued forward until I reached the studio door and peered inside. A flickering candle shined on my uncle as he sat at a table. His pants pulled up to his knees, he sat still and stared off into the distance as my dad knelt before him with his camera.

Usually, my dad takes the photographs and my uncle is more like the set director, setting up the shot, moving lights, and adjusting the costumes on the models. But every so often they switch, one performing the other's typical role, or picking up where the other left off.

Working together is a skill they acquired not from being twins, but because they grew up together and enjoyed the same things.

Although they are twins, they are two completely different people. Each struggles for his own identity, but they are able to think alike while working on projects.

"Hi, Gorgo," my uncle said, his voice calm.

My father turned and stepped toward me, pulling me into the room. "Here, hold this." He handed me a large piece of white cardboard and turned on a photo lamp. My dad pointed the light away from my uncle, aiming it at the board I was holding.

"What is this?" I asked.

My father looked over at me and then back down as he loaded the film into his camera. "It's a piece of cardboard to reflect the light. A direct light would be too intense for this scene. The candle will be in the painting, but it doesn't give off enough light for the camera."

"Oh," I said. But that really wasn't the answer I was looking for.

"Your uncle is Bilbo Baggins," my dad continued. "He is much older now and living at a place called Rivendell. He had helped conquer the dragon Smaug and has now retired to write about his life."

I watched as my father took pictures of my uncle. Although I had witnessed this numerous times before, I was still amazed at how they were able to take a photograph and turn it into a finished painting.

In several clicks it was all over. Uncle Tim blew out the candle. Dad turned off the photo light. I placed the cardboard on the floor and left the studio.

Over the next several days, "Bilbo at Rivendell" came to life in a swirl of browns, black, and white acrylic paint.

Do you see where the teapot sits on the floor in front of Bilbo? That's where I stood, holding the white cardboard. Although I wasn't actually in the finished painting, I'm still a part of it. In my mind, I had been magically transformed into the teapot by my dad and uncle.

"When we painted Bilbo as an older hobbit, we used Tim's body and our dad's face."—Greg

George Hildebrandt, the family patriarch, whose face became that of Bilbo Baggins.

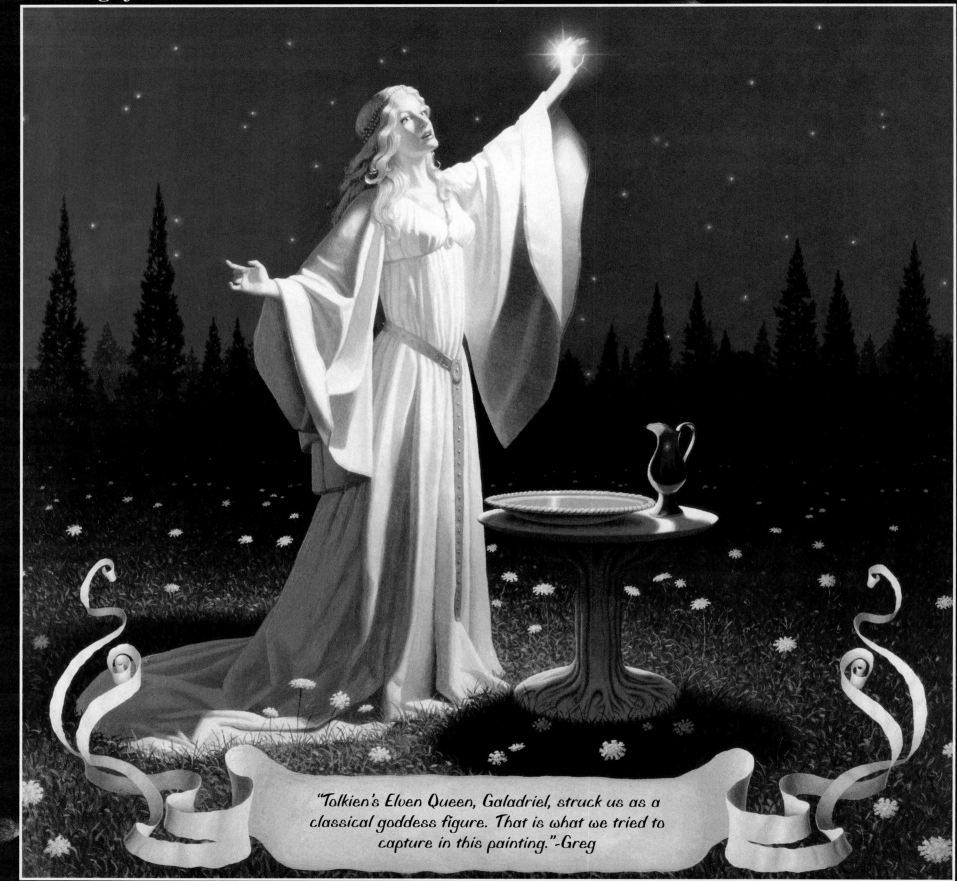

"Tolkien's Elven Queen, Galadriel, struck us as a classical goddess figure. That is what we tried to capture in this painting." -Greg

commotion in the next room awakened me one
morning. Wiping the sleep from my eyes, I opened
the door leading to my parents' bedroom. The glare
hoto lights forced me to shield my eyes. I entered the
m and stood by the massive fireplace. A cool breeze fell
m through the open flue, sending a shiver up my spine.
My mom, wearing a long, white robe and a golden belt,
d elegantly beneath the hot lights. She held her hand
as rays of light reflected off a ring on her finger. My
e adjusted several of the wrinkles in her robe and then
back. Closing one eye, he studied it from an artistic
pective and repeated the process.
A calm silence permeated the room. Not an
mfortable silence, but a welcome one, particularly so
y in the morning.

*Diana Hildebrandt, Greg's wife,*
*is seen posing in this photo for the*
*beautiful Galadriel.*

*Since they met, Diana posed for dozens of*
*characters for Greg. You could say it is*
*either the benefit or the curse of being*
*married to an illustrator.*

I learned that the ring on my mom's finger was the Ring
of Galadriel, and I was bearing witness to its magic.
Galadriel, or "lady of light," was as powerful as any wizard.
The Ring was one of the Three Elven Rings of Power, and
she was keeping it from the hand of evil. I knew that those
seeking ultimate power would covet the knowledge that I
possessed.

I know now that the real magic my mom possessed was
in supporting my dad as his invisible backbone. She anchored
our family to a solid foundation as my father and uncle
pursued their flights of fantasy.

In the truest sense, she was Galadriel.

Spring was fading fast. The trees had already started to change into the deep greens of summer. Inside, the old pipes that snaked throughout the house creaked and moaned as hot water rushed to the antique cast-iron radiators for maybe the last time this season.

I loved those old things. Their clanking sounds and smells made me feel secure.

I wandered through the hallways alone. As usual, I ended up in my father's studio. Carefully, I stepped over half-used tubes of paint and brushes that were scattered all over the floor. I pulled myself up onto his paint-covered chair and marveled at the images on his drawing board.

Sketches of creatures unlike any I could have ever imagined lay before me, massive, piglike men, outfitted in a crude assortment of armor.

They were like something from a nightmare, but none that I'd ever had. Their snarling teeth and beady eyes left no false impressions as to their intentions.

Two young hobbits were tied to a tree, terror was etched on their faces. One of them was looking directly into the hungry maw of one of the beasts. I knew it was a face that I would never want to encounter.

I lifted my head slightly, and there it was. The photograph of my face that I had posed for earlier, taped up next to photos of my tied-up uncle and the sketch of the foul monsters.

Was this a vision of what lay waiting for me in the shadows of my cavernous basement? Or maybe these were the hall monitors, which my two sisters had whispered about, that roamed their school, looking for bad children. Sooner or later, I knew I would have to face these creatures. But now was not the time.

My jaw dropped as I stared at the board. It was me! I was the one who was tied up as a sacrifice to the dark creatures. In fact, there were two victims, and they were both me!

Well actually, they were going to be Merry and Pippin, the hobbits.

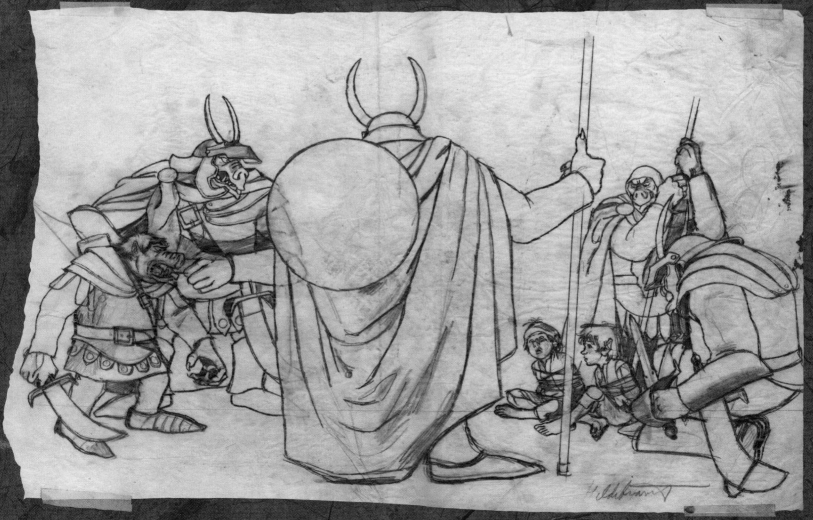

"The photo of the central orc was actually a shot of a Roman soldier taken in the early sixties for a crucifixion scene. It gave me the idea to design the orcs in Roman armor. But it wasn't quite the look we wanted, so I decided to vmerge Roman with Japanese and Persian." —Greg

# "The Fellowship of the Ring" Begins...

Over the next few days, my house was filled with a constant flow of people. Some I knew, others were strangers. Costumes were assembled, photo lights continually shined, and empty film containers littered the floor. They had come to contribute to the first calendar centerfold.

I was dressed again and again. My image, with the addition of overgrown feet and hands, ended up in front of a group of adventurers, headed into the unknown. Bits and pieces of me were mixed into the rest of the hobbits. Eyes here and a mouth there.

In the studio, sketches were spread across the drawing table. These sketches were cut out and taped together to form one giant picture. The visitors had posed for the faces individually at different times, but my father and uncle performed their magic once again by bringing them all together in one image.

The collage of photos gradually became a complete sketch. For me, it was a mix of events that spanned days, maybe even weeks. But for the world, it meant the end of a month at the turn of a page, when June ended. People would see for the very first time a union of heroes dedicated to the future of their land and the destruction of its enemies. These heroes, in reality, were teachers, artists, plumbers, carpenters, mechanics, and a neurobiologist. But the world would see them as the Fellowship of the Ring.

I saw my father's and uncle's friends.

I could see the tension mounting, even though my dad and uncle had reached the halfway point in the calendar. Periodically, they would get calls in the studio from their art director, Ian Summers.

Whether it was my dad or uncle who answered the phone, the conversation never changed. "We're working as fast as we can. We can't paint any faster than we're painting. We'll make the deadline. We've never missed one yet."

But I could see that they weren't sure. It's about at this point that I remember the finished size of the art becoming a big issue, for the very first time.

My dad kept pushing for big paintings, while my uncle kept reminding him of the deadline. But when it came to the Fellowship, they both agreed, it had to be big, really big.

*"This drawing to the left was one of the first we did on Tolkien. Then we decided to take a more realistic approach to the Ring. For six years, Tim and I had illustrated children's books. The Tolkien Calendars were the beginning of a new style of art for us. To design and paint these fourteen paintings in five months was a challenge. The best projects for us have the impossible deadlines."—Greg*

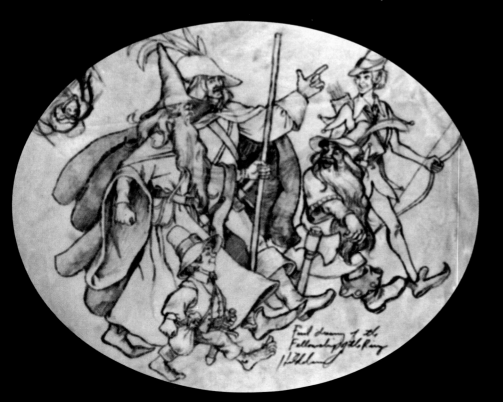

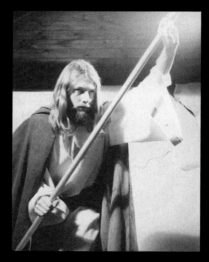

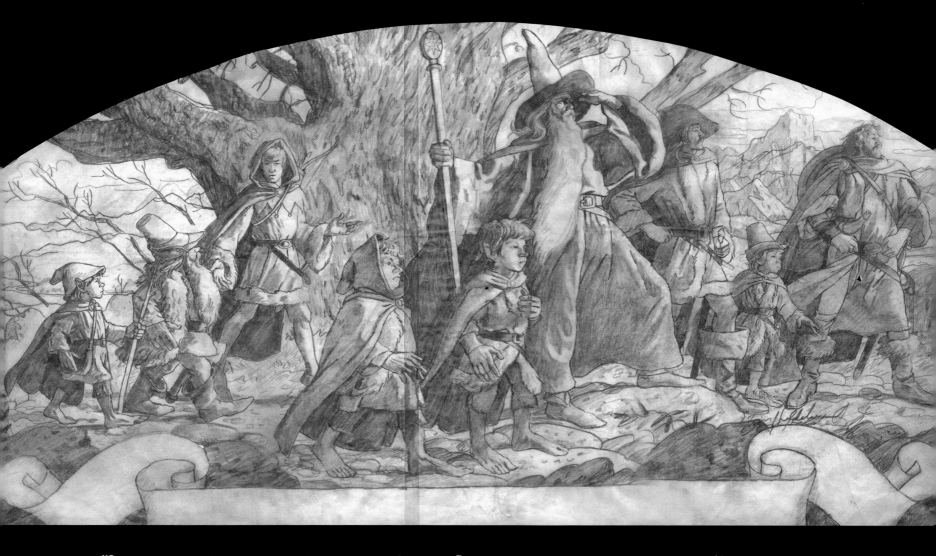

"Compositionally, the main thing that unifies the Fellowship painting is the giant oak. We wanted a tree in the centerfold because Tolkien was totally in love with trees. I also love painting their texture, especially when it's gnarled and twisted bark." —Tim

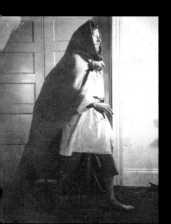
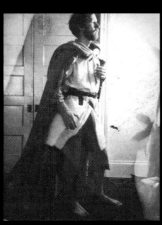
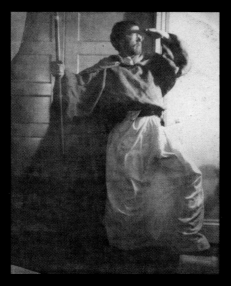
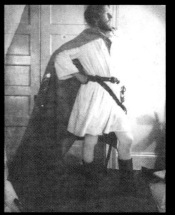

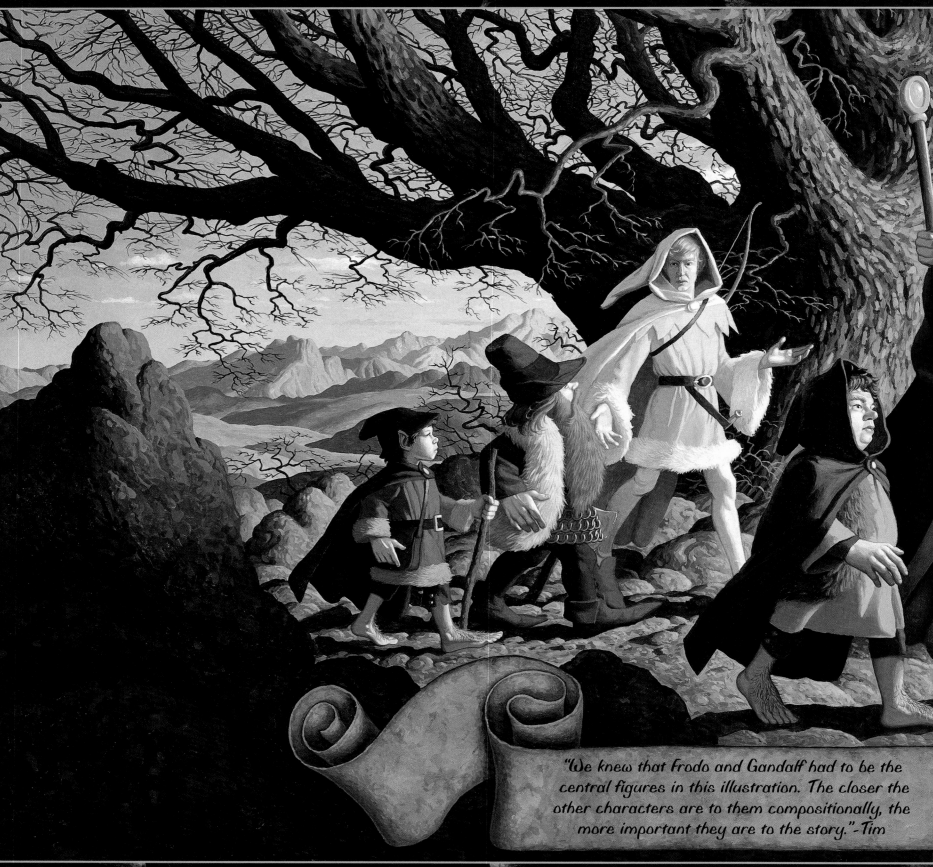

"We knew that Frodo and Gandalf had to be the central figures in this illustration. The closer the other characters are to them compositionally, the more important they are to the story." -Tim

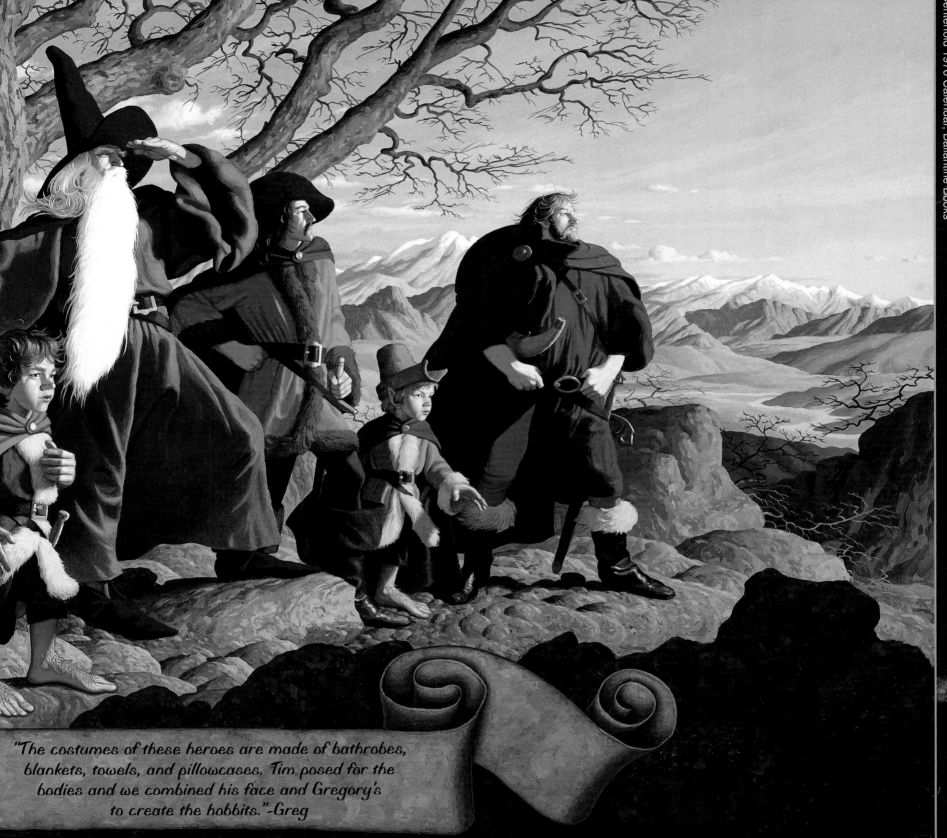

"The costumes of these heroes are made of bathrobes, blankets, towels, and pillowcases. Tim posed for the bodies and we combined his face and Gregory's to create the hobbits."-Greg

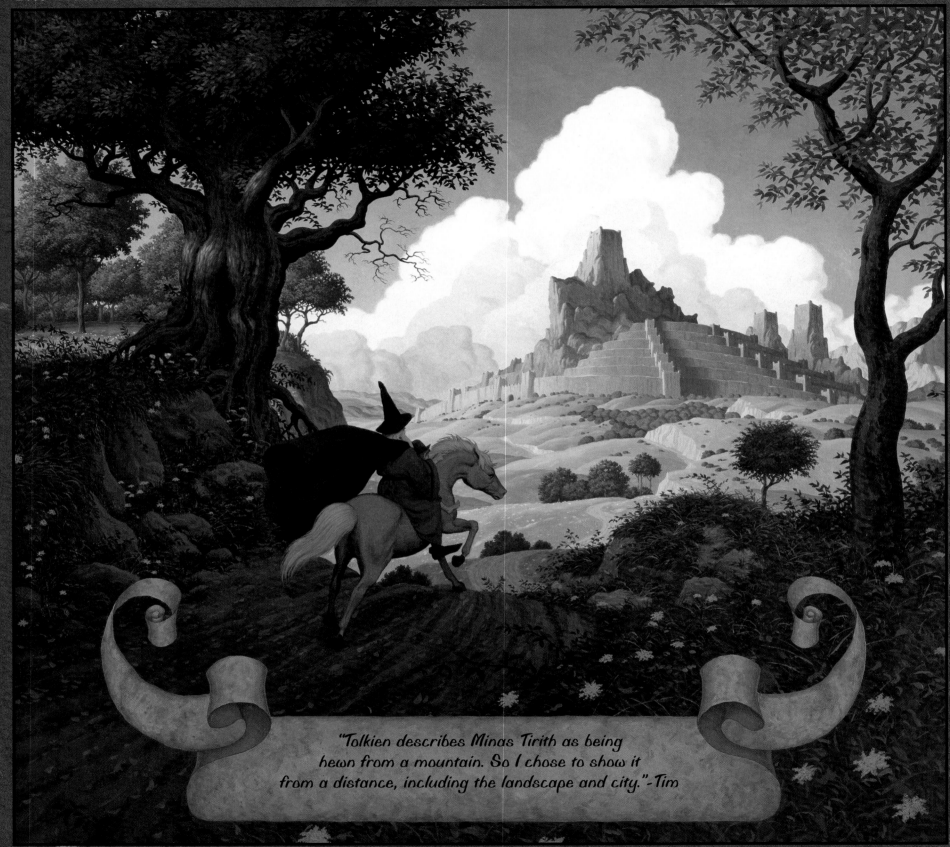

"Tolkien describes Minas Tirith as being hewn from a mountain. So I chose to show it from a distance, including the landscape and city." -Tim

The sun beamed on the back of my neck. My dog Pani, an Alaskan Malamute, dragged me along a trail by her leash. The local reservation was a place that my family and I visited often. Pani looked forward to these walks more than I did because she was in fact walking me.

My dad followed with a camera. He occasionally stopped and took pictures of rocks here, a patch of grass there, and trees everywhere. Crouching in what was certainly an uncomfortable position, he would capture tree branches in his lens as the sunlight showered through them. Then he would lean closer to catch the gnarled roots.

I loved watching him bring the camera to his eye everytime the wind blew. The dust would swirl up from the path and a click of the camera would capture it instantly. Whenever the sun fell on a tree in just the right spot, my father's camera would be there.

I grew concerned when dad pulled out my sister's plastic toy horse and set it down on the dirt path. Lying on the ground, he began clicking pictures of the motionless toy, grunting to himself.

After shooting the horse from several angles he stood up. Dirt was plastered to the front of his shirt, which didn't bother him in the least. He picked up the toy horse and shoved it back in his shoulder bag.

"This is the perfect road to Minas Tirith." He said.

Walking briskly, he moved past me with a smile.

Several twigs hung loosely in his overgrown beard.

"Come on, kiddo! The lake is just around the bend," he said playfully.

I stood silent, my dog poised at my side. I knew what had to be done. On my father's next birthday, I would give him a "How To" book on photography.

The days crept by, as they do when you're a child. I lurked behind my father in his studio, peering over his shoulder as pencil drawings grew more defined.

My dad scattered the photos he had taken, on the drawing table and the floor. Even the plastic horse was there, a few dried smudges of paint staining its body.

Like a great architect, I watched my uncle create an amazing fortress. Layer after layer, the stone structure reached higher and higher, and in the center stood a single rock tower.

Green, rolling fields surrounded the fortress. An old dirt path snaked up to the Great Gate. It was the path from the reservation, sort of. And the plastic horse had become Shadowfax, on whose back Gandalf rode swiftly toward the stone structure.

I had witnessed the construction of the greatest citadel in Middle-earth. Minas Tirith, a city of kings. I alone knew the secrets of her seven levels and the location of each hidden door. Possessing that knowledge made me nervous. With my father and uncle at my side, however, and the walls of Minas Tirith within my own house, I knew I was safe ... for the moment.

*"People usually only see the finished product. We did very elaborate, full-sized pencil drawings for almost all of our Tolkien work. We did them this detailed not only for ourselves, but for Ballantine Books, in order to get their approval."—Tim*

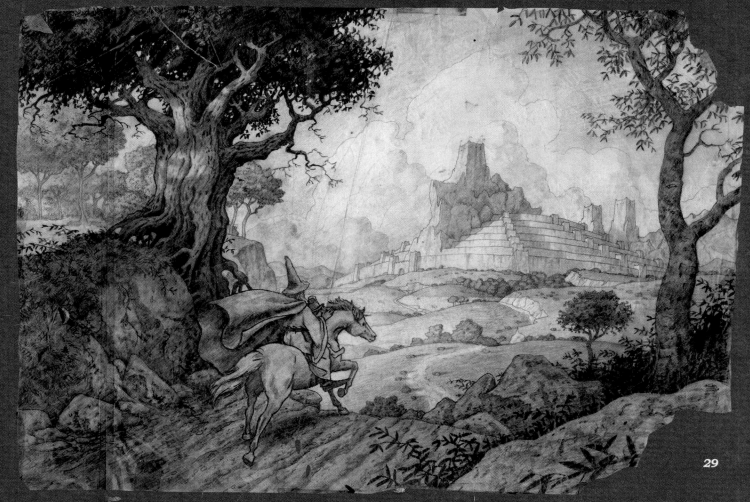

## Treebeard

The shade on one window in the cluttered studio was rolled up. The other was down. My uncle sat at his easel, a spotlight stood behind him. The intense light illuminated a painting of dark roots and a massive stone table.

On the table, two hobbits sat with their backs to me.

A vacant white space in the center of the unfinished painting cried out for completion. As I watched intently over his shoulder, Uncle Tim poked the tip of his brush onto a piece of aluminum foil. Various colors of paint were smeared across the metal sheet, most of them blending into each other.

After covering the brush with a blob of paint, my uncle brushed the leg of his pants several times, wiping off the excess. Resting one hand on the painting, he gently stroked the tip of the brush along the open space. It seemed pretty funny to me that he was getting more paint on himself than the board.

I turned to my father, who was sitting at a small folding table cluttered with empty paint tubes, jars of water, and empty coffee cans.

He began sculpting a piece of clay, rolling and squeezing it. Then he picked up an old stick, maybe a foot long, and placed it on the table. With the clay, he molded the shape of a head on the top of the stick. To complete it, he used the smaller piece for a nose.

My dad and uncle created a lot of their own miniatures for photographic reference. Even today, with all the models and action figures available, my dad will combine pieces of things to form whatever he is trying to visualize. They used the finished sculpture to get the correct lighting.

Combining the photos of the clay head on the stick with photos of two long, lanky arms (either my dad's or uncle's), the image of Treebeard sprung to life in a sketch. Then the artistic magic in the brush-tipped wands of my father and uncle brought the tree creature to life in the painting!

My uncle later told me that the two hobbits whom Treebeard addressed, Merry and Pippin, were looking for his aid in their fight against evil. Treebeard undertook their plea and, from what I heard, they emerged victorious.

After that day, I never climbed a tree in my backyard without wondering if it could talk.

*"Most of the photos for the 1976 calendar were shot with an old black-and-white Polaroid camera. We chose to use a Polaroid for the instant certainty that we got the shot. I fondly remember peeling back the film and fixing it with a little pink sponge filled with chemicals that got all over my hands. The Polaroid camera was the greatest thing ever invented for artists with deadlines."*
*-Greg*

*"The difficulty here was to get the right blend of human and treeishness. The reader judges whether or not an illustrator succeeds in interpreting a character or a story. You have to make sure you satisfy yourself first. If you are not 100% happy with your interpretation, then no one else will be."-Tim*

August 1976 Calendar, Ballantine Books

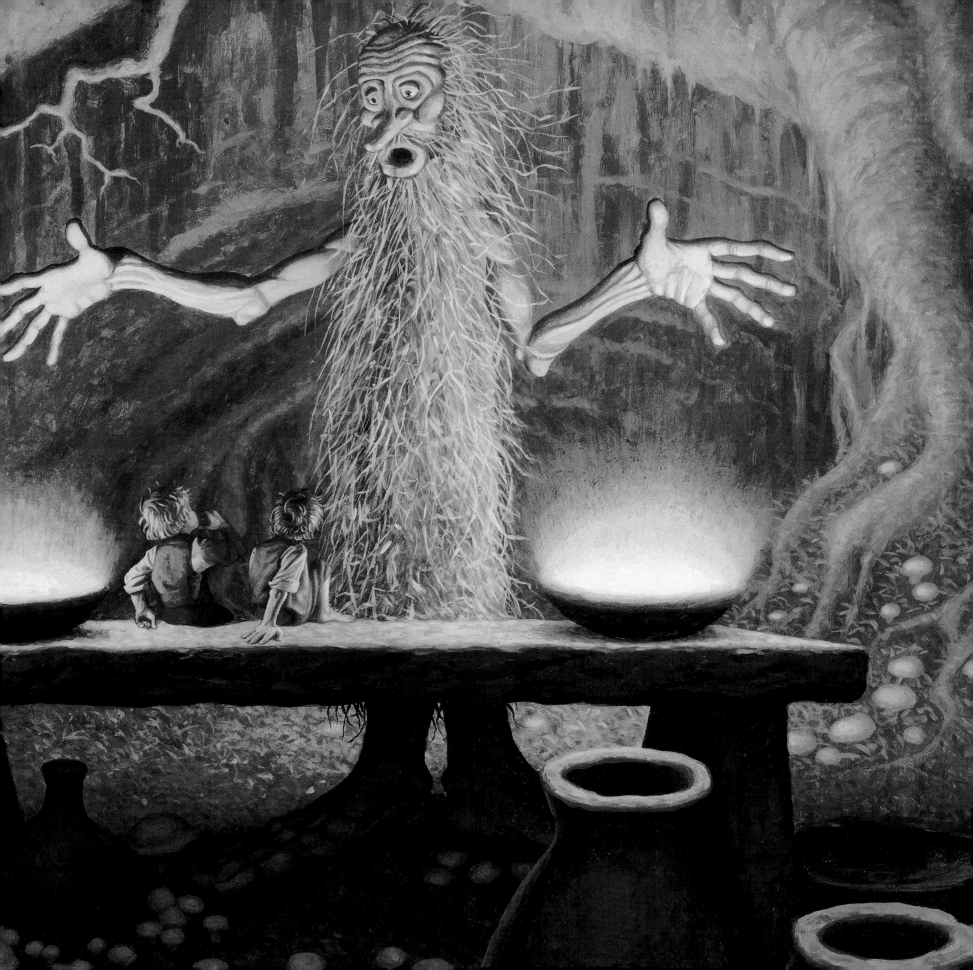

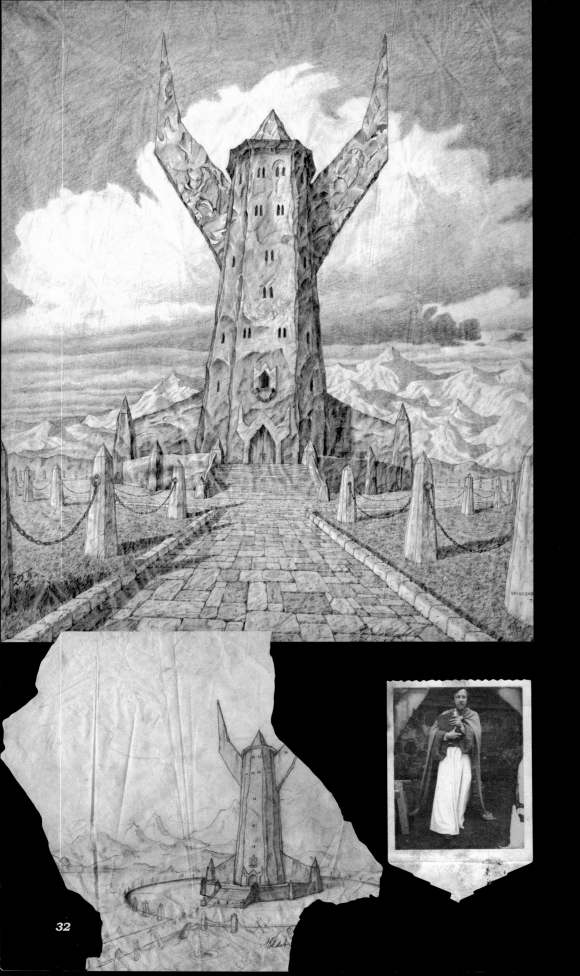

From overheard conversations, I learned that something sinister was happening. An evil wizard, whom they called Saruman, was coming from a place called Orthanc. My dad had left early for my uncle's studio, and I was alone with my sword set firmly in my grasp, prowling the vacant halls of my house as its protector.

I stopped in the family room and felt a strong breeze, which ruffled the cloak that was tied to my shoulders. Something wasn't right.

I made my way through the kitchen and crept up the back stairs to the studio. The door was slightly ajar.

I pushed the door open with the tip of my sword. I walked in. Most of the sketches usually scattered across the floor were gone. They must have cleaned.

I looked down beneath my feet. Had there always been a rug in here? Neatness is something that was not one of my dad and uncle's strong traits. In the midst of the creative process, certain things must take a backseat. Keeping a neat and organized studio for them was so far in the back seat, it was in the trunk.

In the unfamiliar studio, I felt as though I was being watched. A chill ran up my spine. I turned around cautiously and there it loomed.

A dark chiseled tower rose before me. I was standing in front of Orthanc in the center of Isengard. Orthanc, the castle of the evil wizard, Saruman the Many-Colored. But where was Saruman?

The wind blew through the window and the door slammed shut. I was trapped! Was he here in the studio?

My father and uncle had told me that Saruman's tower in Isengard was impenetrable. But now it was up to me to stop him! I grabbed my cloak and covered the drawing. I kept my sword pointed toward it.

In the distance a loud noise startled me. Was it a door slamming? I couldn't tell. Then I heard footsteps on the stairs. They were faint at first then louder, louder and closer they came. They were in the hall coming toward me. It was Saruman! He was coming to get me!

The door swung open and standing in the shadows was my dad and uncle. They entered the studio. "Watch out!" I yelled. "Saruman is in the hallway!"

"He's not in the hallway, Gorgo," said Uncle Tim, holding a painting in his hands.

"He's right here in the painting we just finished at Uncle Tim's studio," said my dad. "By the way, kid, put down that sword you're going to poke your eye out."

# Saruman at Orthanc

September 1976 Calendar, Ballantine Books

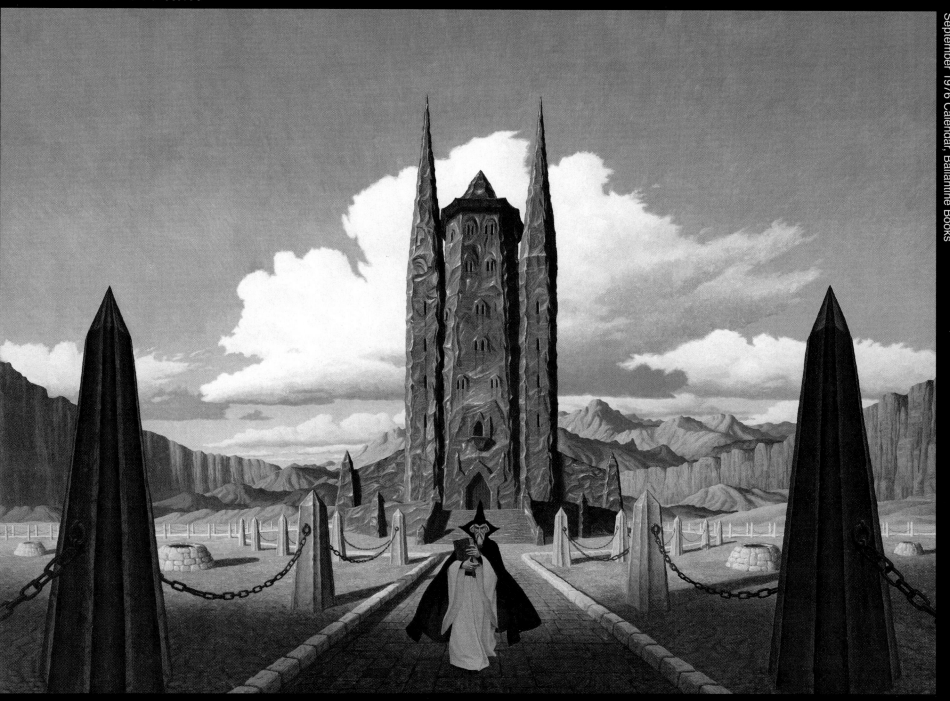

"Wanting a more sinister look, I first designed Orthanc to look like the horns of a demon. Lester del Rey, who was the chief consultant on the calendars, said that my interpretation of the tower was not accurate. He was right, and I corrected it to make them spikes rather than horns." —Tim

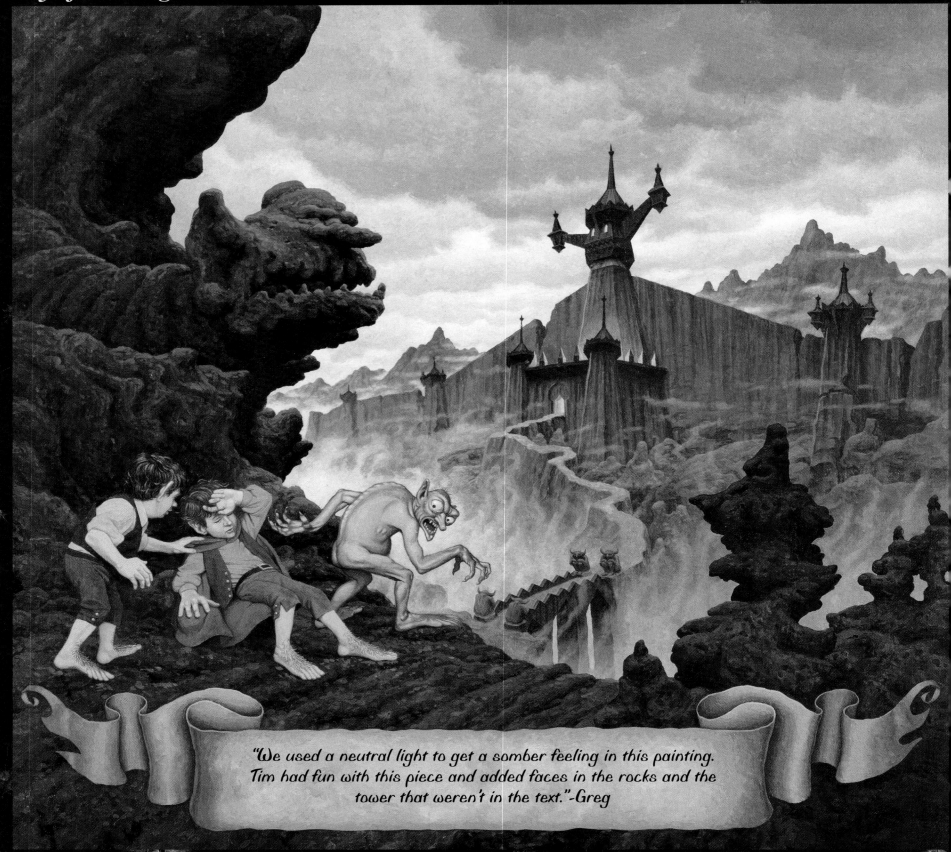

"We used a neutral light to get a somber feeling in this painting. Tim had fun with this piece and added faces in the rocks and the tower that weren't in the text." -Greg

I leaned uncomfortably against the wall. A safety pin that bound a cloak—actually a dusty blanket—to my back pinched at my neck. Spotlights reflecting off the ceiling bathed me in a soft light.

My father and uncle studied a sketch lying in front of them. They chattered, pointing at me every so often. I fidgeted with the cape around my neck, as they spoke in hushed whispers about a creature, a small, dirty thing that lived only for treachery. It was once hobbitlike, but the Ring of Doom had transformed him into an evil being.

They called him Gollum, a creature that dwelled in the shadows of the night and the dampness of the underground. Could this be the evil that lurked in the depths of my house in the dark corners?

My dad told me to keep my eyes closed and to place one arm over my head. I did as I was told. The camera clicked several times.

Suddenly dad lifted me up. "That's it," he said.

He and my uncle turned off the photo lights and returned to their drawing boards. Working with the pictures that had just been shot, they began to sketch.

Classical music drifted from an old radio in the background.

Hours passed, the music flowed from one tune to the next, and before my very eyes a black-and-white vision of another world appeared on what was once a blank sheet of white paper.

I let the old blanket fall to the floor. The wrinkled cloth pooled around my feet. I stepped out of it and withdrew from their world of Middle-earth. But every so often I would venture back, searching for the one they called Gollum.

Over the next few weeks as a new painting rose from piles of sketches and photos, a place of darkness grew before my eyes and Gollum was there. As each stroke of paint was applied to the board, the *City of the Ringwraiths* came to life. The one called Gollum was taking two hobbits to the fiery soul of Mount Doom to destroy the ring of power. And I was one of them.

*"Whenever we started working on a new character, we did dozens of drawings. These were quick sketches done without the use of models. Character studies defined movement and personality."-Tim*

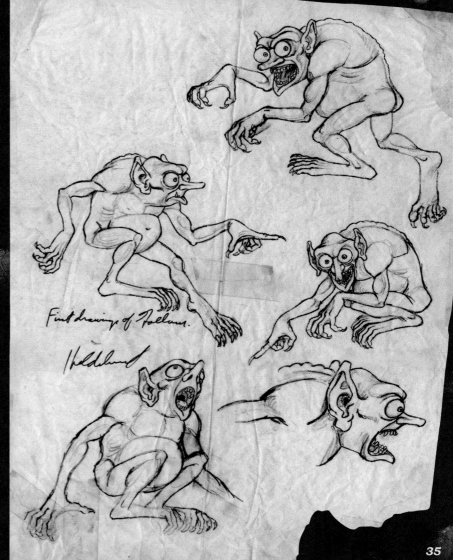

First drawings of Gollum.

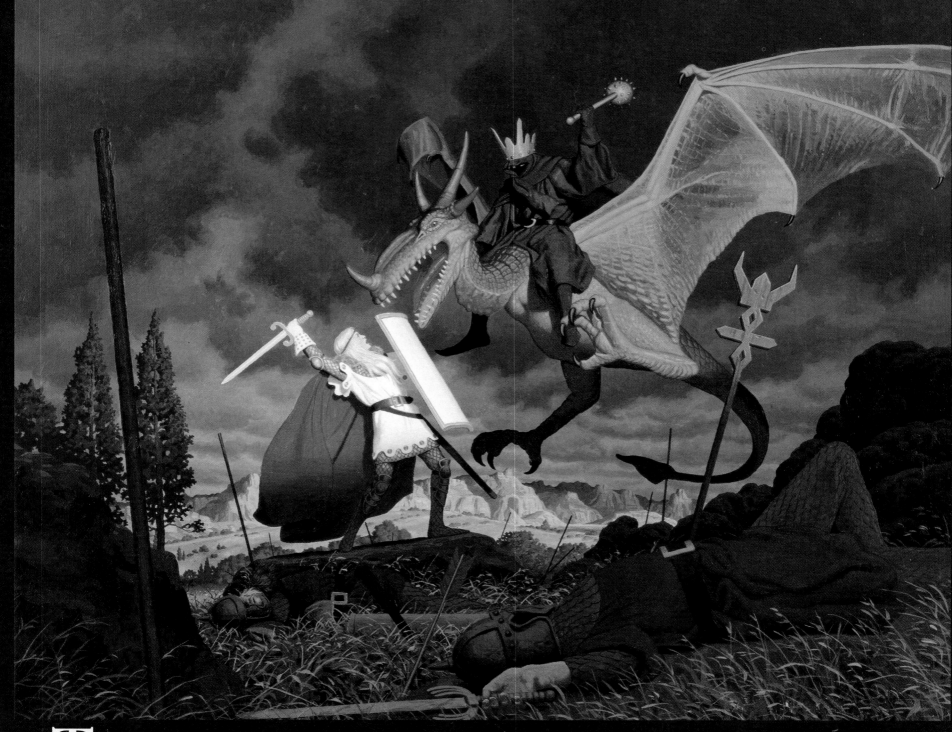

**T**he extreme heat and humidity of July prohibited me from playing outside. No matter, dad's air-conditioned studio suited me just fine.

My uncle roared with laughter as dad held up a rubber chicken with a pair of fake wings attached to it. The chicken was nearly two feet long. I'd seen rubber chickens before, but this one was by far the biggest and the best. My father and

uncle obviously thought so too.

Having fun while they work was a necessity for them since they drew and painted seven days a week, nine hours a day. I've heard them say over and over again that no matter how many hours they worked they were extremely thankful that they were able to do what they loved.

The spotlights shined on the rubber chicken. My uncle

clicked away with the camera. It was their playtime, and I was intruding. I quietly turned and left.

The next day a very strange thing occurred in the studio. At least it seemed strange to me. My dad and uncle were getting ready to shoot the photos for the painting of *Éowyn and the Nazgûl*, which would mark the completion of the first calendar.

As I walked toward them in the studio I saw what I thought was a woman in costume, with her sword held high and her cardboard shield firmly in her grip. A woman? It was no woman—it was my uncle Tim! Were my eyes playing tricks on me? I asked my dad.

"Gorgo, that's not your uncle, that's Éowyn. Éowyn is a woman, but in this scene she is posing as a man," said dad.

"But what does that mean?" I asked.

Simple. "Éowyn is fighting the Nazgûl, who can't be killed by a man. To trick the Nazgûl, she disguised herself as a man. So your uncle Tim is really a man posing as a woman posing as a man. Understand?"

Huh? The expression on my face matched my confusion. I left the studio.

The next day I watched as the rubber chicken was transformed into the grotesque flying beast called the Nazgûl. I admired the drawing my father and uncle had created from the photos. The figure of Éowyn had been drawn into the sketch to confront the flying chicken.

During the last few months, I had traveled to distant lands, met wizards who had the power to destroy or create anything they desired, and learned not to fear that which I did not understand.

My dad and uncle only had a few weeks left to finish the last two paintings. My mom thought it would be a good idea if I stayed out of their way, so I didn't go near the studio for a week.

But soon, curiosity got the better of me and I entered the studio once more. I froze. A lone painting propped against the far wall glowed from the rays of the setting sun shining through the window, illuminating a spectacle of good versus evil.

Éowyn against the Nazgûl.

The bodies of dead soldiers littered the ground. The battle had not proceeded well. The evil, winged beast stretched its claws open, ready to rend its prey.

Éowyn's purity radiated. Her white tunic and gloves, long blonde hair, and unscathed white shield glimmered brightly against the approaching evil.

One thing was very clear to me. Uncle Tim never looked so good.

*"We originally painted the Nazgûl red. Lester del Rey said that it was too bright for a minion of Sauron."-Tim*

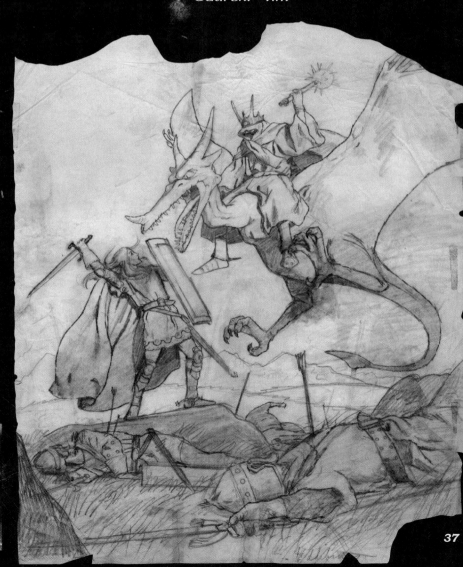

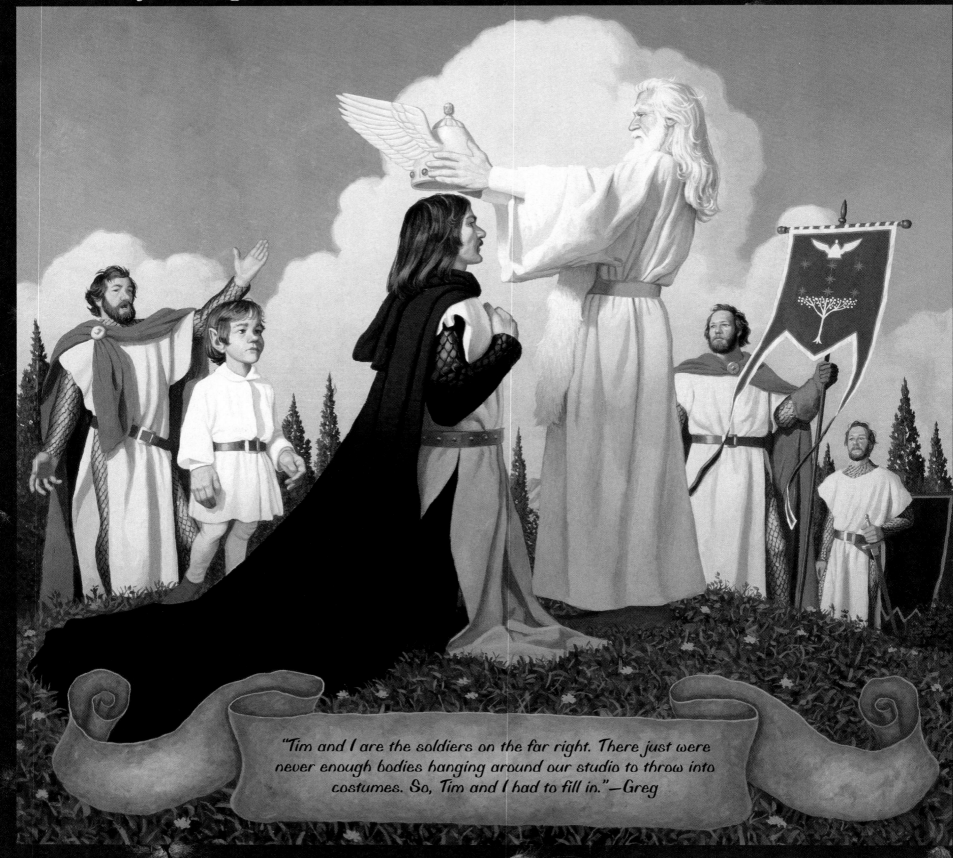

"Tim and I are the soldiers on the far right. There just were never enough bodies hanging around our studio to throw into costumes. So, Tim and I had to fill in."—Greg

The king. A man who rules a nation and fights battles to protect a multitude of people whom he will never know. The crown he wears represents authority, power, and justice.

My dad fitted the crown on the king's head. It looked like a cooking pot to me, but as I had learned, nothing is as it seems in the Halls of Hildebrandt.

The photo sessions for this painting turned out to be more of a family portrait than a coronation ceremony. My uncle posed as a soldier. Then my dad posed with a banner. I posed as the hobbit. Gandalf was positioned in the center, placing a crown on the king's head.

As usual, they immediately went to work with the photos to create individual sketches of the characters, then combining them into one large finished drawing.

The skies were gray the day the painting was completed. A relentless rainfall flooded my backyard. But through the doorway of imagination, a vision could be seen of blue skies, white clouds, green grass, and trees in full bloom.

It was a sign. Aragorn, the king, had returned. And with him came change.

The old studio in the house had become my sister's room. Now the once-vacant carriage house behind the house was a beehive of activity, filled with men and their weapons of choice. Hammers and saws replaced the shields and swords. Walls were torn down, windows installed, and electric cables strung.

From the small, second-story loft in the barn, my friends and I would eventually witness the creation of such monumental projects as the first Star Wars poster, *Urshurak*, a novel by my dad, uncle, and their friend, Jerry, and of course the next two Tolkien calendars.

An old sheet hung in front of the loft, cloaking my sanctuary. From there I observed the activity below. The smell of fresh cut wood filled the air. At last, a new easel—homemade and solid enough even for my dad.

Storage crates, books, spotlights, and dozens of toys were brought up the two flights of stairs. Even an old record player with an eight-track deck found its way into the new studio.

The 1976 calendar was complete. The deadline pressure was over. The publisher was overjoyed. The public had gone wild for their art. My dad and uncle were exhausted. But they were ready. Ready to start their next journey into Middle-earth.

As for me, how many kids can say that their clubhouse shared a space with the fabled walls of Minas Tirith?

*"I posed for all of these figures. It's clear from these that we don't follow the photos slavishly. They are a point of departure. As an artist, when posing, I am totally aware of where the light hits. I know I am going to be painting this later so I want to get the most dramatic lighting and pose I can." —Tim*

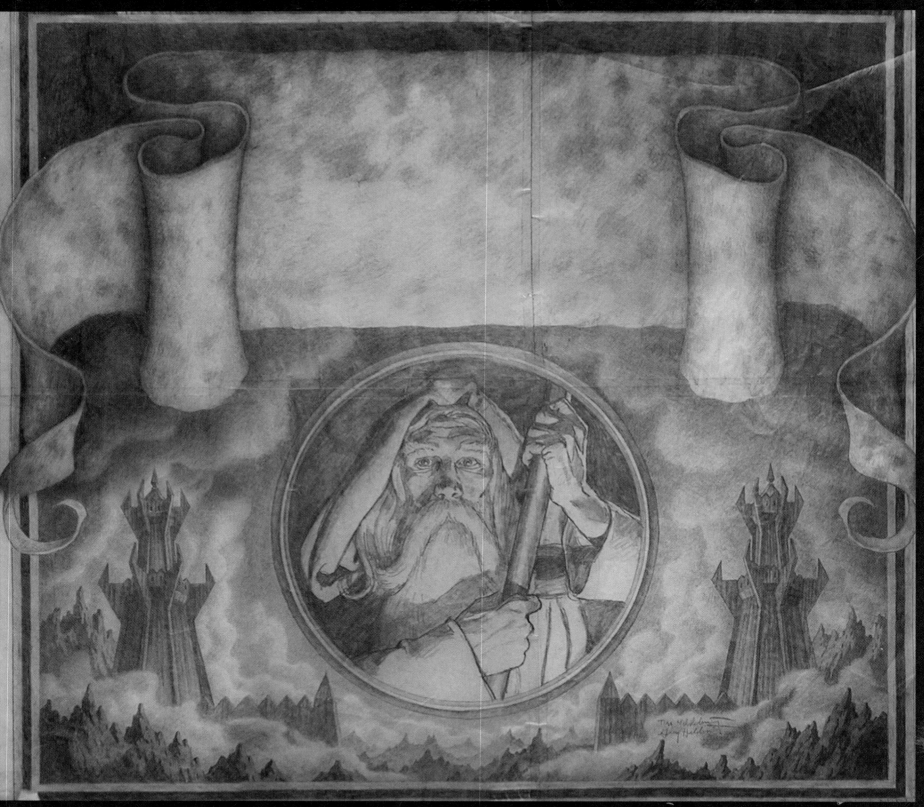

*This sketch for the cover of the 1977 Calendar is one of the most detailed of all the Tolkien sketches.*

*"One of the greatest American illustrators was Maxfield Parrish.
He did many paintings with magnificent scrolls. Parrish was the main source
of inspiration for all of the scrolls in the calendars."—Tim*

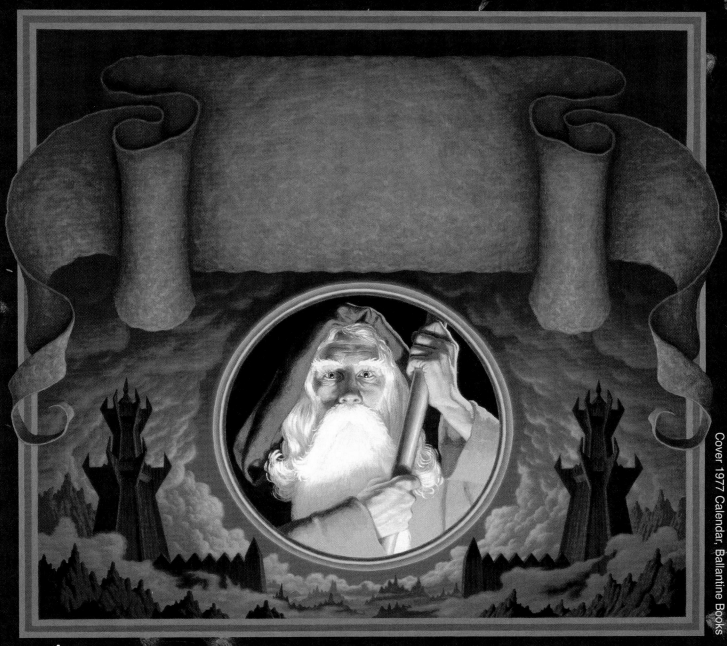

"Tim and I wanted to use the ring to achieve a more designed look for this cover. We took off Gandalf's pointed hat and gave him a hood so he would fit in the circle."—Greg

Cover 1977 Calendar, Ballantine Books

A comfortable silence settled within the barn. My dad and uncle were ready to begin their second Tolkien calendar.

Sitting on the ladder to my loft, the only way up or down, I watched Gandalf stand motionless, his knuckles whitening as he clutched a staff. His hood hung loosely on his head.

To my young eyes, he was an image of pure power. To my father's eyes, his hood needed adjusting. My dad leaped from his crouched position to fix it.

"It's covering his face," my uncle said.

Gandalf remained as still as a statue while my dad pushed one wrinkle in and pulled another one out. They moved their flood lights back and forth, trying to capture just the right shadows.

Even for what may appear to be the simplest of illustrations, my father and uncle may take up to twenty photos of a single element to get the right lighting.

Even so, the photo sessions were usually very relaxed. The models typically laughed and joked. Often a few gag photographs of the costumed subjects would appear on the roll of film. But no matter how outwardly crazy it got, my dad and uncle always kept an inner eye on their ultimate vision.

In this particular instance, that inner eye was reflected in Gandalf's stalwart gaze.

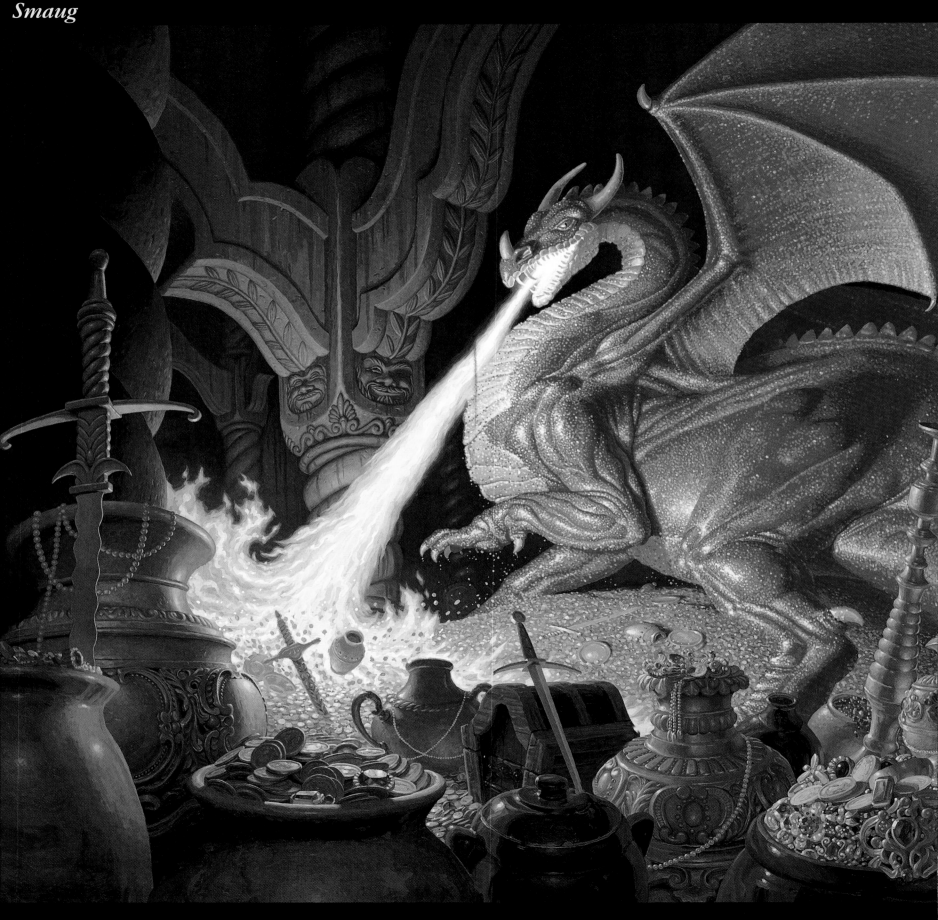

Smaug

"Most of the jewels in Smaug's hoard were from my wife's costume jewelry collection. I remember spending nearly a month painting all of the coins and jewels. The candelabra in the foreground was purchased in Ghana, West Africa, when Greg and I were there making documentary films in 1967."—Tim

"It's interesting that we became so well known as fantasy artists during the Tolkien years. Our fans acted like we had been painting dragons forever. But the truth is Smaug was only the second dragon Tim and I had ever painted. The first was for Judy-Lynn del Rey's cover for Tolkien's Smith of Wootton Major and Farmer Giles of Ham."—Greg

# S

maug, the greatest of all dragons!

I had heard the name time and time again. His scaly hide glistened, encrusted with the gold and jewels of the treasure upon which he had slept for two centuries. His fiery breath could melt the hardest metal in the blink of an eye.

In contrast, the clay model of Smaug, only eighteen inches long, sculpted by my dad and uncle, looked pretty cool, but it didn't appear all that threatening.

I watched as they painted carved pillars into the background. They squeezed yellow, orange, and red acrylic paints onto their homemade aluminum foil palettes.

Over the next few days, the image began to take form. The powerful figure of Smaug came into view: a dragon like no other, rearing back in his cavernous lair over a bed of gold coins, swords, gems, and diamonds.

Smaug was an image that took extremely long to paint. My father and uncle rendered each individual coin and jewel in the dragon's hoard.

They worked tirelessly and seamlessly over a period of four weeks to complete this piece. Rarely talking about the job at hand, they shared a communication deeper than the spoken word.

Somehow they always knew what the other was thinking with regard to their art. The two brothers shared a more intimate bond than most twins do—the bond of creation. While each one had his individual style and technique, these merged when they painted together.

Having the luxury of almost ten months to complete this second calendar, they chose to paint Smaug on a large scale. I remember overhearing them say that though the larger size board made it easier to paint detail, it would take twice as long to complete.

Evil had come to the Hildebrandt Hall, in all its striking beauty...

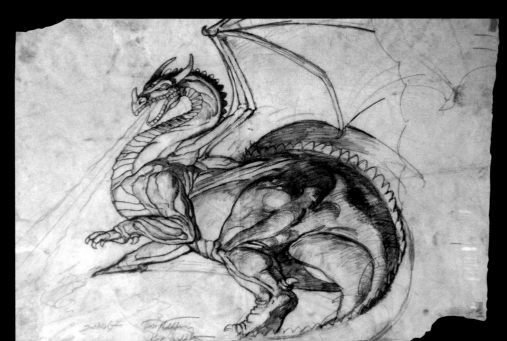

# "Goldberry" Begins...

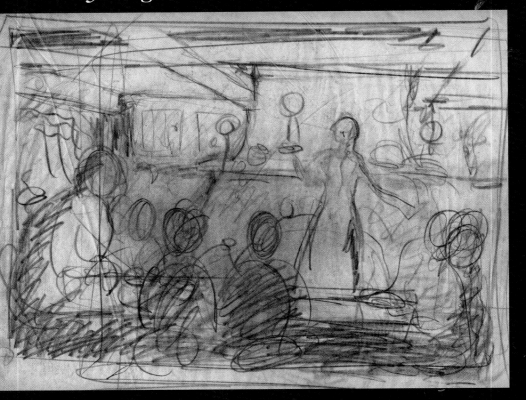

*"My wife Rita posed for Goldberry. Rita is a graduate of the Fashion Institute of Technology. She designed and made this costume for Goldberry and many others for the second and third calendars." — Tim*

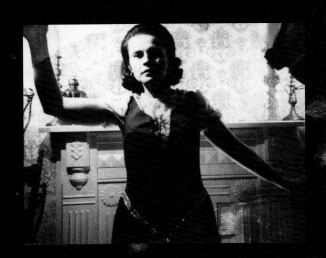

*"According to Howard Pyle, the grandfather of American illustration, you should sketch a scene fifty different ways and imagine yourself as a part of it, not just as an observer. We have been doing this since childhood." — Tim*

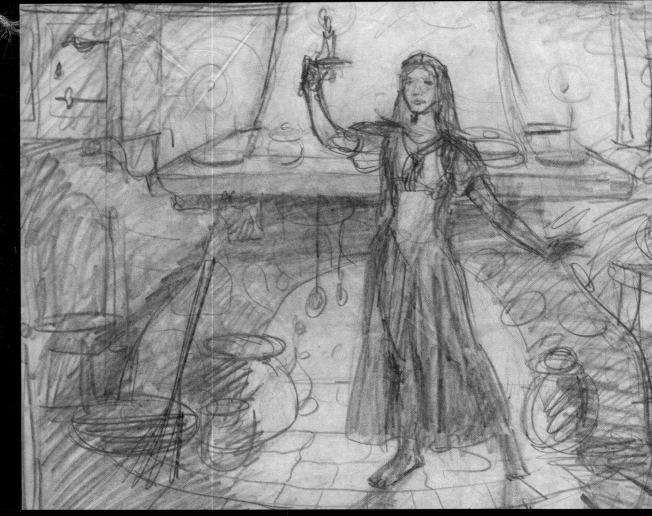

44

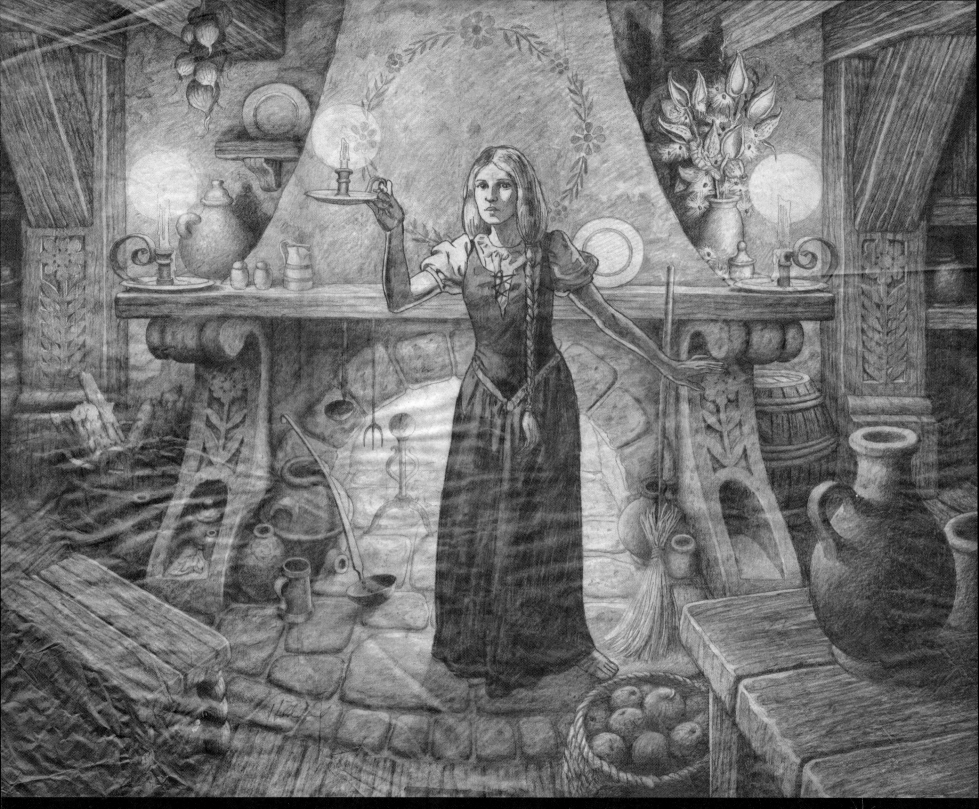

"In the seventies, Tim and I sketched primarily on tracing paper, which we bought in large rolls. All of the original sketches were done to the finished size of the paintings. We were crazy in those days and rendered each final sketch as if it were a completely finished piece of art. Even though for us they were just a means to an end—the final painting." —Greg

## *Goldberry*

During the quiet times, I took the liberty of outfitting my sanctuary with the coolest stuff. I divided it into two sections. Two lamps lit each side, and blankets and pillows cushioned the floor.

I thumbtacked my own drawings to the back wall. It was my home away from home. The loft served as a haven from the pressures that hound the typical five-year-old. (There was no way my mom could find me here to make me clean up my room.)

I continued to watch my dad and uncle paint. This particular image was nothing like the last one. It was peaceful and comforting. The soft glow of candlelight and the warmth of a fireplace lit a quaint little room. A white space occupied its center. Taped to the easel were photographs of my aunt Rita. She was a friend of the Fellowship and had posed as Goldberry.

"What is this?" I asked.

"It's Goldberry's house," my uncle answered as he continued to paint. "Do you remember Tom Bombadil?"

I thought for a moment, then replied, "The Dancing Man?"

"Yeah," my uncle said. "She's his wife, and this is their house."

A few days later, while lost in thought up in my loft, I heard the Fellowship enter the studio. Scrambling to my door, which was simply a torn bedsheet, I cautiously peered down.

The men of the Fellowship were huddled together, their bodies obscuring something from my view. Curiosity urged me to abandon my post and descend into Minas Tirith. As I was about to make my move, the Fellowship parted.

Through the parting figures, I caught sight of the finished painting. There she was. My dad and uncle had transformed my aunt Rita into Goldberry. A lock of her long, blonde hair was neatly braided and hung loosely from her fair head. With a candle held high in one hand, she gazed up at me.

It was indeed the beautiful Goldberry, standing where empty space had stood before.

*"Notice the difference in the color of light from the candles and that of the fireplace. The candlelight is white and the fire is orange. We used the white light to contrast and enhance the colors of the fireplace."—Tim*

*"Since there are so few women in the story, Tim and I wanted to make sure we did a major illustration of each one. When it came to Goldberry, we had very few scenes to choose from. We chose the interior shot because Tim wanted to design a fireplace."—Greg*

February 1977 Calendar, Ballantine Books

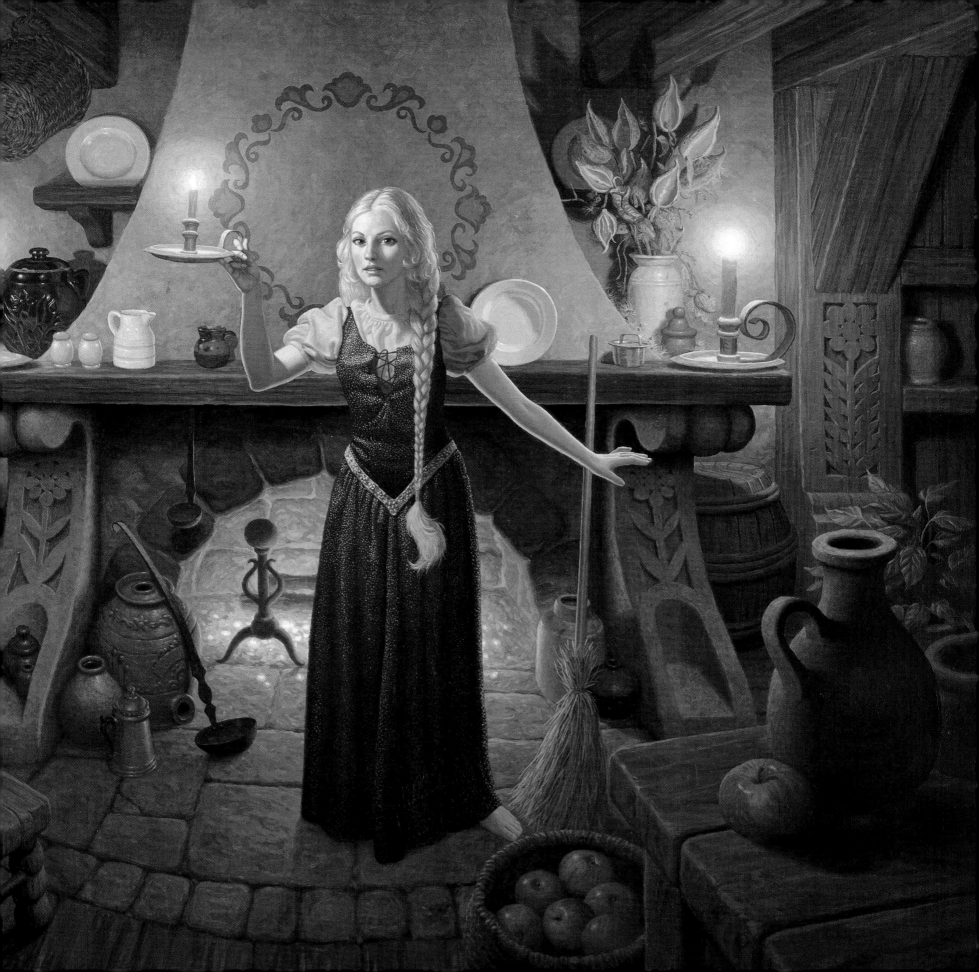

## Rivendell

As the weeks went by, I noticed that the Fellowship visited less frequently. Perhaps the cold November weather kept them away.

Meanwhile, another quiet image began to emerge on my dad and uncle's drawing board. This one was neither menacing nor action-packed. It was simply an Elven house hidden in the forest. A neat path led from a stone bridge up to the strong wood door.

There were no photos taped to the easel. Spurred only by a vision that had settled in their minds, my dad and uncle filled the board with the image of an ancient refuge they had never visited. (Or had they?)

My only knowledge of its creation was what I picked up through their conversation. I listened, trying to soak up as much information as I could.

They called it Rivendell, a haven for the good and kindhearted people of Middle-earth. And then I remembered: It was where Bilbo Baggins had retired to to write his memoirs. Two weeks later the painting was complete. Elegant in its simplicity,

Rivendell's walls housed secrets only known to very few—among them, my dad and uncle.

It was about this time that I first noticed my dad and uncle's concerns over their individuality as artists. In the next couple of years, their artistic struggles would become more difficult, as the world began to associate the two as one, the Brothers Hildebrandt, instead of Greg and Tim.

The title "The Brothers Hildebrandt" was actually conceived by Judy-Lynn del Rey, as a catchy marketing tool used for the 1976 calendar. She was trying to connect the Hildebrandt Brothers to the Brothers Grimm in the minds of the public. She went so far, while publicizing the calendar, as to create the legend that Greg and Tim were so identical that you could not tell in the brush strokes of a painting where one brother stopped and the other one started.

It was this hype around the first calendar that began to cause personal problems between my dad and uncle.

*"I designed Rivendell to be the most ideal place for me to live. A house like this in the middle of nature is my dream. Sort of a Walt Disney take on Frank Lloyd Wright."—Tim*

March 1977 Calendar, Ballantine Books

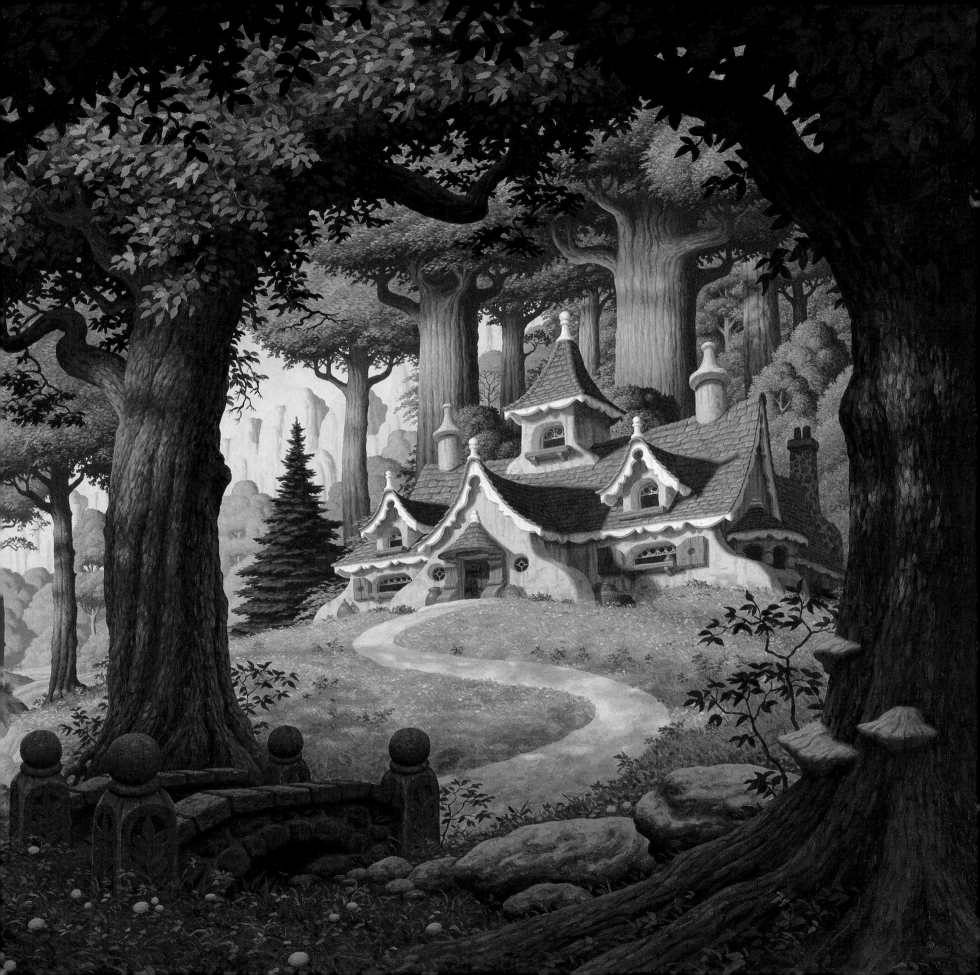

## Balrog

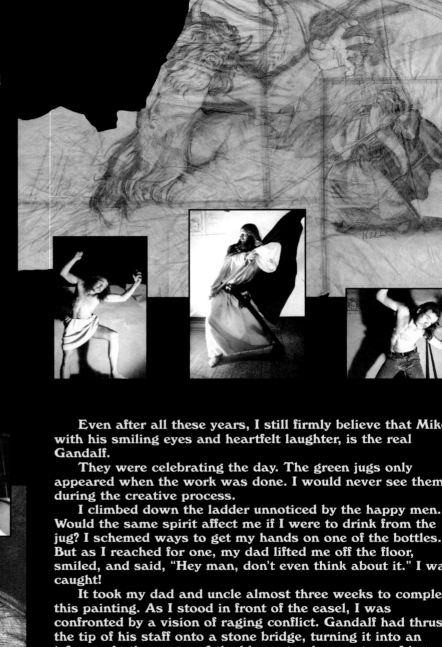

Christmas was approaching fast. I had written Santa and asked for a real bike, like the ones my sisters had. Impatience was getting the better of me when suddenly, music filled the carriage house with gaiety. I crawled over to the makeshift door of my sanctuary and peered down.

My father, uncle, Gandalf, and the men of the Fellowship were gathered around, laughing and talking. Everyone smiled while passing around a green jug. The cork had been pulled from the stem, and the Fellowship hastily poured the contents into their cups. They appeared to be under a spell, but I was unsure whether its effect was good or evil.

The more these giddy folks drank from the jug, the more they laughed. Friendship warmed the night air. So it was a potion of goodness that had overtaken them, after all! Since Smaug's evil presence had departed this place, darkness had been banished from the hall.

My dad and uncle had spent the day photographing the models for the scene with the Balrog. A member of the Fellowship, a man known only to me as Rags, had posed for this diabolical creature. He snarled as he lifted the handle of an axe high above his head, while my dad and uncle positioned lights and took photos.

Gandalf posed shortly afterward, his staff illuminated by a spotlight. I looked on the wizard now in our company and, to my surprise, found his eyes meeting mine. He sat with his legs crossed and an elbow on his knee, gently stroking his beard.

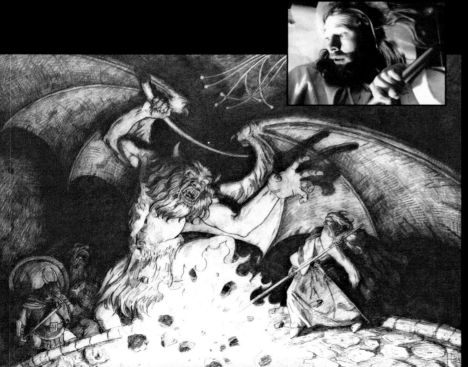

Even after all these years, I still firmly believe that Mike, with his smiling eyes and heartfelt laughter, is the real Gandalf.

They were celebrating the day. The green jugs only appeared when the work was done. I would never see them during the creative process.

I climbed down the ladder unnoticed by the happy men. Would the same spirit affect me if I were to drink from the jug? I schemed ways to get my hands on one of the bottles. But as I reached for one, my dad lifted me off the floor, smiled, and said, "Hey man, don't even think about it." I was caught!

It took my dad and uncle almost three weeks to complete this painting. As I stood in front of the easel, I was confronted by a vision of raging conflict. Gandalf had thrust the tip of his staff onto a stone bridge, turning it into an inferno. At the center of the blaze stood a creature of hatred. Massive wings stretched from its back and horns protruded from its head. It was the Balrog, a creature who dwelled underground in Moria in the misty mountains. The Balrog, whose sole purpose for existing was to destroy the Fellowship.

It was the Balrog, a living weapon of evil and a messenger of death.

Christmas came and went. And I did not get my bike. I was certain that mom had forgotten to mail my letter to Santa.

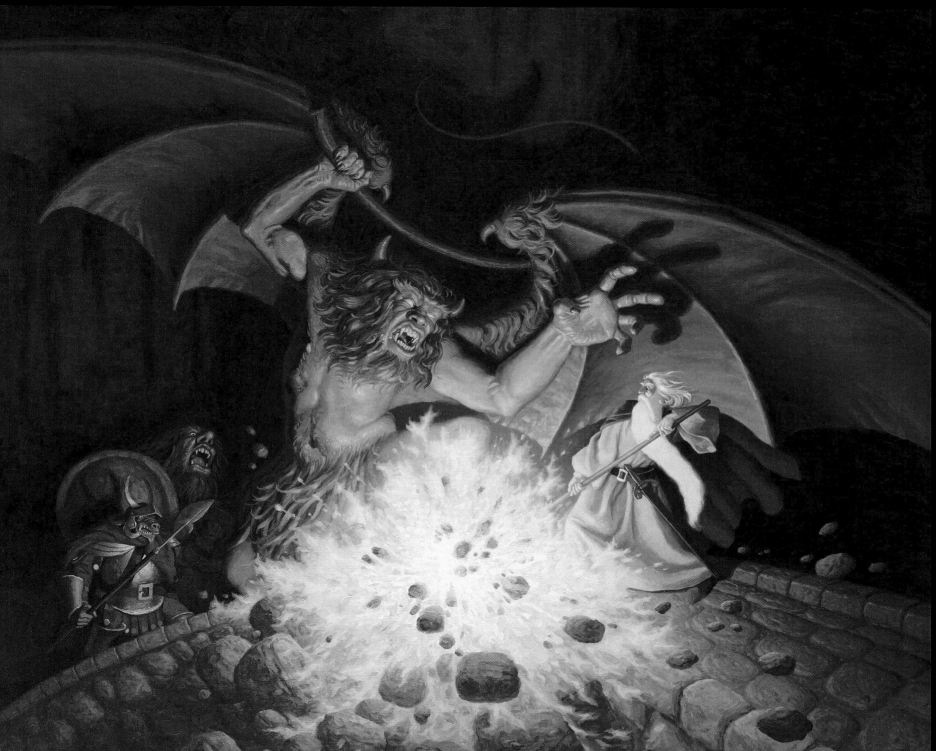

"For good or for bad, we decided to take the Balrog out of Tolkien's shadow form. We made it a solid figure. It was a creative decision, it was what we saw. We were interpreting the text into a visual image. As an illustrator, you really do agonize over this stuff: What to put in, what to leave out. It's only a matter of the choices you make at any given moment. Today you like vanilla, tomorrow you like chocolate." —Greg

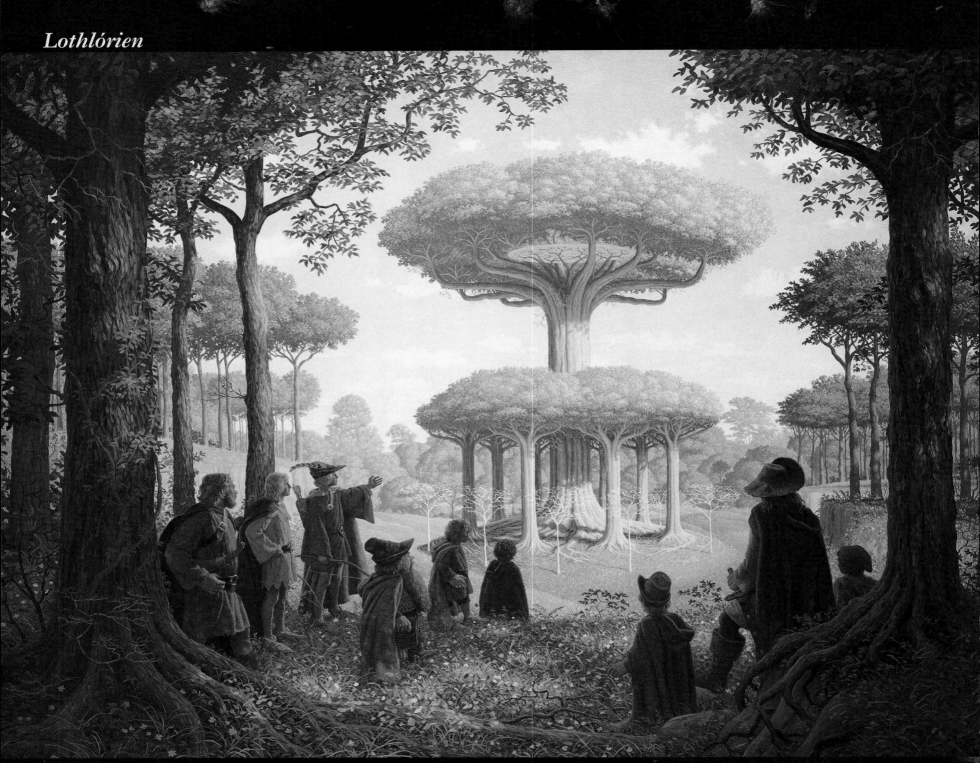

May 1977 Calendar, Ballantine Books

*"Even though Lothlórien is the highest manifestation of peace and beauty,*
*I always thought the finished shape of the trees looked like an atomic explosion."—Tim*

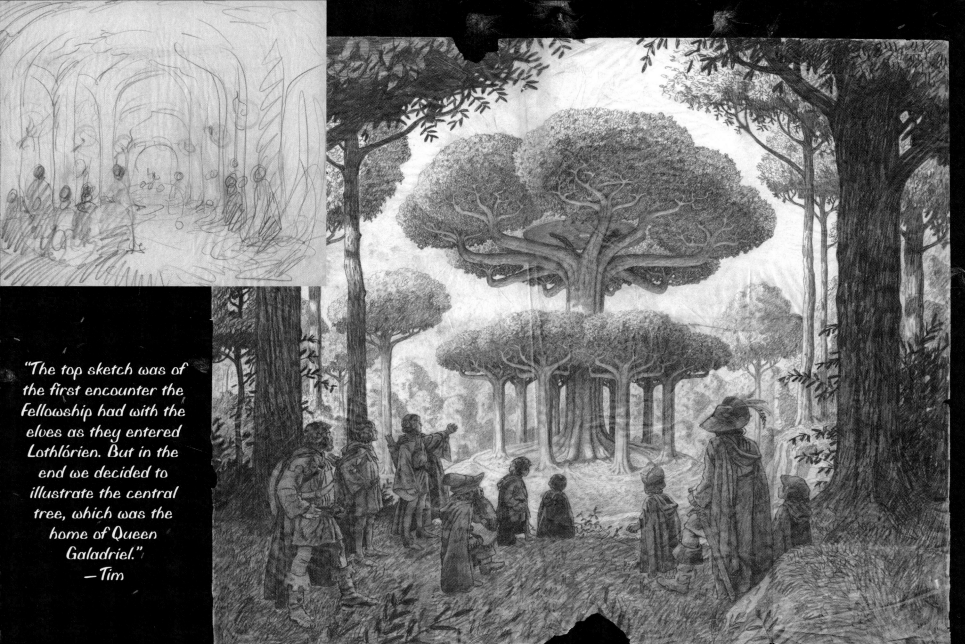

"The top sketch was of the first encounter the Fellowship had with the elves as they entered Lothlórien. But in the end we decided to illustrate the central tree, which was the home of Queen Galadriel."
—Tim

I t was 1976 and the beginning of a new painting. The old cloaks and ragged clothes belonging to the Fellowship were pulled from boxes. Again, I would be posing for the hobbits.

Photos of trees lined the easel, several were taped directly to the masonite. The drawing of the center tree was gigantic. High among the topmost branches, a platform held the dwelling for the elves and their visitors. I couldn't see the tree people in the drawing, but my dad and uncle assured me they were there.

They had laid out a variety of magazines for reference. Piles of *Arizona Highways* and *National Geographics* were found on the studio floor. Although my father and uncle used the photos in these magazines as reference, the finished painting was purely a product of their imagination.

Dad had told me that Lothlórien was protected from evil

by Queen Galadriel, who had cast a powerful spell over the land. Weary travelers would journey there to rest. Tonight, the Fellowship would gather in mourning, fearing that Gandalf had been lost to the Balrog.

It had been another long day of posing. My dad and uncle would have to wait until the next week for their 35mm black-and-white film to be processed. The days of the Polaroid camera were gone.

As they began the background of Lothlórien, I climbed the ladder to my loft and retreated to where only I could enter my imaginary worlds. On the blanket-lined floor, I closed my eyes and took comfort in the knowledge that I was in the dreamland of Lothlórien.

The end of January was finally here. And with it came the completion of the painting. But more importantly, it was my sixth birthday.

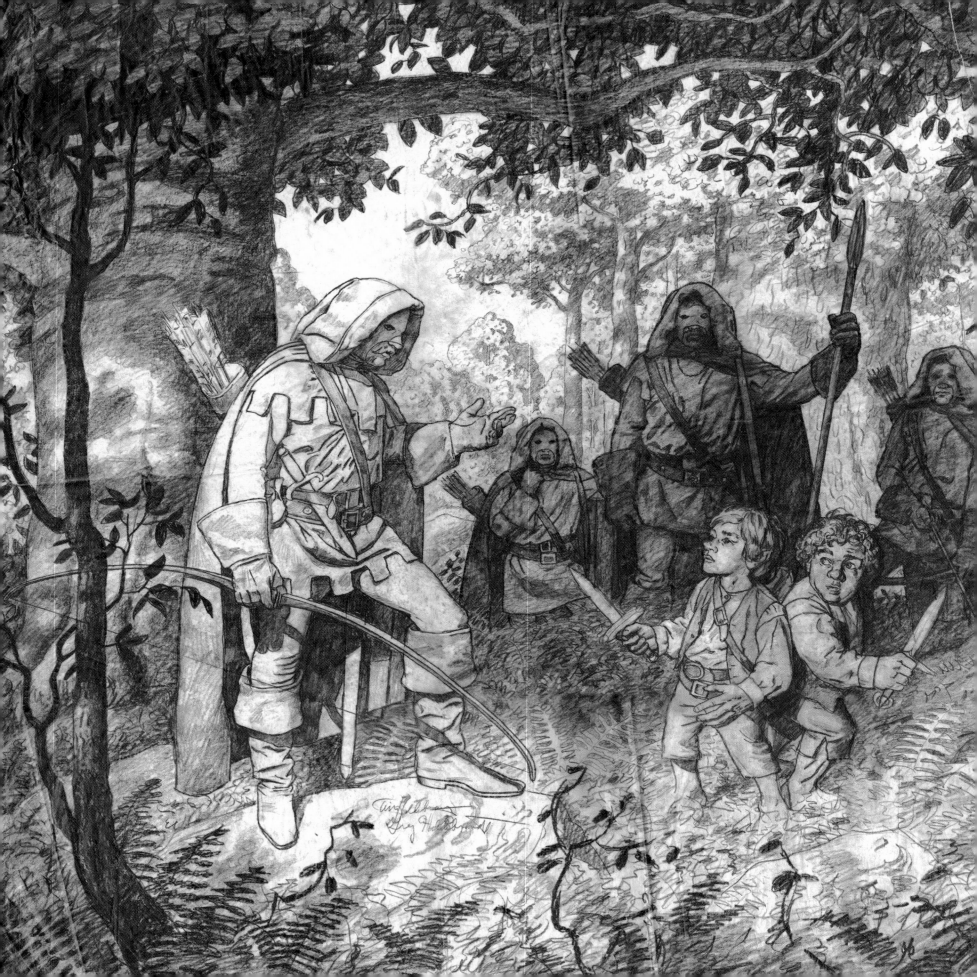

## "Faramir" Begins...

The first of February was a date that meant nothing to anyone except to my dad and uncle. They were once more confronted with an unbending deadline. They had spent too much time on the first six paintings of the calendar. Now they had five months left to complete another six paintings, all of which were the most complex art they had ever designed. Once more, the pressure was visible on their faces.

The spotlights felt hotter than ever. The white heat seared my face as I posed as Frodo. I felt as though I would go blind. There were spots before my eyes, then suddenly—total darkness!

When my sight slowly returned, a member of the Fellowship stood before me. It was the man called Rags. He wore a hooded cloak loosely over his shoulders, a brown tunic and white long johns.

I stumbled out of his way and the spotlights flashed back on. It was Rags' turn to pose. My father and uncle shot him first as Faramir.

# Faramir

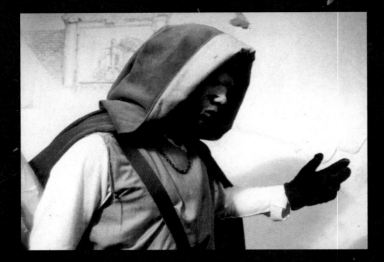

Dad tried to position Rags to conform with his sketch. This was not a smooth process. It was late in the day, and my dad and uncle were tired. I could see that my dad was getting ready to blow.

He directed Rags to put his left foot on the pile of books that served as a stone. Rags refused, preferring to elevate his right foot on the pile of books.

My dad repeated, "Put your left foot on the damn books! I don't care what the Hell you think would look better."

Rags refused. My dad began to scream. Rags continued to insist that his right foot would look better.

My father tried over and over in vain to get him to use his left foot. All of a sudden, as if possessed by an evil demon, my father jumped up and hurled one of the spotlights at Rags, almost hitting my uncle. Then dad stormed out of the barn and into the night yelling, "God damn it, shoot it yourselves!"

I sat in my loft, confused, wondering why the men of the Fellowship were turning against my dad.

An hour later, he re-entered the studio. He had calmed down and quietly requested that Rags put his left foot on the pile of books. Rags smiled and complied.

It had been a tiring day. Costumes were crafted and sketches reworked up until the last minute.

I had heard the name Faramir spoken often throughout the day, but the name had little meaning to me. I assumed he must be significant, so I asked my uncle, "Who is Faramir?"

My uncle replied, "He is a captain of the land of Gondor."

After all the trouble he caused, the one thing I was sure of was that my dad and uncle would never invite Faramir back.

*"When we brought this painting into Ballantine Books, the feathers on Faramir's arrows were red. Lester del Rey instantly said, 'That's wrong. The feathers are green.' He quoted the exact page where we could find that information. I always looked at Lester as though he were a wizard."—Greg*

June 1977 Calendar, Ballantine Books

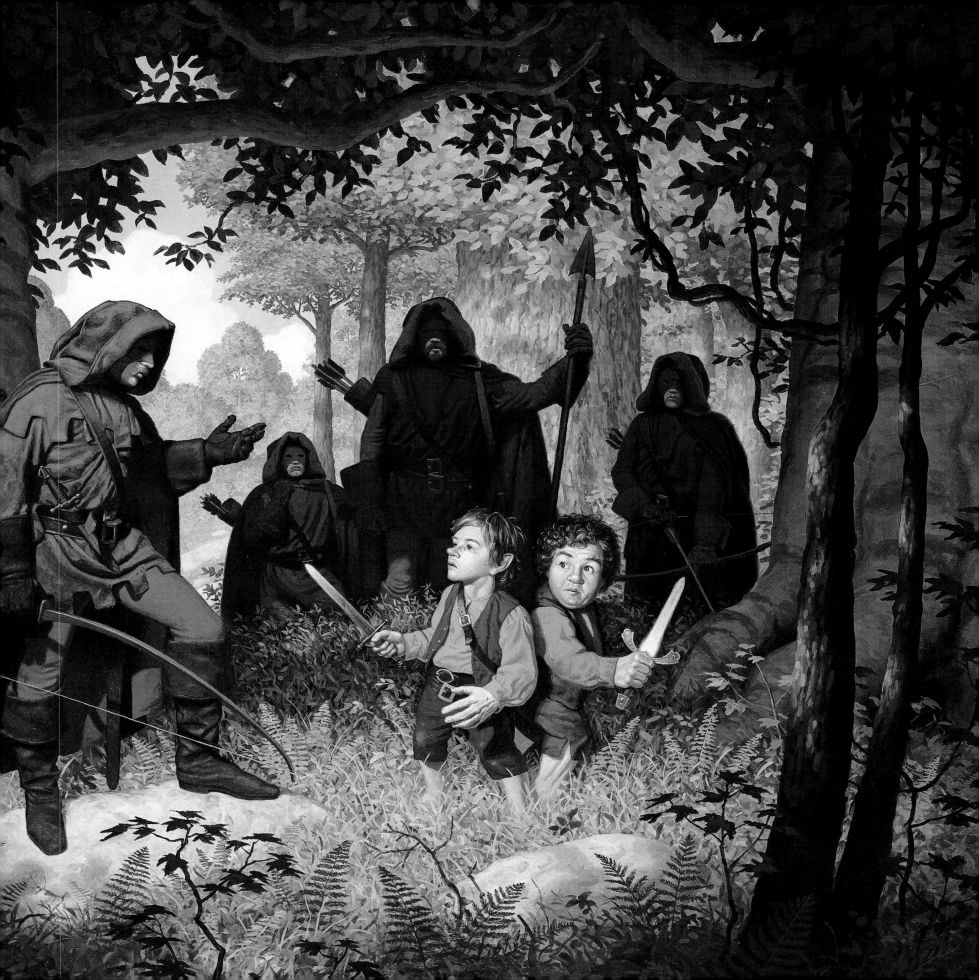

## "The Unexpected Party" Begins...

After the usual photos and sketches were completed, my dad and uncle began painting the Unexpected Party.

For three straight weeks, eighteen hours a day, they labored over this painting. The pressure of the deadline, now ever present, was actually causing them some anxiety. Had they bitten off more than they could chew? I stayed out of their way.

When the painting was nearly complete they realized that they had forgotten to add the smoke from the pipes. The fact that the scene had no smoke in it at all totally freaked them out. They began to yell, and to blame each other for forgetting the smoke. This went on for only about fifteen minutes before they calmed down and returned to painting.

For the next two days they focused all their energy on completing the painting until the final version was done, which you see here.

I recently asked my dad about the numbers on the clock over the mantel in the final painting. Because there exists no visual reference for numbers in the land of the hobbits, and my father and uncle couldn't very well use Roman or Arabic numerals, they turned to the one man who would have the

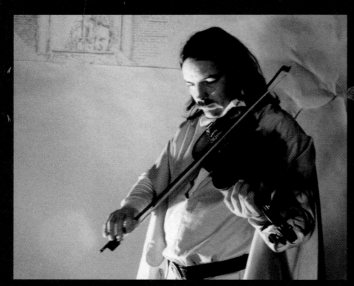

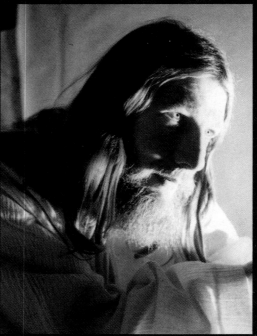

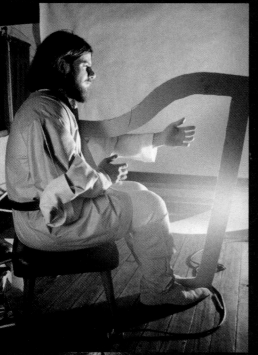

*"This photo shoot went on for the whole day. A lot of the guys were drinking and partying. I became a dictator while trying to dominate and control the session. These were all my friends, and they were doing us a favor. So it was a dilemma for me to yell and swear at them to get them to do what I wanted."—Greg*

answer, Lester del Rey at Ballantine, "the Tolkien expert," as his business card stated.

Lester told them to use the first twelve runes from the Angerthas, one of the many alphabets that J.R.R. Tolkien devised for the people of his Middle-earth.

In the end, together with my uncle, I became the centerpiece of this painting. Unbeknownst to me, I had become an integral part in one of the greatest centerfolds in the history of illustration.

*"Here is an example of combining two photos, one of Gregory and one of Tim, to create Bilbo. We merged the adult and the child to create the proportions of a hobbit."—Greg*

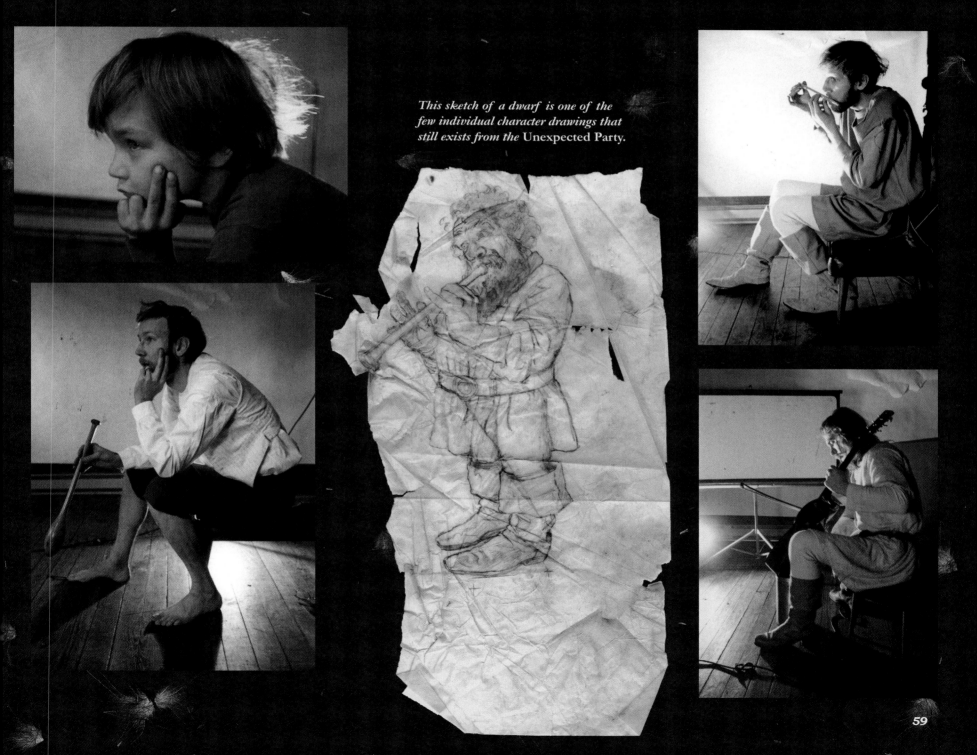

*This sketch of a dwarf is one of the few individual character drawings that still exists from the* Unexpected Party.

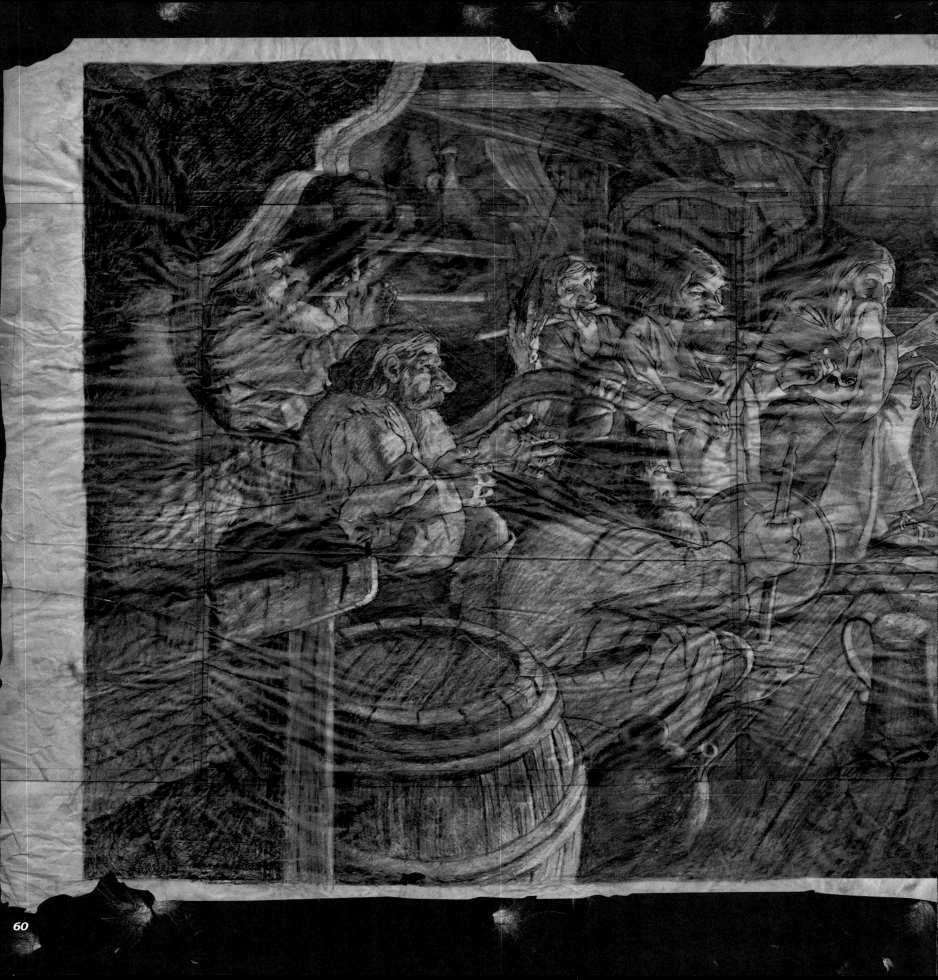

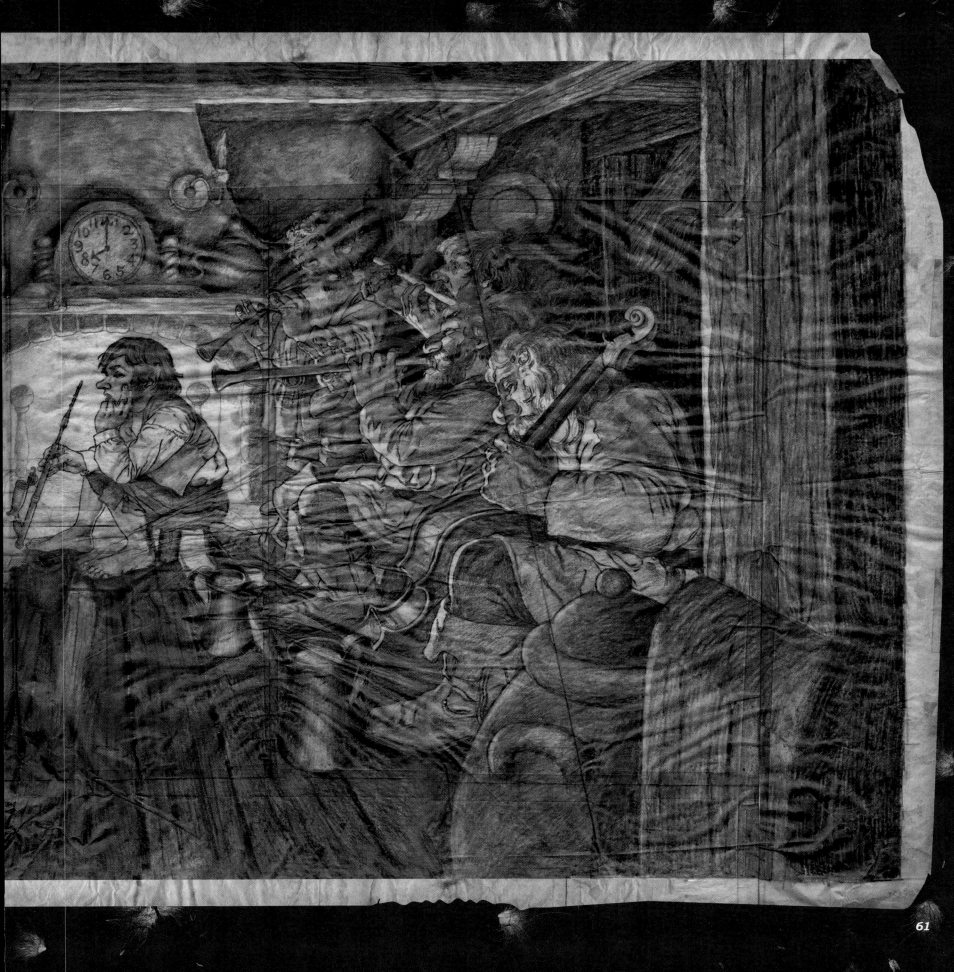

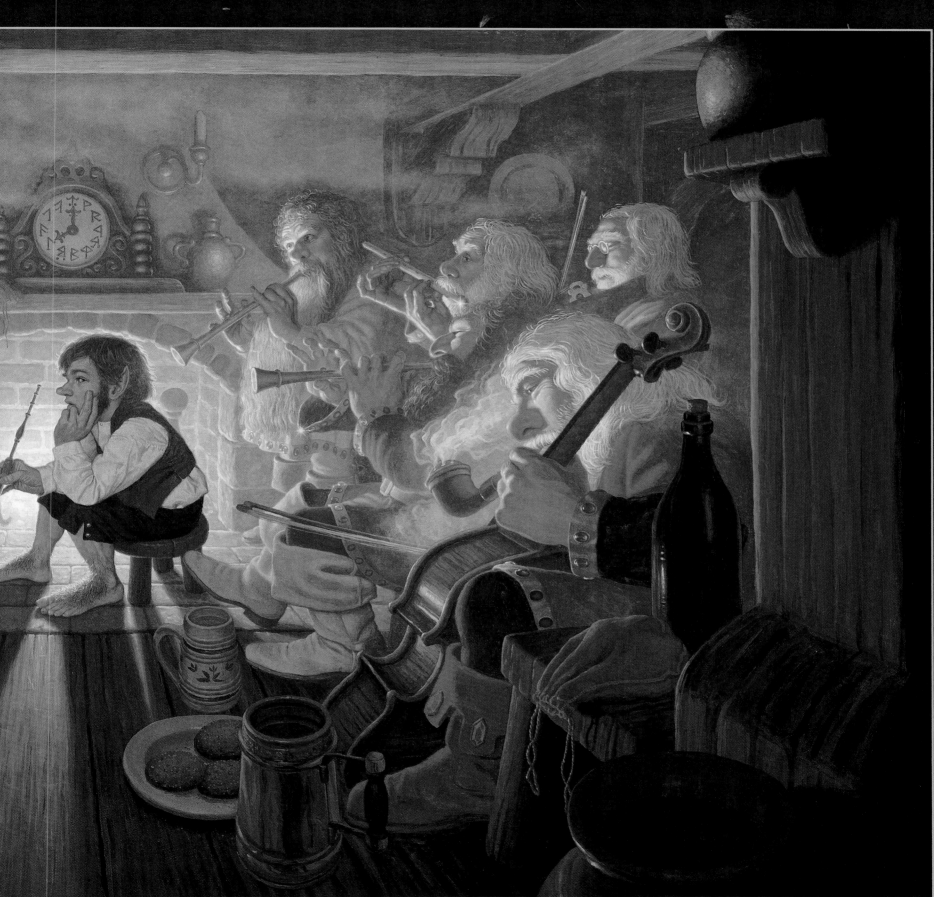

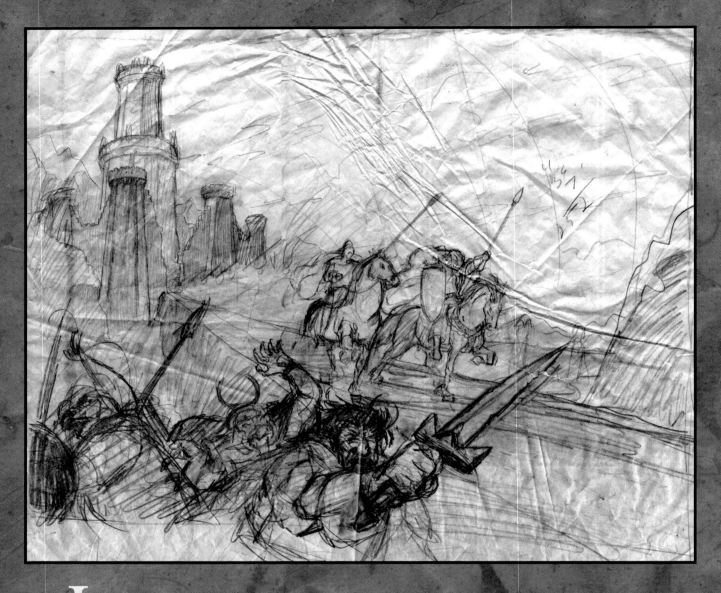

"One of my favorite artists of all time is Eyvind Earle. He did the production designs for Disney's Sleeping Beauty. The film was designed based on the style of medieval art. I tried to get that look and feel into this painting." —Tim

"Originally this scene was going to be closer up and filled with figures. We changed the angle to a higher, longer shot, which meant the figures would have all looked like ants. It wasn't dramatic. It was better not to have them there at all. So we eliminated them." —Greg

I t was time to share my sanctuary with my friends Andy, Joe, and Tommy.

My father and uncle weren't working in their studio the day I brought them in. It was just as well, because my friends would have probably ended up as hobbits. (After all, hobbits were hard to come by.)

There was no music as we entered. No crushing of paper. No laughter. The studio was empty. But as my friends and I cleared the top step of the staircase, a feeling of warmth consumed us.

My friends regarded the studio as a museum. They gaped in wonder at the drawings that were strewn about. They didn't allow themselves to touch anything. I would pick up a sketch, look at it, and toss it aside, explaining why one picture worked while another one didn't.

Suddenly, Joe observed, "Hey, they left their skin here."

We quickly moved beside him as if someone had said, "Free fireworks!" His slender finger pointed at two pairs of blue jeans slung over a chair. They were spackled in a rainbow of acrylic paint. Reds, greens, and everything in between had formed a second skin over the fabric. Two shirts that hung over another chair were covered with the same stains.

Tom broke the silence. "Look!" He pointed to a painting that was sitting on the wooden easel. A tall tower rose on the painting's left side. In the distance stood a stone wall with smaller towers. Beyond that, the sun hung low in the sky. We agreed that it must have been a sunset and not a sunrise.

A piece of drawing paper was taped to the painting. King Théoden was marching from the castle on the dirt road. Dressed in armor and bearing weapons, his intentions were clear.

The dreamlike quality of the tower against a sunset had quickly turned to one of impending battle. Andy was always the most observant of us. "The colors on their clothes are the same as the colors in the painting," he said.

We looked back and forth from the painting to the clothes. He was right. Paint-splattered clothes were something that I had seen many times before, but I had never made the connection until now: My dad and uncle left a part of themselves in every painting they did, but each painting also left a part of itself on them.

# Helm's Deep

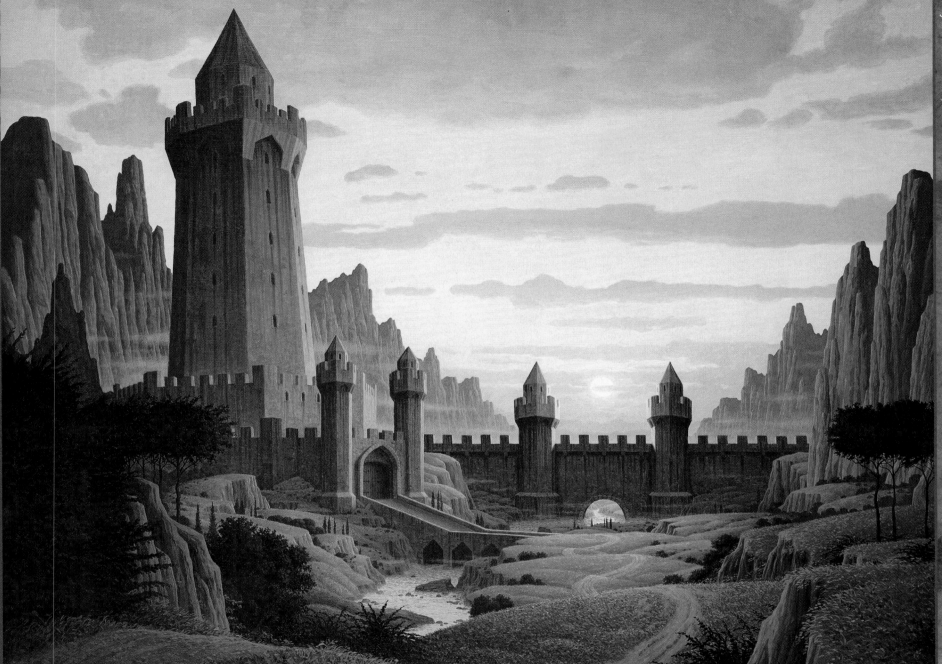

Outside, a horn beeped. It was time to go to the video arcade. We ran down the first flight of the old wooden stairs. One by one, we jumped out the small window, the same way we had come in. The big people needed keys to open the door and enter the halls of imagination. For halflings it was always open.

Due to time constraints and their constant striving for perfection, my father and uncle never finished the painting as they first envisioned it. King Théoden's army, although fully sketched, was just too time consuming to paint. So, we are left with the image you see here.

The heroic tone in this piece is conveyed through their use of light and color. You can almost sense the presence on the empty road of hundreds of brave soldiers marching into battle.

With three months left on the deadline and five paintings left to go, my uncle was forced to start on *Ghân-Buri-Ghân*, while my dad finished *Helm's Deep*. To complete this calendar on time, they had to work on two or three paintings simultaneously. It was only by working in this way that the 1977 calendar would be completed on time.

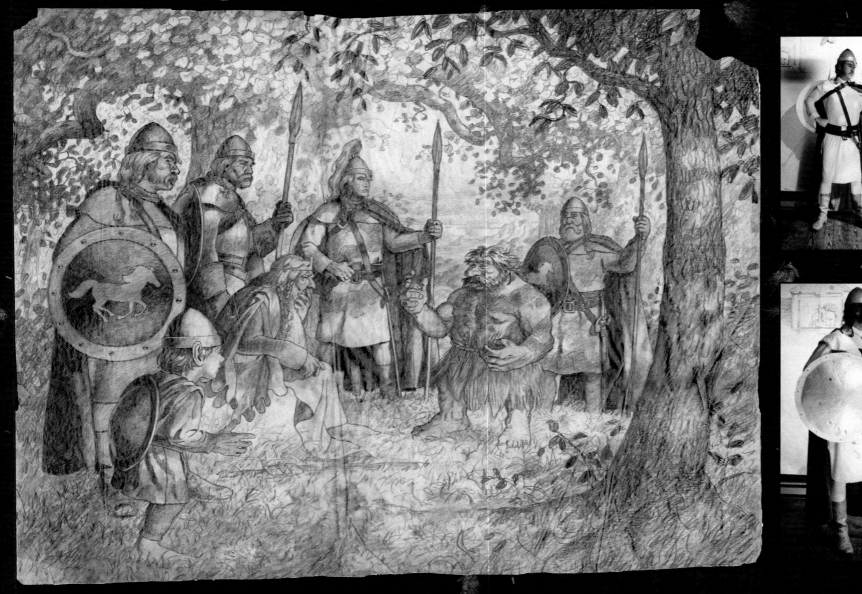

A cool breeze blew through the forest. I sat by the small waterfall listening to the soothing sound of running water flow over the rocks.

The sun had long moved beyond its highest point. I had to depart now to make it home before sunset. I made my way deep into the woods. Breaking through a row of trees, I ran across a field, down a road, through more trees, and reached my destination—the studio.

I pushed open the giant red door and climbed up the stairs. I quietly moved across the cluttered floor. An album was spinning on the old record player. The sounds of Procol Harum drifted from the two speakers. A painting of a forest rested on the long wooden easel.

Several members of the Fellowship were in the room. Against the far wall, my dad and uncle were busy helping them slip into their silver coats of chain mail, which were actually just long johns. Their armor would not have been complete without the shiny shields and helmets made of spray-painted cardboard and tape.

They worked closely together during this photo session. The deadline was loomimg and there was no time for disagreements about poses, no time for mistakes.

This was a complex painting and would take at least two more weeks to complete. Uncle Tim had started painting in the forest and now my dad was adding in the armored men. There would also be the white-haired King Théoden, and some hairy, stumpy-bodied guys, one of whom was their chieftain, Ghân-Buri-Ghân. These men dwelled in the Druadan Forest.

When I finally saw the finished painting, I couldn't help but wonder if these legendary woods and the one in which I played were one and the same.

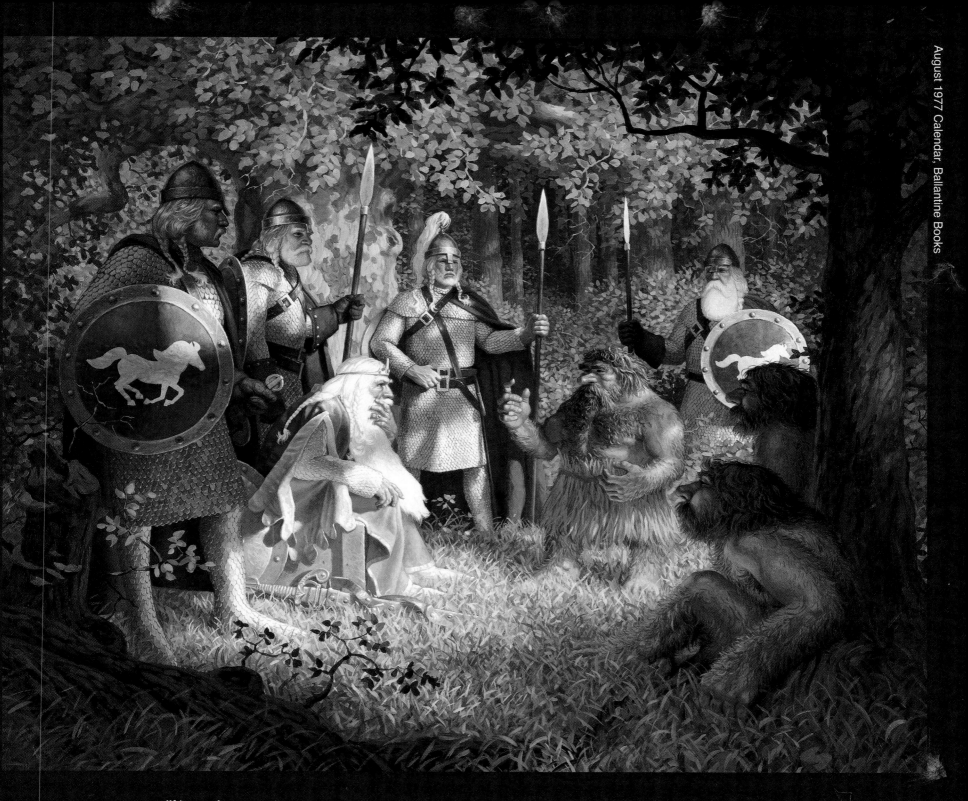

August 1977 Calendar, Ballantine Books

"What I remember most about this is how long it took to paint the leaf-mail armor.
This was part of my obsession with the look of gallery paintings—photorealistic fantasy.
Or as a friend said, Frodorealism!"—Greg

## "Siege of Minas Tirith" Begins...

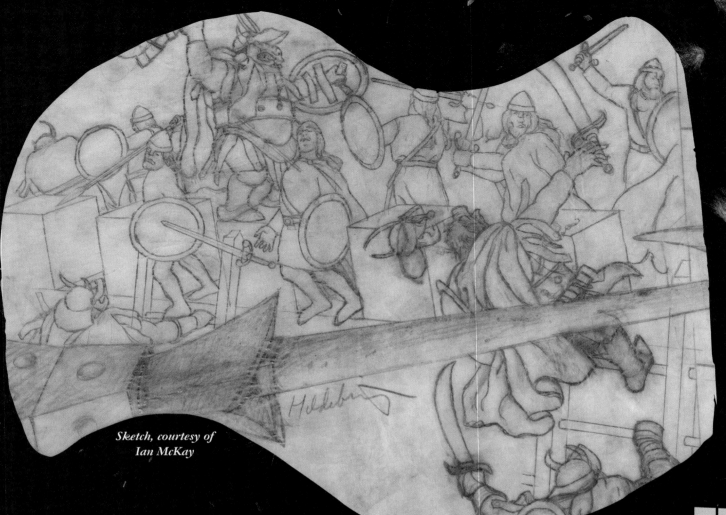

Sketch, courtesy of
Ian McKay

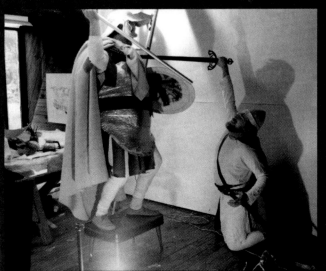

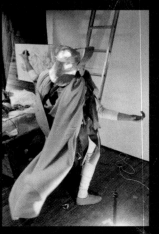

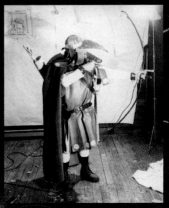

*"We designed and made all of the orcs' armor out of cardboard, masking tape and papier-mâché spray-painted with silver."* —Greg

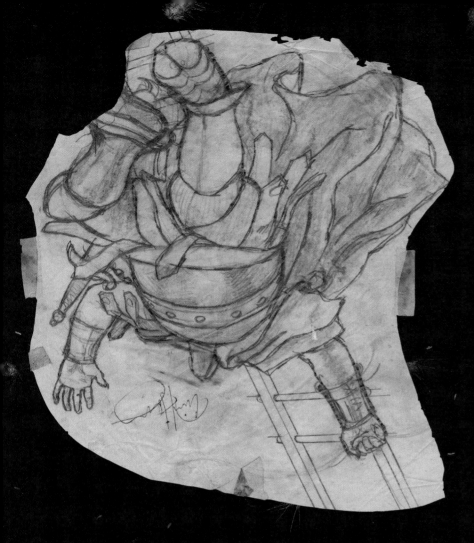

"To create the effect of the orcs falling, we laid the models down on the floor. This enabled us to position the arms, legs and cloth exactly the way we wanted them. Then we stood on a ladder to get the shot." —Tim

It was at this time that my dad and uncle decided to shoot the remaining poses for the remaining paintings all at once. It was clear to them that they would save time by setting up one massive photo shoot. This would ultimately last three straight days.

Since they shot over a weekend, I was able to watch some of the sessions from my sanctuary. During much of the time, my dad and uncle were very tense. In addition to deadline pressure, they had to worry about logistics. The photos had to be precise in order to conform to their thumbnail sketches. At the same time, they were very conscious of the fact that their friends were holding difficult poses under very hot lights and in uncomfortable costumes. When it was all over, they were tired, but content in the knowledge that they could move on to the actual sketching and painting of the final four pieces.

During this time, my friend, Joe Varanelli, became a frequent visitor to my sanctuary. Together we explored our own creative impulses. We drew old warplanes and images of battles that we had never seen except on television. Joe was now a part of the journey of imagination, which I had been on alone for the past year—a journey from reality to Middle-earth and back again.

One day, after school, we entered the studio and were knocked off our feet by a violent scene from the *Siege of Minas Tirith*.

Joe stood silent at the artistic marvel before him. His eyes locked on the army of orcs who seemed to be overpowering the soldiers who where defending the walls of the city.

When my dad and uncle originally chose to illustrate the *Siege of Minas Tirith* in the 1977 calendar, they wanted it to be a much more complex depiction of the dramatic battle. But it was the march of time, not an army of orcs, that was the true enemy. My father and uncle were forced to scale down their concept to the version you see here. This finished piece is a mere detail of a much grander vision.

My favorite memory of the creation of this painting took place right after the photo shoot. My father dressed me in the finest oversized battle gear in all the land and propped a helmet on my head. I picked up a sword off the floor and hefted it high in the air. The weight nearly pulled me over. I took several practice swings and the wood floor splintered when the blade landed with a heavy clang.

I turned. Rags stood menacingly before me. His red hair glowed brightly in the overhead lights. It did not take long for me to realize that he could defeat me easily. I fell to the floor and my opponent covered me with his shield. The large disk nearly covered my entire body, and I was left for dead.

## Siege of Minas Tirith

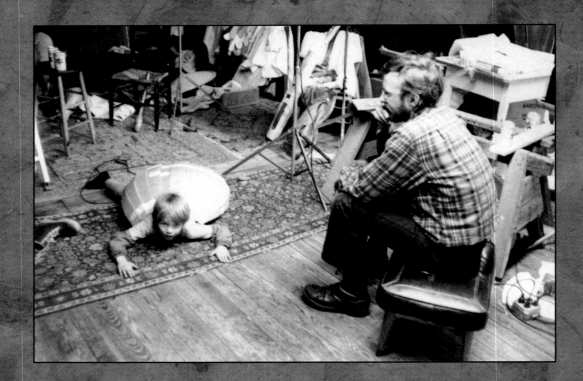

"This painting was the biggest yet, five feet by five feet with lots of detail. By this time, I was ready to kill Greg for insisting that the paintings be so big!"
—Tim

"I remember starting to draw this scene and totally losing my sense of perspective. I totally freaked out. As the deadline got closer and closer, I kept making the pictures bigger and bigger, and they were taking longer and longer to do. I just had to crash and sleep for twenty hours, or so. When I woke up I tackled it again and got it right."—Greg

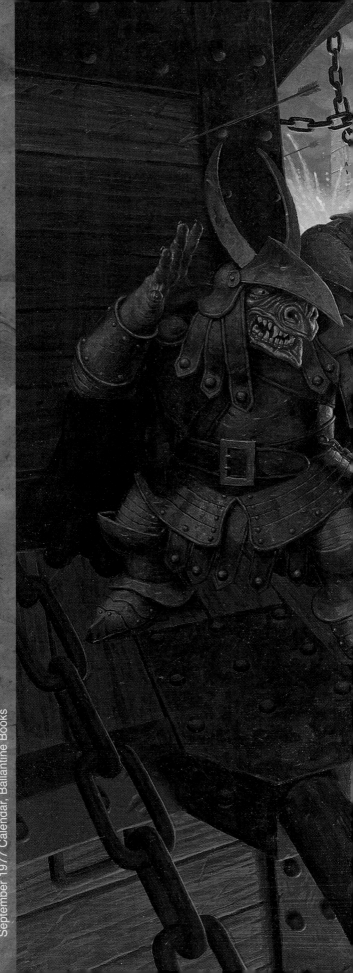

September 1977 Calendar, Ballantine Books

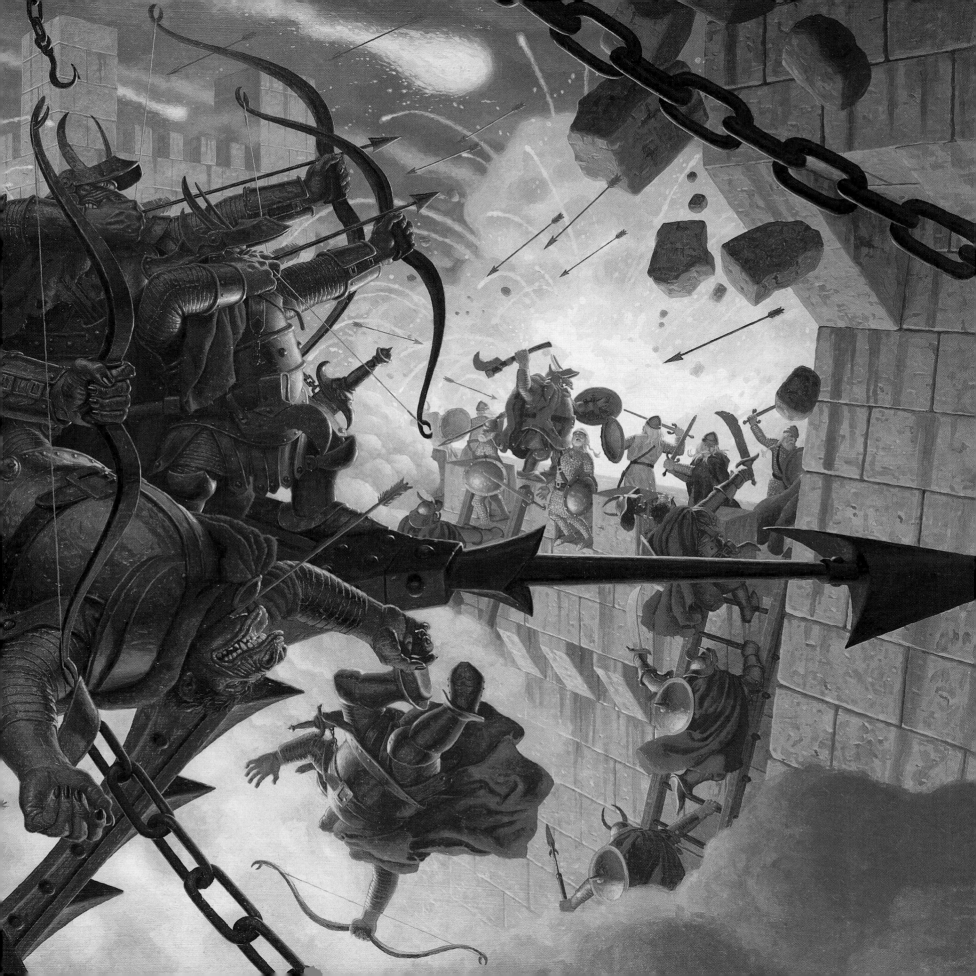

I watched and struggled to learn. My father and uncle were creating an image right before my eyes. Every stone was perfect.

For some time, it was only an image of an empty room. I racked my brain, trying to think of where it was. Parts of it resembled our basement. But there was an element that indicated this was a place of safety, despite the cold, overbearing stonework.

Then, one by one, figures took shape. A light cascaded from above, lending its warmth to the stone room. Éowyn lay dying on the bed, lost in a deep sleep following her fight with the Nazgûl. Strider knelt by her side, and Éomer, her brother, stood vigilant at the foot of the bed. The third person was Gandalf, standing in the center. They all appeared worried.

I thought the painting was finished. My father and uncle thought otherwise. They weren't satisfied with the mood it conveyed. While the image depicted a tragic scene, it was also supposed to express an element of hope.

I heard them discussing that the light was too gray, making the painting too dark and hard-edged. What began next was a tedious, aggravating process of correction and perfection. It was painted, repainted, and painted again until the rays were warm and gave a soft appearance to the painting. To achieve this, they worked around the clock for four days.

In the end, their instincts had been right. The light did add to the emotion of the scene. But I had been happy with their first attempt.

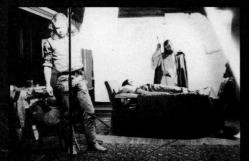

"As we painted the rays of light streaming down, I thought of this as a religious painting. Basically that's what it is to me. Aragorn, the Christ figure raising the slain Éowyn from the dead. Or maybe it's just Strider with a bowl of Magic Chicken Soup." —Greg

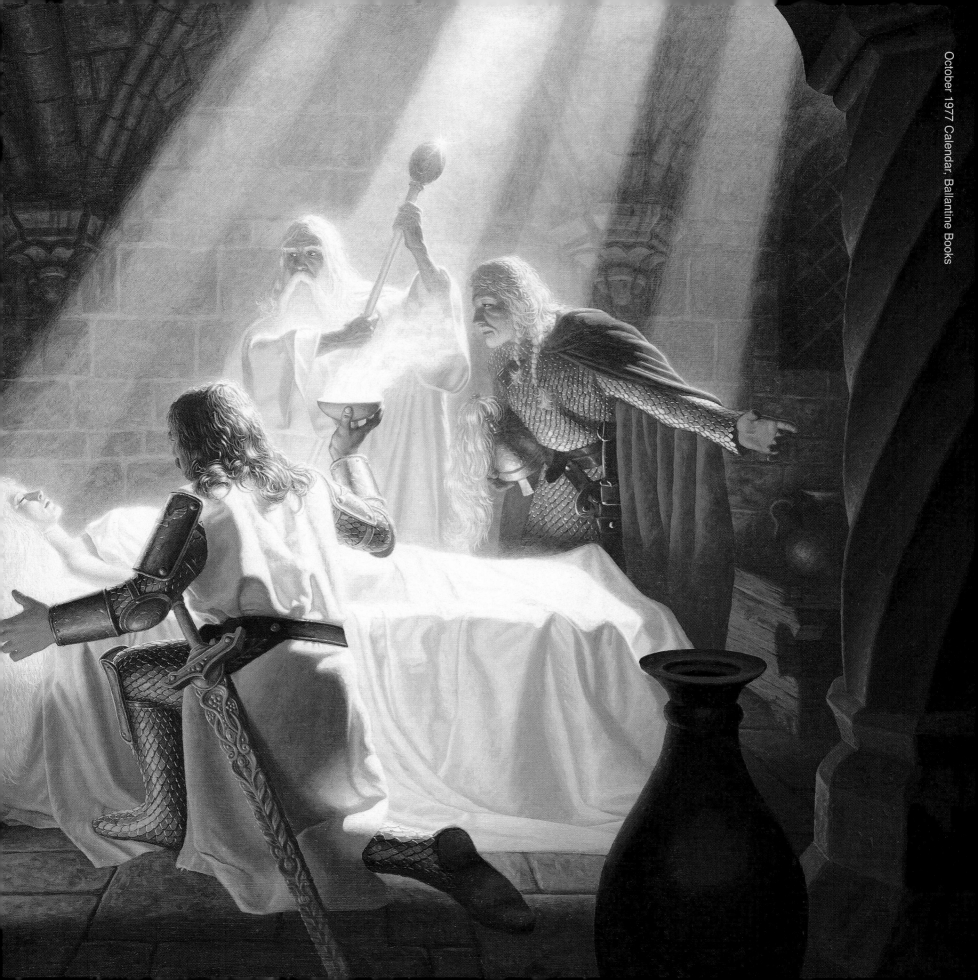

# Cirith Ungol

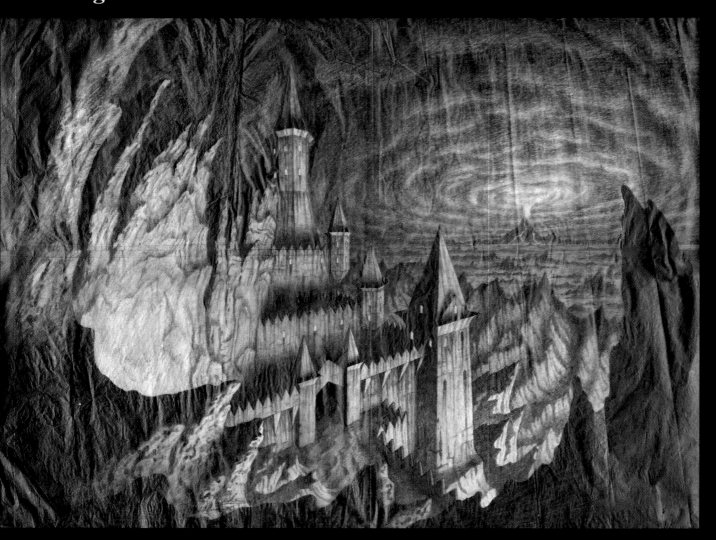

At the edge of our property, past a dwindling line of bushes, stood a small, one-story house. The windows were always dark and the lawn unkempt.

A vague sense of dread hung heavily over this place. I had never seen anybody back there. A loud noise from the house caused my heart to jump, my feet to scurry, and my imagination to soar. I ran as fast as I could to the barn.

Once inside, I shut the door behind me and breathed a sigh of relief. I never found out what the noise was.

The studio was safe and inviting. An air of familiar comfort surrounded me. My father was transferring the sketch of the final calendar painting, *The Wedding of the King*, onto a board, while my uncle sat at the easel staring into the cavernous mouth of Mordor.

I gazed at the painting that my uncle was painting. Chills ran up my spine. A dark castle sprung out of a rocky mountain. In the distance, a fiery volcano spewed its scorching ash into the sky, consuming it. One look and I knew that this was a place where evil lived.

Actually, my uncle told me that Tolkien described Mount Doom as flaring up only occasionally, but he decided that it should spew fire and ash continuously into the atmosphere. This would then form a ceiling of smoke and ash that would block the sun completely from one end of Mordor to the other. He and my dad decided that to achieve this effect of total darkness, the ash would have to spread out from the center in continuous billowing rings. Uncle Tim saw Mordor this way because it resembled his vision of a stifling hell.

Once my uncle finished his explanation, I turned to leave the studio. I looked out the massive bay window at the front of the barn. In astonishment, I shifted my eyes back and forth, between the painting and the view beyond the glass.

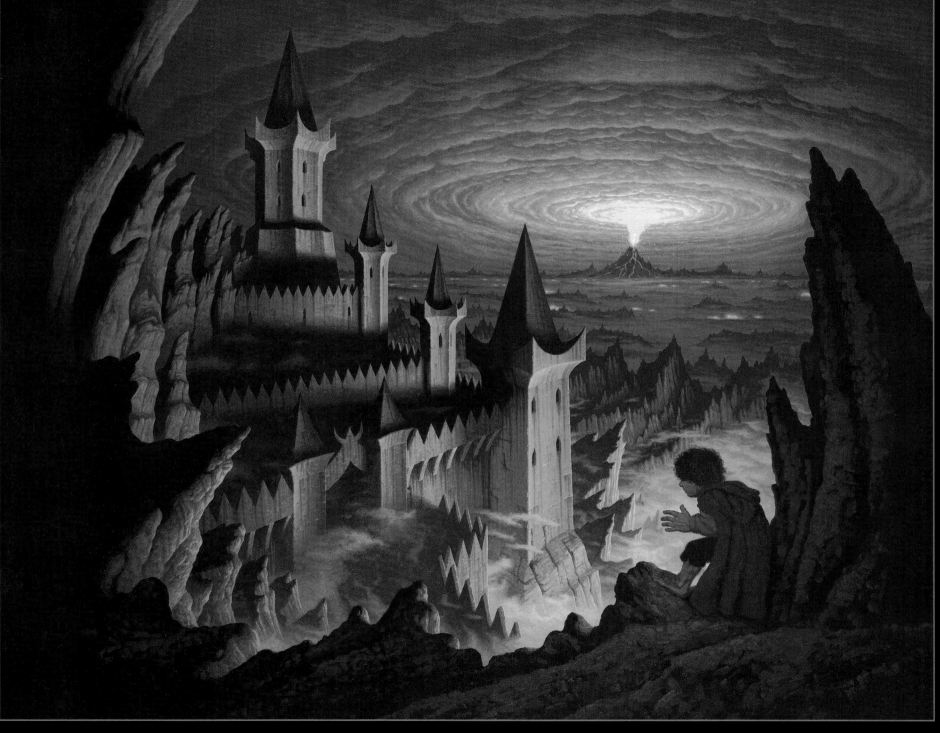

Outside, the sun had nearly sunk below the horizon. Its reddish glow bathed the dark house behind our property in supernatural colors. It was an image that was clearly different from the one in the painting, yet they were somehow similar.

My uncle had displayed his uncanny ability to perceive the true nature of the world. Where I had seen a house with dark windows and an uninviting presence, he had seen Cirith Ungol, "the pass of the spider." This was where Shelob the giant spider had made her lair, to guard the pass. And the noise I had heard earlier was perhaps the desperate struggle of her most recent victim.

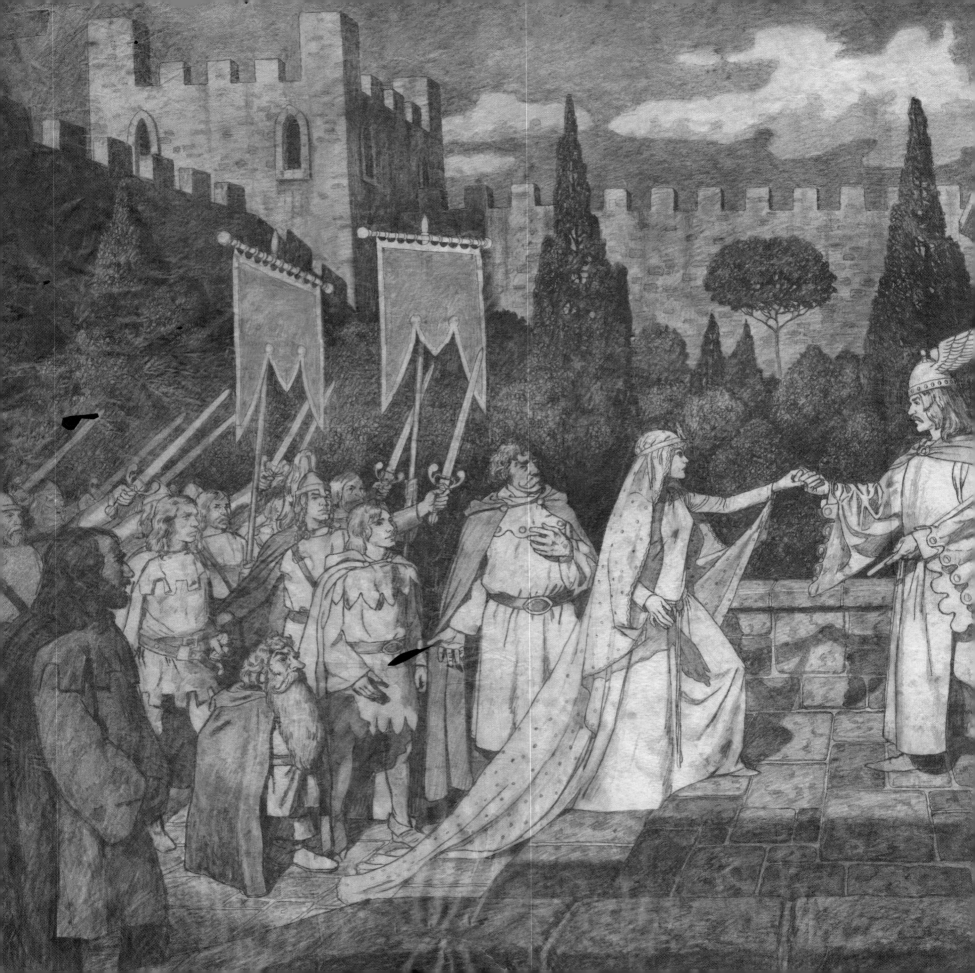

## "The Wedding of the King" Begins...

I t was July 1976. My dad and uncle had delivered the final painting for the 1977 calendar, *The Wedding of the King*, to Ballantine the last week in June.

This was an exciting month. Not only for my dad and uncle but for the whole country. It was the bicenntenial year and the tall ships were on display in New York harbor. I couldn't wait to go. The New York Historical Society and the Society of Illustrators came together to have a show on 200 Years of American Illustration, and their painting of Éowyn and the Nazgûl was chosen to be in the show. But what was really special was that my grandparents were coming in from Detroit to take us.

I didn't know very much about American illustrators, but my dad and uncle said this was going to be one of the great honors of their lives because they would have a piece of art hanging alongside the work of hundreds of their heroes. A few whom they mentioned to me were Howard Pyle, N.C. Wyeth, Maxfield Parrish, Dean Cornwell, and Norman Rockwell. I had seen many books on these artists in the studio, mostly on the floor.

My sanctuary became a bit crowded as my friends continued to visit. Together, we crossed the imaginary bridge from reality to fantasy. I was delighted to share the things I had seen.

My dad and uncle decided to have a party to celebrate the completion of the second calendar, the signing of the contracts for the third calendar and in general their good fortune as illustrators. Dozens of friends and family came for the festivities.

My father, uncle, and their friends had united once again. But this time, they welcomed me and my friends, as well. I realized then that my friends and I were creating a Fellowship of our own.

Tired but enthusiastic, my dad and uncle pushed on for what was slated to be the third calendar in a series of four, which, alas, would be the last.

When I recently asked my dad for his thoughts on the 1977 calendar paintings, I was surprised at his response. My dad said if he had the opportunity to do it over again, he would paint the pictures a lot bigger so they would look amazing all together in a gallery show.

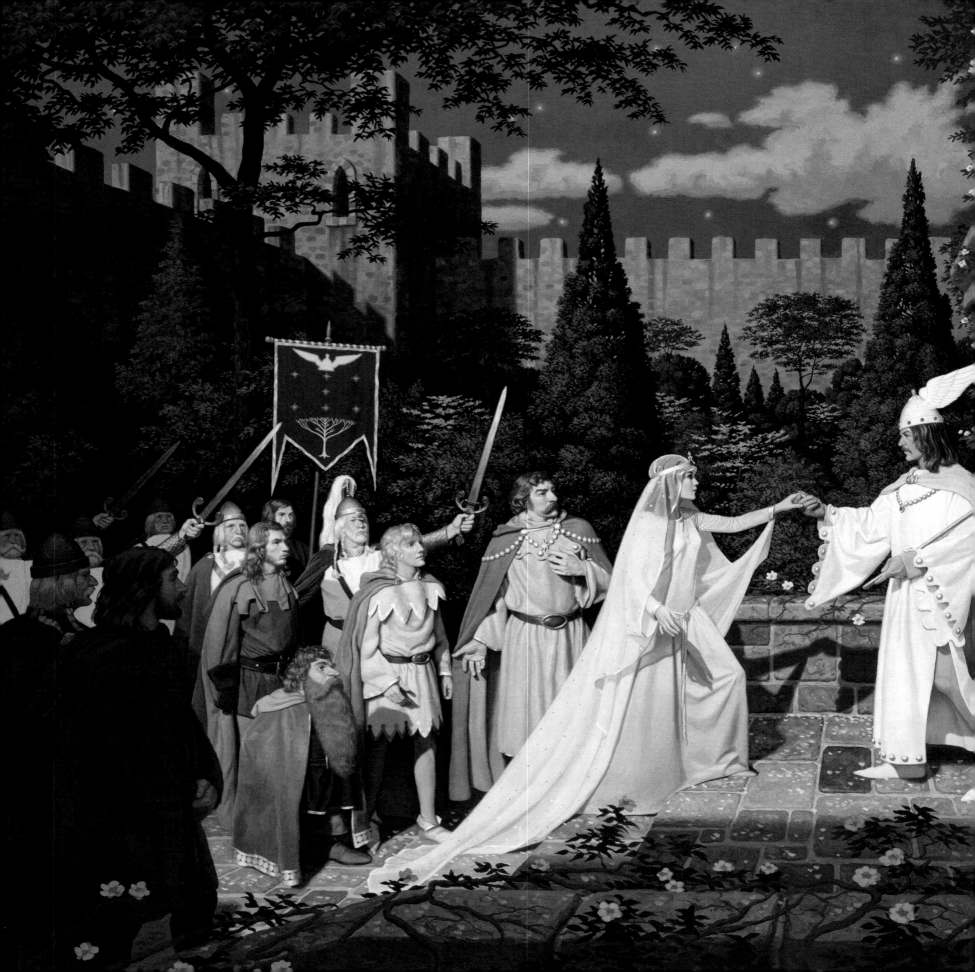

# The Wedding of the King

By now my dad and uncle were receiving piles of glowing fan mail for the first two calendars. They had gained international reknown and were faced for the first time with having to create for fans as well as for themselves.

So they decided to give this calendar a new, yet old classic look. Pulling on their passion for N.C. Wyeth's book cover illustrations, they chose to do a scene representing two of the main races in Middle-earth.

And so began the 1978 calendar. It seemed appropriate for the first illustration to depict two men gazing into the distance—two men who were bound for adventure.

In reality, my dad and uncle chose a dwarf and an elf because they were shorter than everybody else in Middle-earth. You see, the publisher wanted a really big scroll on the cover so they were limited to a small space for their characters.

Most calendar covers reprint art from the interior. But my father and uncle insisted that the cover be a separate painting. They wanted to give as much to their fans as they possibly could. They said it was the least they could do for all the support they had received.

*"Mike McGuire, posed as Legolas. He happened to stop by the studio one evening. We immediately threw him into a costume and began to shoot. Funny thing about it though, Mike never just stopped by again."—Greg*

*"When we started the sketch for this cover, I was inspired by an N.C. Wyeth painting that he did for the cover of The Black Arrow. It showed two men looking out into the distance standing under an oak tree. I first saw this original Wyeth at the Society of Illustrators in New York."— Tim*

"*Judy-Lynn and Lester del Rey had three little toy bulls sitting on a shelf in their apartment. They treated them like children and named them. Judy-Lynn wanted them painted into the calendar, so we chose this particular scene where they seemed to fit.*"—Greg

I sat staring into the distance. Ever-faithful Pani was by my side. I held her firmly as my dad and uncle adjusted the lights and shot the photos.

I was really looking forward to this painting, not because I was going to be a hobbit one more time, but because I was going to be in it with my mom and my dog. I thought that was pretty cool.

Once Pani and I were done, it was mom's turn. She posed for Farmer Maggot's wife. My uncle told me that this scene was out of a chapter called "A Short Cut to Mushrooms." I always thought that was kind of strange, eating a plate filled with just stewed mushrooms. But, hey, why not? After her photo shoot, my mother changed back into her "mom" clothes and returned to the house.

My dad and uncle actually finished this painting in record time—one week. Probably because they painted it smaller. It seemed that this time around my uncle had won the battle of size.

*Farmer Maggot's Hospitality*, the first image of the **1977** calendar, had come to life.

*"My wife Diana wasn't really happy when I asked her to pose for Farmer Maggot's wife. It was a far cry from her last pose as Galadriel in the first calendar."—Greg*

*"The stress of painting for fifteen hours a day causes you to act goofy once in a while. We took a lot of these shots for fun, never expecting that they would actually be published one day."—Tim*

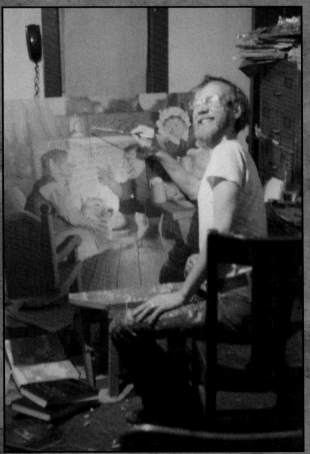

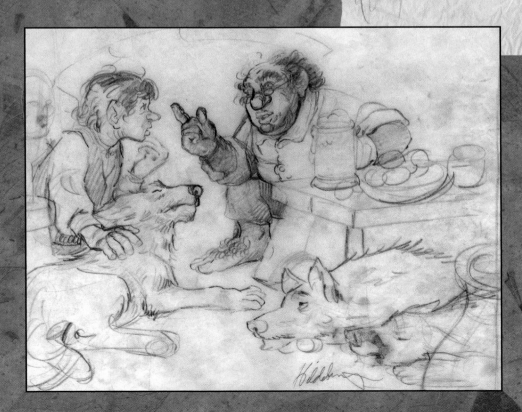

# Old Man Willow

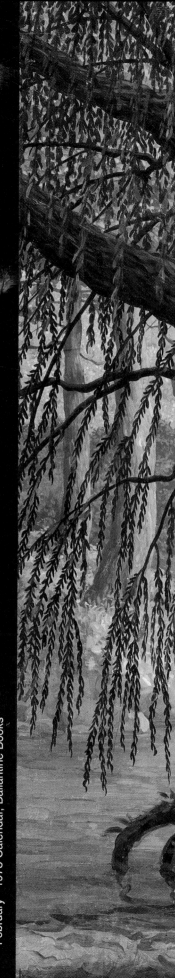

It was September 1976 when my dad and uncle started designing *Old Man Willow*. This was a really important month for me. I was starting first grade. Going to a brand new school, new adventures lay ahead.

One afternoon dad and Uncle Tim were in the backyard standing under our giant willow tree. It towered toward the sky and blanketed the yard in shadow. I stood there and watched as they talked and pointed at the sturdy old tree, snapping occasional pictures of it.

My father had always taught me to respect nature and I knew that our willow was an example of nature at its best. Dad told me that Mother Nature was responsible for all living things, and I imagined that she must resemble the beautiful Galadriel.

At the base of the willow, I studied the intricate layers of chipped bark and roots. This tree had been here long before me.

A few days later, I entered the studio and carefully stepped over the piles of paper and empty paint tubes on the floor. Dad and Uncle Tim were absent. I glanced at the easel and experienced a strange sensation. Our old willow tree was painted on a board, just off-center and slightly tilted. But was it our tree? This one was distorted. It had eyes, which were dark with hatred, as if its heart were rotten to the core.

This was Old Man Willow. My dad and uncle had warned me about this tree. They told me he lives in a place called the Old Forest and would use his mystical powers to lure travelers into his grasp. If a traveler got too close, he would snag them with his snakelike roots, pull them toward his massive trunk, and eat them.

The old willow in my backyard didn't have a stream next to it. One was added to the painting to portray Old Man Willow's domain next to the Withywindle River, into which it fed. It didn't have a face either.

Actually, my dad and uncle's Old Man Willow wasn't really the one that Tolkien described in his text. Tolkien's tree had no face and had a slit in the trunk for a mouth. My uncle Tim said he couldn't imagine designing this tree without a face. So he did his own thing with it.

I thought the face was really cool. This was one of the things that I remember loving about their art as a kid. They could take any object and give it a personality. They would bring it to life and make it real.

"Tolkien's text didn't describe Old Man Willow as having a face. But I always felt that he had a definite personality, so I gave him one. The knots and gnarled bark of willow trees make it easy to see faces in them. I have always had a passion for giving human traits to objects in nature. They are all living anyway, I just take it a step further."—Tim

"Tim designed this piece and painted it without me. I have always thought that it is one of the best paintings in the three calendars. I love the lighting, the mood, and the atmosphere. I have to admit that my brother's ability to paint nature with magical color and light has always blown me away."—Greg

February 1978 Calendar, Ballantine Books

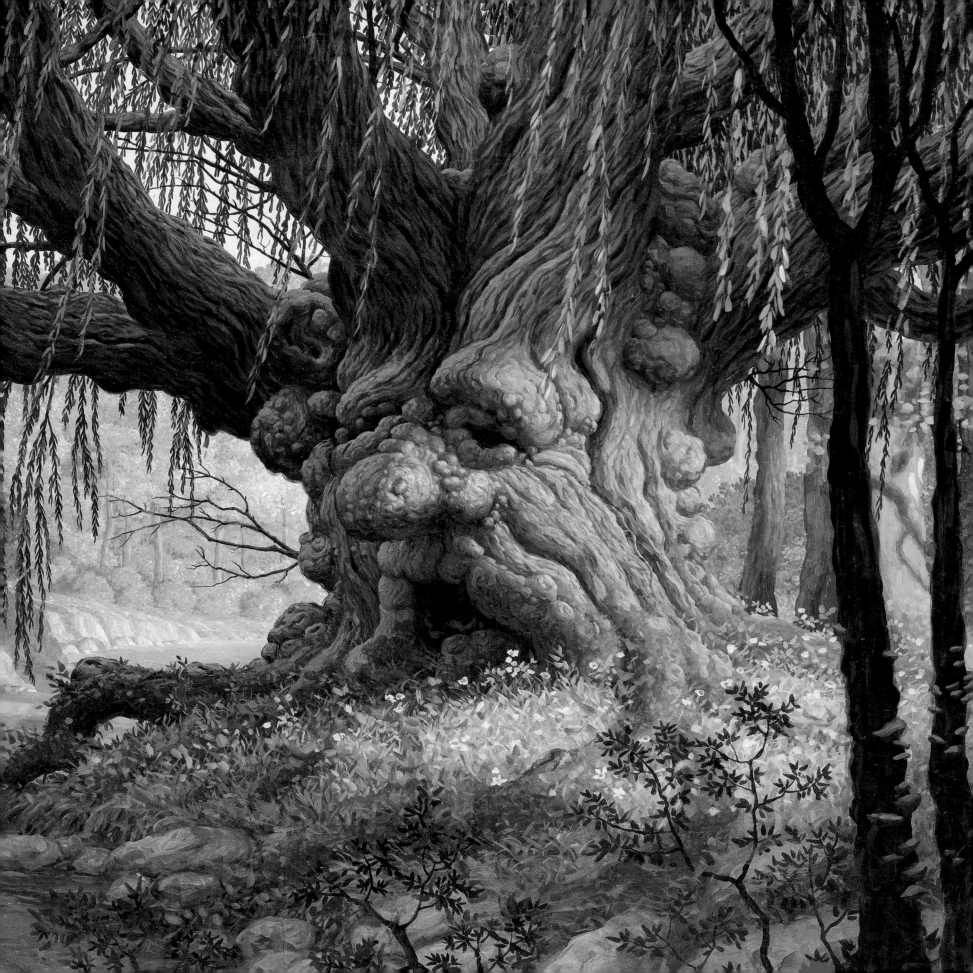

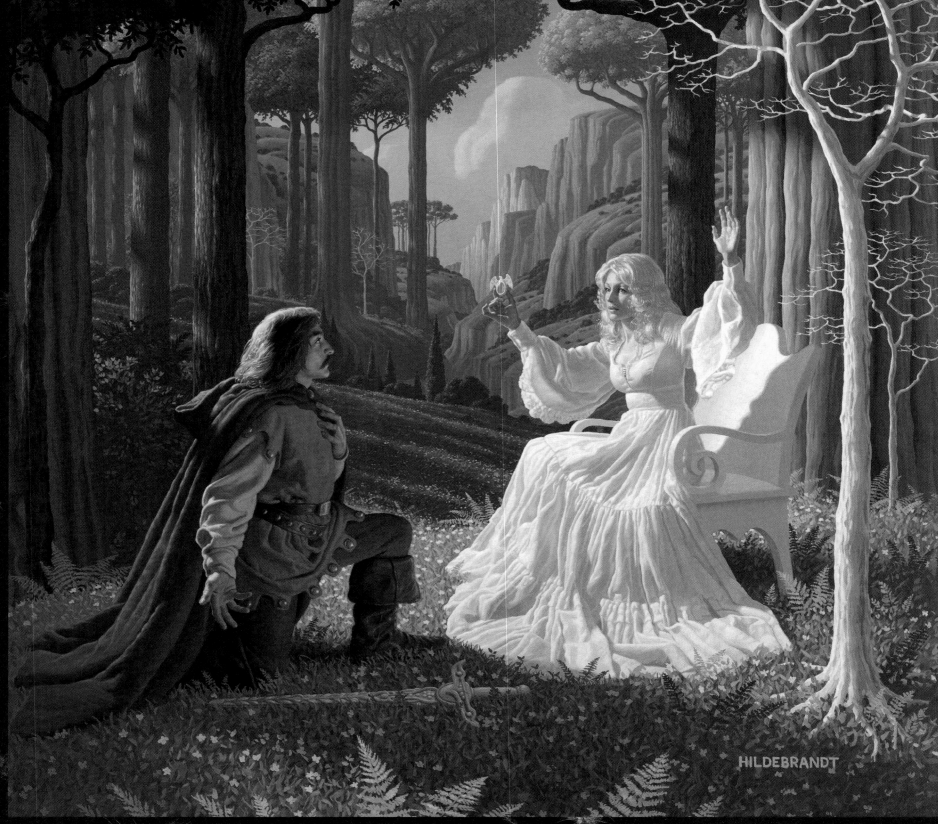

"I felt that Galadriel's throne room was all of nature. So we created
the illusion of pillars with straight tall trees." -Tim

**S**tanding before me on my father's easel was the next Tolkien painting, *The Gift of Galadriel*.

Galadriel, the beautiful Elven Queen, stood deep in the forest of Lothlórien, which was filled with golden mallorn trees. This was her realm. Her image, pure and white, glowed in the warm sunlight.

At her feet knelt Strider. She bestowed upon him a silver broach and a sheath of magic. The broach was inlaid with the Great Emerald stone, which was the Elven stone of the house of Elendil. The sheath, which had been made to fit his sword, would protect him in battle.

Such was the power of the Gift of Galadriel.

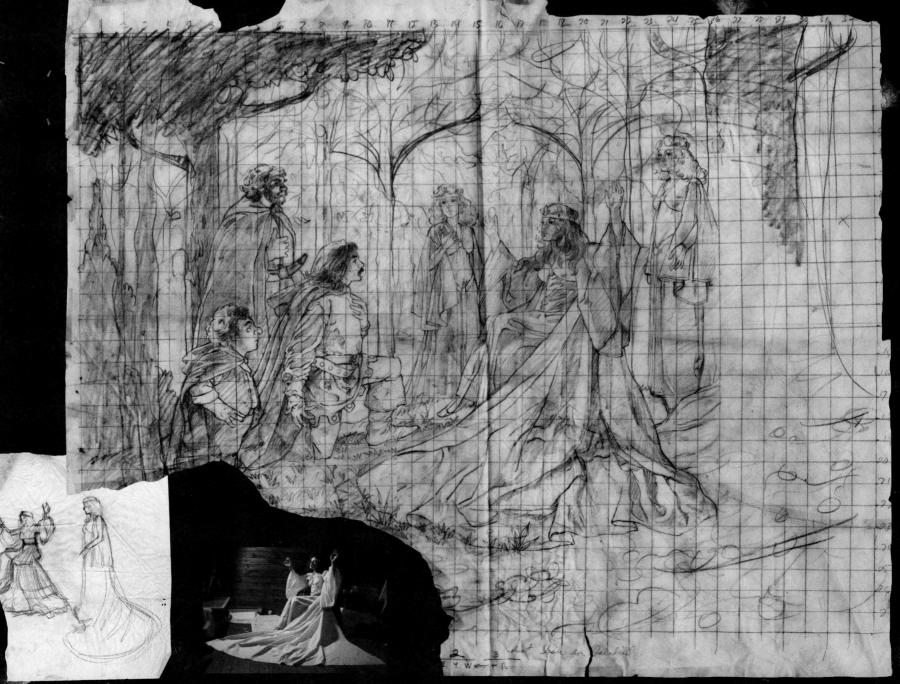

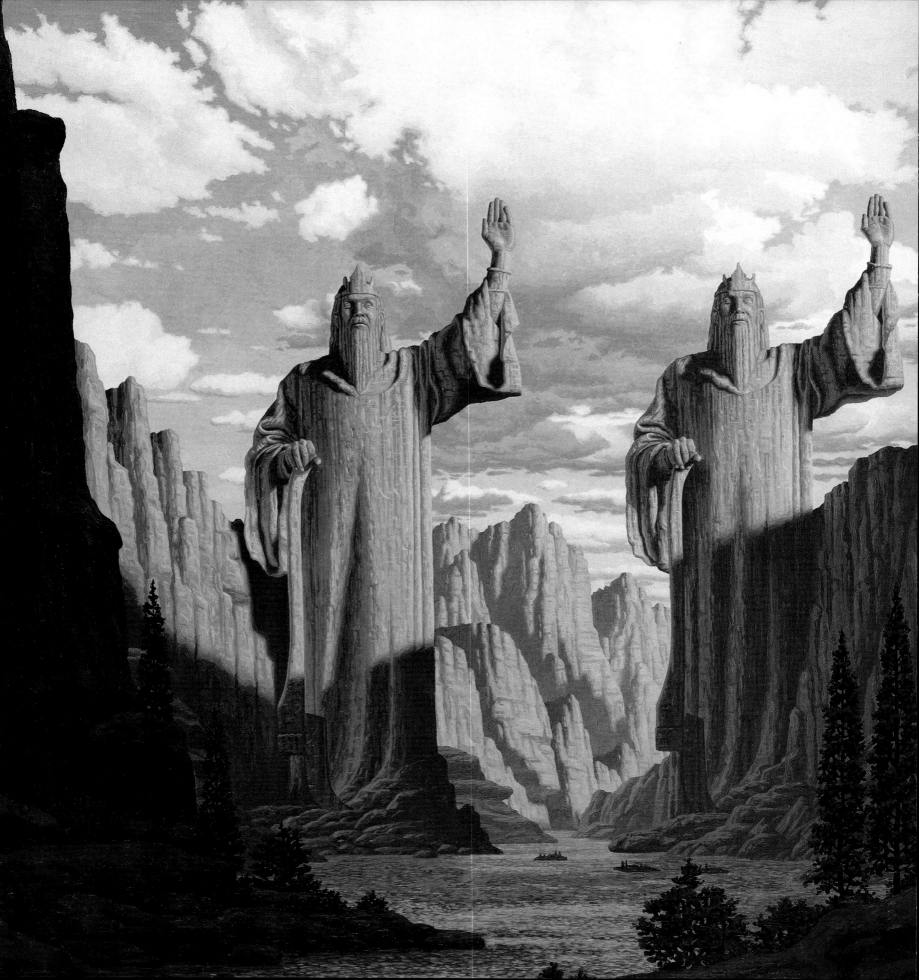

April 1978 Calendar, Ballantine Books

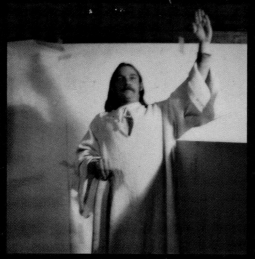

## The Pillars of the Kings

**H**alloween was just around the corner. My favorite holiday.

This particular year was one I will never forget. My whole family had been working on our costumes together for weeks. Dad had decided that we were all going to be martians that year.

Dad got together the stuff we needed. There was newspaper, masking tape, and papier-mâché all over the studio. We worked diligently, dad, mom, me, my sister Mary, and my sister Laura.

Dad designed giant heads with bulbous eyes and strange ears. We painted them in a variety of colors, oranges, reds, yellow, greens, black, and purple. We made breast plates of cardboard painted in silver, with a silver lightning bolt in a black circle at the center. Dad made plywood ray guns. Each of us would wear a black cape and silver boots.

As the weeks passed while we made our costumes, my uncle quietly painted at the easel. I guess you could say that my dad had Halloween fever, so he didn't work much on *The Pillars of the Kings*. Of course, he helped my uncle design it and shoot models for it. But this painting was more of Tim Hildebrandt than the Brothers Hildebrandt.

Occasionally, I would break from making my costume and watch my uncle paint.

I could see that my uncle really loved painting this type of scene. He really loved landscapes and architecture. He worked steadily and almost never spoke. With each stroke of his brush, the giant statues of the Argonath became more chiseled. They stood tall, guarding the entrance to Númenor. Approaching the giants on small boats was the Fellowship.

When it was finally finished, just about the same time as our costumes, I knew that the world would see the beauty of the lighting and the majesty of the towering stone giants.

I saw twins: twin Giants designed and painted by twins.

*"In the painting of Old Man Willow, I felt free to give the tree a face because Tolkien didn't say that he didn't have one. When I read the scene of the Pillars of the Kings, I felt that it would look better if the statues' arms met in the middle over the river. But here Tolkien did describe the statues as having both left arms raised, leaving no room for interpretation." —Tim*

*"This was my very first drawing of the hobbits, and I approached it almost in animation style. I drew Sam with a cast-iron pot on his head—Sam the cast-iron pot-head?"—Greg*

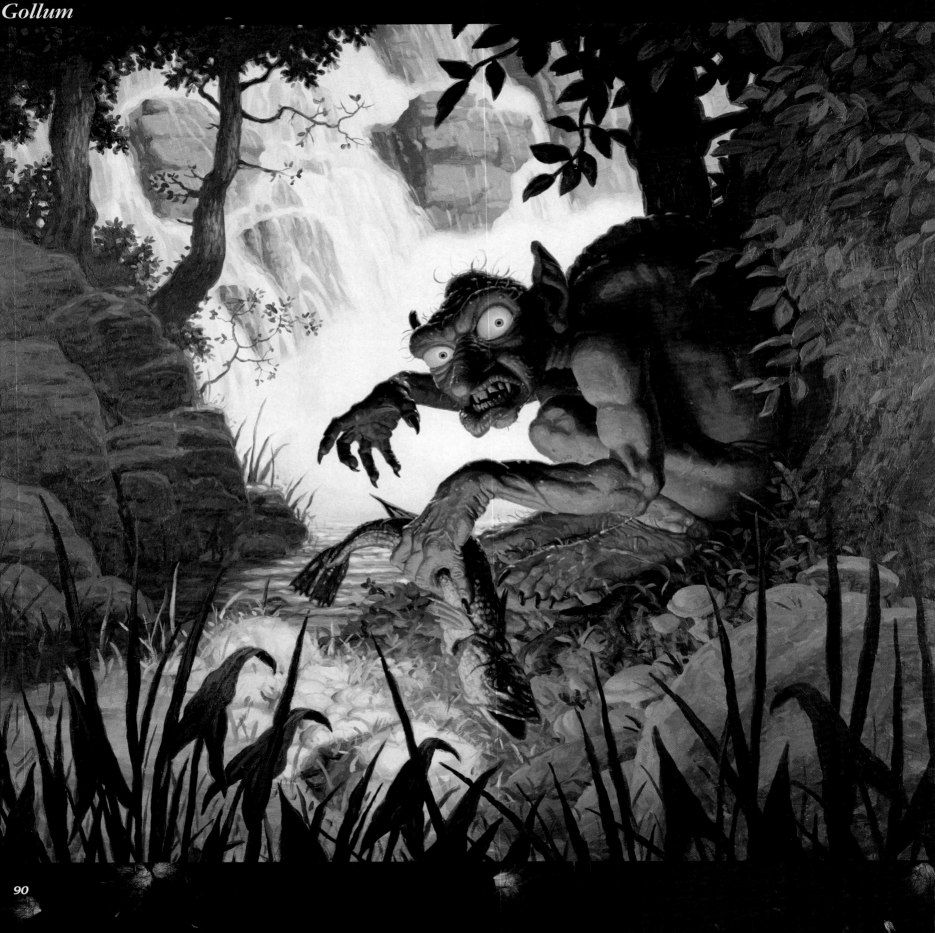

The station wagon smelled of fish. My mother was at the wheel, smiling and humming a song as we returned from the market. The cold November air prevented me from opening the window.

Finally, the old wagon pulled into the driveway. I helped Mom carry the oversized grocery bags into the house. Just when I thought my duties were finished, she handed me something long, wrapped in a white piece of paper. It squished in my fingers. Then an aroma tingled my nose. It was a fish!

"Be a dear and take this to your father," she said. Why he wanted it, I didn't know or care. I ran to the studio where my father gave me a hearty welcome, as he took the stinky package from my hands.

"It's here!" he exclaimed.

Suddenly, my uncle began to take off his clothes! What was going on! I wondered. My curiosity kept me glued to the old floorboards.

My uncle stripped down to his underwear and took the package from my father. He unwrapped it and held it in one hand. The dead fish hung limp. I watched as my uncle crouched down and clutched the slimy fish. He twisted face into a wretched scowl and contorted his body into something inhuman. He kept petting the fish and called "my precious."

The hot spotlights cast shadows to make his body look like a thing of pure evil. My mouth became dry and the on the back of my neck stood on end. What malevolent had mutated the body of my uncle?

Then my uncle made a gurgling noise in the back of throat. I could barely make out a word, or a name.

"Gollum."

I shuddered at the sound. I had heard his name in whispers before. Now the creature crouched before me. Gollum. A life turned sour, transformed into a minion of through his own greediness.

As my father clicked the camera, my uncle became and more immersed in his character. Had he too been consumed by the darkness? I made a mental note to avo fish.

*"We flipped a coin to decide who was going to pose for Gollum. Tim won the toss or lost, depending on how you look at it. It certainly wasn't the most flattering pose for anyone."-Greg*

*"This is a close-up of me posing for Go Thank God you can't see the long shot w in my underwear!"-Tim*

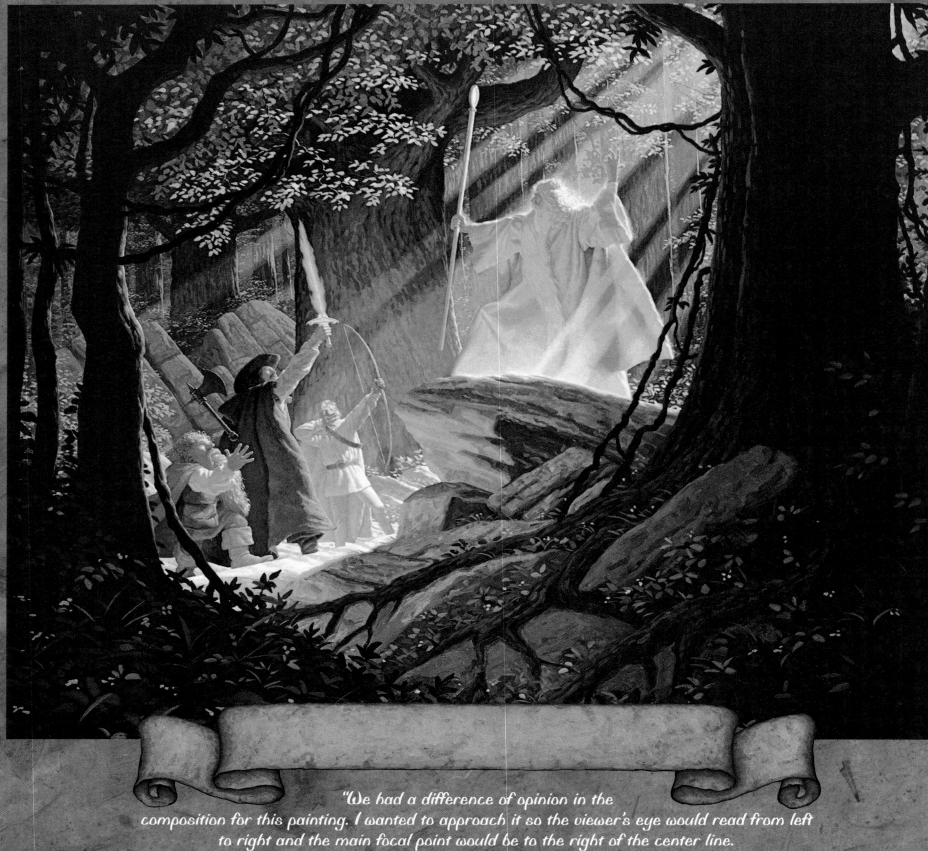

"We had a difference of opinion in the composition for this painting. I wanted to approach it so the viewer's eye would read from left to right and the main focal point would be to the right of the center line. All the elements in the picture lead you to Gandalf." —Tim

Once more, Christmas was fast approaching. Once more, I wrote to Santa to ask for a bike. Once more, I would give my mom the letter to mail and then I would wait.

While I waited for Christmas morning to arrive, Gandalf returned to my dad's studio. I watched the photo session and knew that Gandalf was somehow different. He had fought the Balrog and survived. Instead of his robes of gray, my dad and uncle painted him dressed all in white.

I couldn't tell whether he had really escaped death at the hands of the Balrog or died and been resurrected. But I was sure that my dad and uncle Tim knew.

As they continued to paint, I watched as they painted in Strider's flaming sword and wondered what magic had occurred with Gandalf's reappearance.

On Christmas Eve the painting was finally finished. I made my way up the stairs of the old carriage house. The familiar scent of acrylic paint hung heavily in the air. As I entered I was struck by a powerful image.

Gimli, Strider, and Legolas stood transfixed before the sunlit figure of the wizard, who stood on a tall ledge. Thick, lush green woods surrounded the figures, who were bathed in the purifying light of day. Once more the Fellowship had their spiritual guide to protect them.

It was time for bed, but the anticipation of Christmas morning and the image of Gandalf made sleep come reluctantly. Finally, Christmas arrived. I jumped out of bed, flew into the living room and slid to the bottom of our Christmas tree.

Still no bike. Eventually, I had to ask myself whether I would have had better luck just asking my parents for it, instead of Santa.

*"This sketch was my take on The Return of Gandalf. It is a frontal, formal, triangular composition. I very rarely use this type of composition. As you can see, in this instance, the composition Tim chose gives you a much better view of the characters."—Greg*

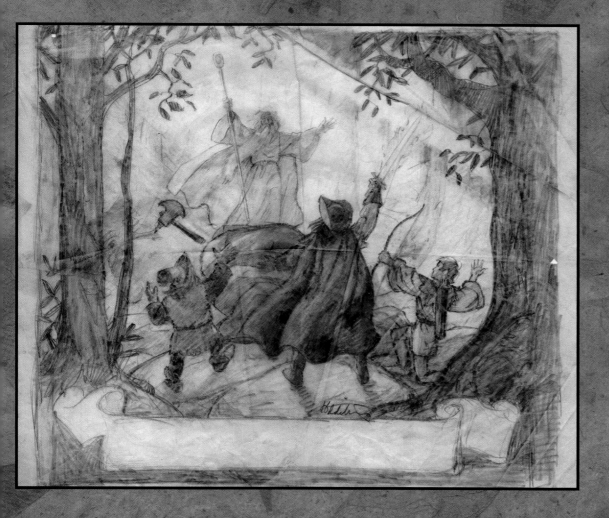

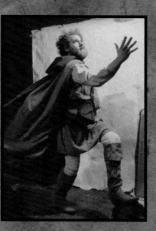

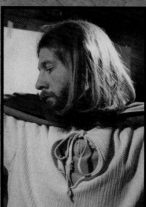

# *"At the Grey Havens" Begins...*

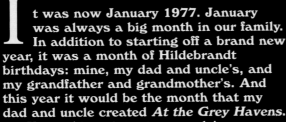

I t was now January 1977. January was always a big month in our family. In addition to starting off a brand new year, it was a month of Hildebrandt birthdays: mine, my dad and uncle's, and my grandfather and grandmother's. And this year it would be the month that my dad and uncle created *At the Grey Havens*.

Up to this point, at my uncle's insistence, the paintings for the 1978 calendar were all smaller than previous ones. But this painting would be different. The scene depicted the end of Middle-earth, so they both agreed that this centerfold had to be very large. When I saw the board that they cut for it, I couldn't believe my eyes.

I overheard them saying that it would probably take at least a month to paint it this size but that they didn't care. So it ended up being over six feet long.

Actually, it took them almost two months to paint. Two very, very long months.

They had finished the photo sessions for this piece in December, as well as the sketch. Now they started the task of determining the color of the light sources in the painting. Normally, they would have already had an idea of this in their minds, but this painting was different. I heard them discussing the color of the light sources as they mixed their paint. For four days, they painted in the background.

One late afternoon, I entered the studio to find them both agitated. The background color was wrong. That was all I had to hear to know that it was time for me to depart.

So they sanded down the entire board, transferred the sketch, and started again. This time I knew they would get it right. I was wrong.

The process of transferring the drawing, mixing paint, and spending days

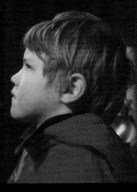

on the background began. But the second time it was also wrong and had to be repeated yet again. By then both my dad and uncle were like wild men. It was rare for them to get off to a bad start on a painting, and three bad starts in a row were definitely unheard of. To my relief, they got it right on the last try.

They had painted the background using acrylic paint. When they finished, my dad decided he wanted to use oil paint for the figures like the old masters used. This was very unusual. But since they had never used oils before, dad told me he wanted to conquer his fear of the unknown. This turned out to be a giant mistake.

One Saturday I watched him for hours as he very carefully painted in Gandalf's face. He hadn't used oils in years.

The face was complete. He was pleased. But since he was so used to working in acrylic, which dries instantly, he made a grievous mistake. He rested one hand on the painting while working with the other. When he lifted it off the board, it was covered with Gandalf's face!

I don't think I ever saw my dad so angry before or since. I know it was the only time I ever heard certain words come out of his mouth. It was clear to me that I needed to get out of the studio and not come back until they finished this painting.

Dad and Uncle Tim decided that they should stick with what they knew, so they went back to acrylics, and to this day, I never saw oil paint in my dad's studio.

I did go back into the studio when the painting was almost done. I remember walking in and seeing both of them sitting at the easel, side by side, putting the finishing touches on it. Because it was so large, it was one of those pieces that they could actually paint on together, at the same time. Every once in a while, they

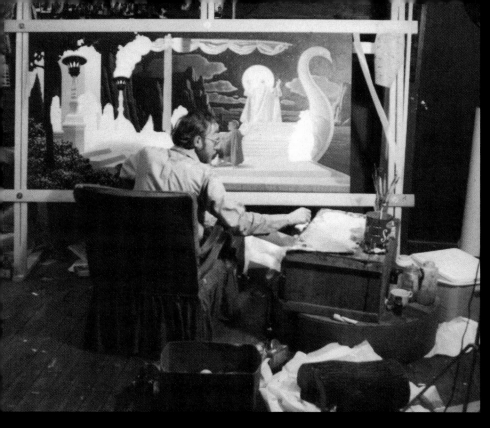

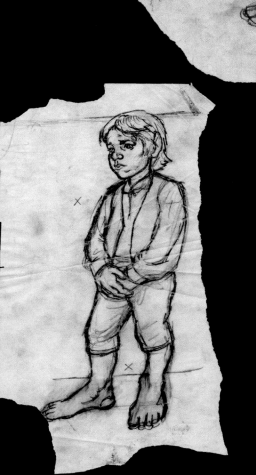

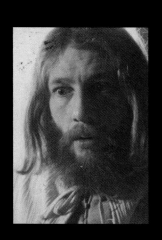

*"As far as I was concerned it still wasn't big enough. This was going to be the last centerfold for the Lord of the Rings Calendars. It should have been eight feet wide!"—Greg*

would get up, switch chairs, and start working on the section that the other one had just left.

Although it was Judy-Lynn del Rey who spread the legend, it really is true that my dad and uncle can switch places on a painting and no one can tell where one starts and the the other one stopped.

When *At the Grey Havens* was done, they were both very relieved. They had six more paintings to go to finish the calendar and four months left to do it.

One thing was certain: This would be the only giant painting they did for this calendar.

*"I gave into Greg's 'bigger is better' concept on this painting. We made this centerfold six feet wide. It was the biggest of all our Tolkien paintings and took the longest to do."—Tim*

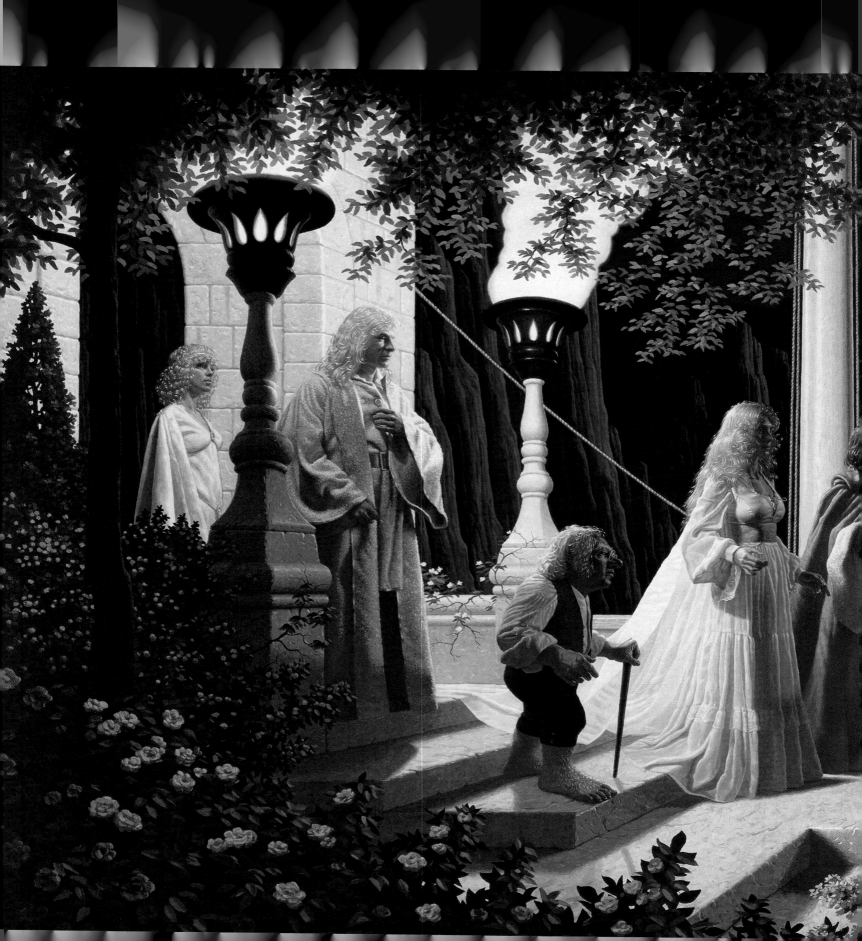

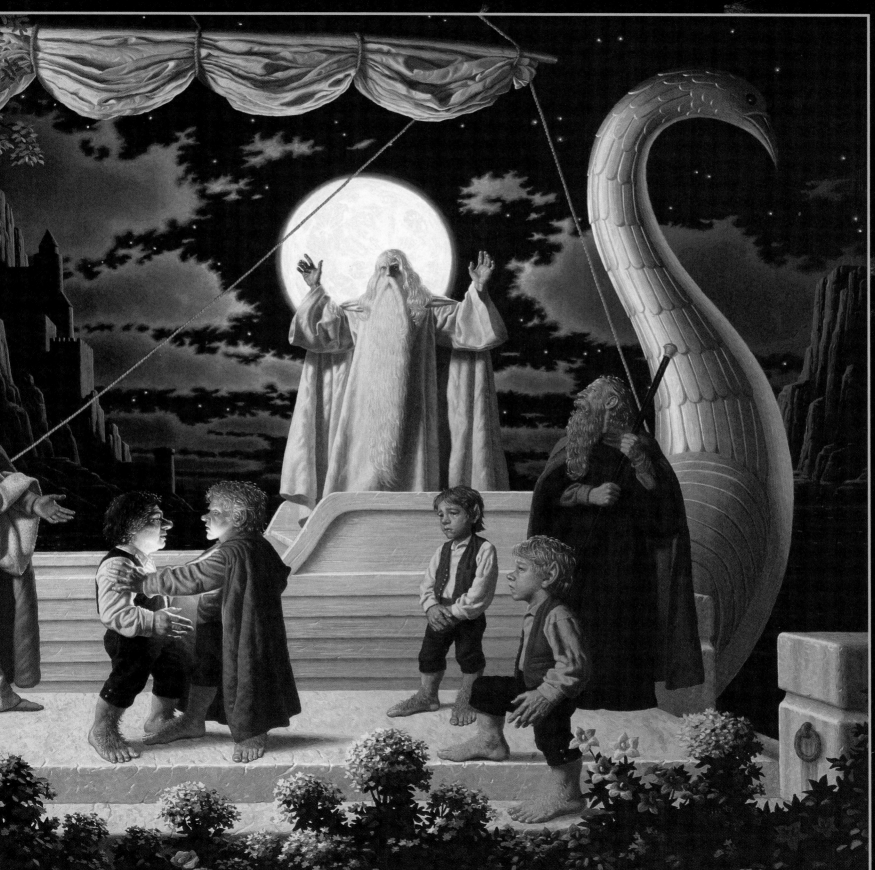

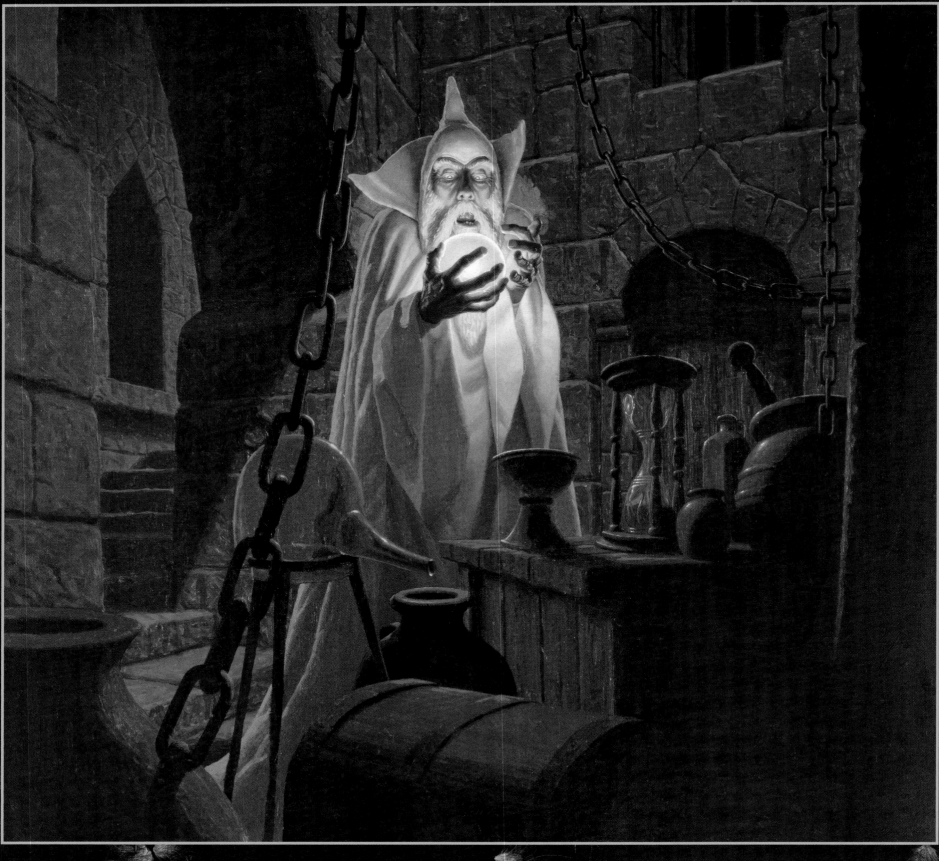

Saruman, the evil wizard, whom I had encountered long ago, had returned. He had now given his allegiance to Sauron, the Dark Lord of Mordor.

In the past, he had tried to enter my house. Now he was in the studio. Dressed in black, he held a glowing orb before his face. His eyes reflected torment. Another painting was complete. Or at least I thought it was.

My dad and uncle thought so too and took the painting into New York to drop it off with the publisher, as usual. But this time they came back with the painting. The publisher had asked for changes.

J.R.R. Tolkien had cloaked Saruman in a robe of many brilliant colors. My dad and uncle had worried he would look as if he were wearing psychedelic tie-dye clothes, so they had painted him wearing black.

Lester del Rey didn't like the black, but he agreed that it shouldn't be multicolored either. So Lester instructed them to paint him in white, as he was called Saruman the White. Once more, they returned to the process of sanding and repainting.

Since the start of their first Tolkien calendar, my dad and uncle had completed thirty-four paintings that were approved without a hitch. Now they had encountered problems on two paintings in a row. This was getting on their nerves. They wondered if the remaining five pieces would also present difficulties.

Over the next few days, I watched as they reworked the painting. Finally, Saruman was cloaked in a shimmering white robe. I asked myself, if the bad guys were no longer wearing black, then how was I supposed to spot them?

*"The combination of colors in this painting was the most exaggerated. It also has the highest color contrast of all the paintings. The simple reason for this is that we chose to use the primary colors—yellow, red, and blue."—Tim*

*"To get this pose we had Mike stare into a 50-watt light bulb for almost five minutes. He said he saw purple for a week, and that he never wanted to do another shot like that as long as he lived."—Greg*

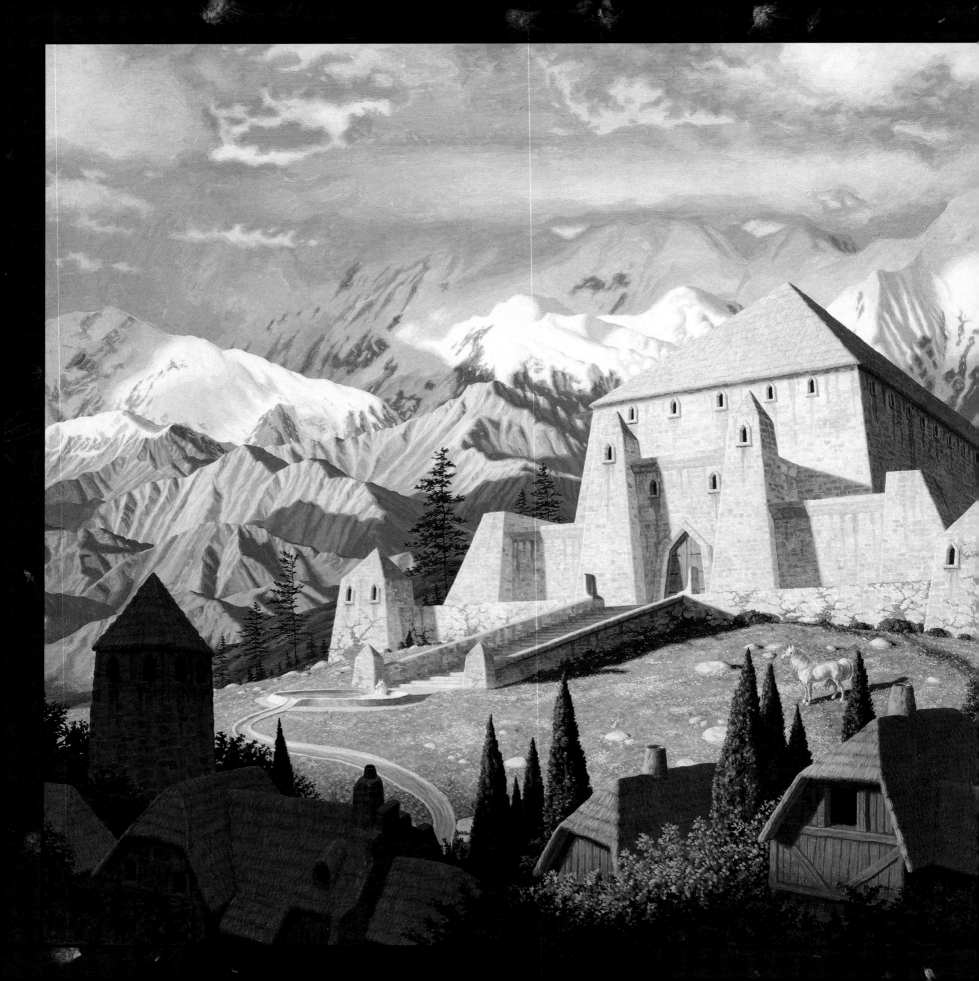

## The Golden Hall of Rohan

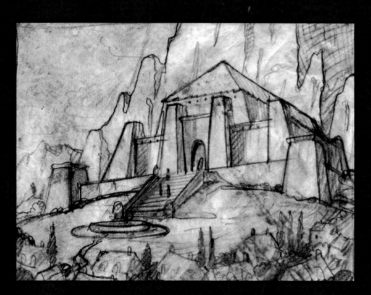

**A**ndy, Joe, Tommy, and I watched as my uncle Tim constructed a model of the Golden Hall of Rohan, the hall of King Théoden, also known as Meduseld.

He needed a cardboard model in order to light the scene just right in his sketch. My uncle told us that they decided to paint *The Golden Hall of Rohan* so they had a balance of the cultures and architecture of Middle-earth in the calendar.

The Golden Hall of Rohan is a place where the men of Middle-earth unite to defeat the encroaching shadow of the Dark Lord, Sauron. It is a place of light, honor, valor, strength, and courage.

In the combined vision of my father and uncle, the massive stone building is shadowed by enormous snowcapped mountains rising behind it. A village of wood and straw structures graces the foreground.

Many people believe that the Golden Hall of Rohan does not exist. But I think you'll find it anywhere you find diverse people uniting in a common cause.

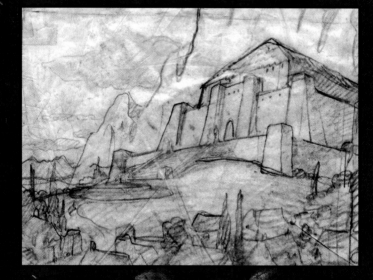

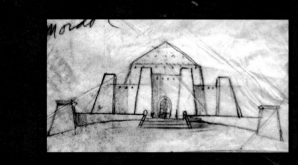

*"To some degree, this painting helped satisfy the frustrated architect in me. Tolkien's description of this hall wasn't too detailed, so I had the chance to design it. I think if I had to do my life all over again I could be happy as an architect." —Tim*

## Beorn the Beserker

**F**our paintings remained to be completed. Three months were left to finish, and everything was going smoothly. At least I thought so.

Then one day, from the safety of my sanctuary, I heard my dad and my uncle arguing. I looked down on the confusion below. To my amazement, I saw Uncle Tim holding the painting of Beorn the Berserker high above his head. What happened next, I will never forget.

My uncle was screaming about the two light sources he had chosen not working together. Then he threw the painting as hard as he could across the studio. It smashed against the wall. When it hit, the corner of the board caught just right and the board split right down the middle. The hard wood didn't separate into two pieces, but I knew it was ruined.

I was trapped. There was only one way out of my loft and it meant having to pass by my dad and uncle. This was not a good idea.

They looked at the shattered board and froze. In the heat of the moment, my uncle had lost his temper and my dad had let him. But when they realized that the painting was ruined, they went into shock. They knew that they would have to start all over with a new board and that they had wasted precious painting time.

I saw my chance to escape. I snuck down the ladder and, quiet as a mouse, ran down the stairs.

When the painting was finally complete, Beorn the Berserker stood smiling. He wore an old tunic and, in one hand, he held an oversized, beaten axe. Two of my sister's plastic horses had made it into the background. The scene looked peaceful and serene.

But I knew the truth. Beorn was actually laughing at my dad and uncle. Laughing because he knew that it was really they who had gone berserk.

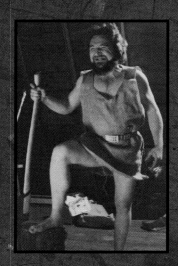

*"This was painted toward the end of the project. At the time, I was thinking more in terms of illustration than fine art. We joke about what the distinction is between the illustrator and the fine artist. We have come to the conclusion that the illustrator sits to paint, while the fine artist stands."-Greg*

*"I think this was our first and most effective use of multiple light sources in the calendars. The main light source is the sun directly behind and above the whole scene. Next is the light from the sun that hits the ground and is reflected back on Beorn. The final light source is the diffused cool light from the blue sky above filling in the entire scene."-Tim*

September 1978 Calendar, Ballantine Books

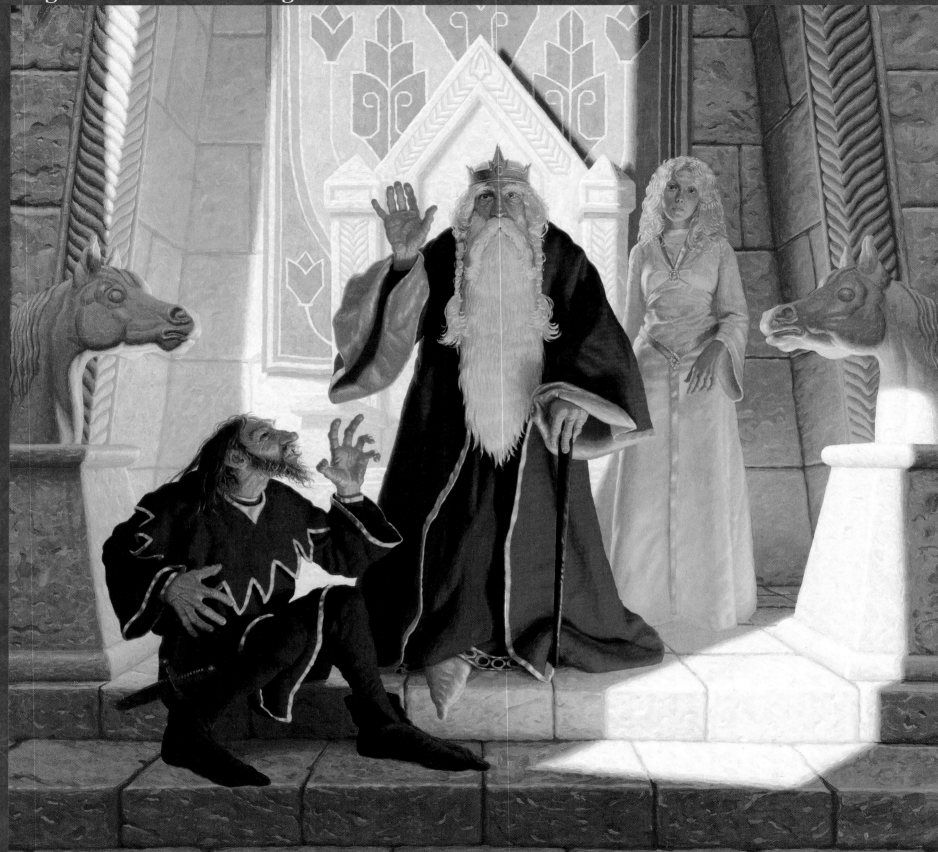

A light supper, a good night's sleep, and a fine morning, have sometimes made a hero of the same man who, by an indigestion, a restless night, and rainy morning, would have proved a coward.
— Lord Chesterfield, 1748

Heroes are born of circumstances. Saints, thieves, and beggars do what they must to survive. Thus, might not those we call evil have been formed by necessity?

King Théoden and Wormtongue—were they a Fellowship gone bad? After all, under the evil enchantment of Saruman, the king was only doing what he thought was best. At the realization of his own misdeeds, the king led six thousand troops to victory at Helm's Deep to save the besieged city of Gondor, at the cost of his own life. What is heroism if not the glorious triumph of the soul over the flesh, and courage over fear?

Gríma Wormtongue, one could argue, was also doing what he thought was best. In his case, he never atoned for his lying counsel to the king. Wormtongue lived in falsehood and was ultimately crushed by it.

This portrait of the two of them is stunning. You can almost feel the cool air blowing off the stone, a sensation created by the combination of bright light in the background and cool shadows in the foreground. It wasn't until much later that I learned the true story behind the image. It was about mistrust. Dishonor. Lies.

The year was 1985 and my dad had a show in the D. Christian James Gallery in Summit, New Jersey. At the opening, a man approached me. He was obviously a Hildebrandt fan, but more importantly he was a Tolkien fan. I was standing in front of this painting, *King Théoden and Wormtongue*, when he approached. He went into a detailed explanation of the relationship between Théoden and Wormtongue. He made his passion for Tolkien's world clear to me. Where I saw a painting, he saw reality.

I had heard people say that one man's fantasy is another man's reality. But I never understood what that meant before the art show.

It was the first time I realized the depths of passion in the fans of my dad and uncle's work. Art was their dream and their life for as long as they could remember. The road that a freelance illustrator chooses is an uncertain road. But they had no regrets.

They are my heroes.

*"This is an example of a strong reflected light. The characters are lit from a bounced light coming from high above and hitting the floor. We designed it this way to conform to the architecture of the Golden Hall of Rohan painted earlier. The building is a huge stone structure with tiny windows set high in the ceiling."-Greg*

## Shelob

I lay on the floor wrapped in old rags. Dad told me I was supposed to be trapped beneath the belly of Shelob, a giant spider who wanted to have me for dinner. This would be my last pose. What a way to end.

A model of Shelob, made out of wire, masking tape, and papier-mâché, sat on a small table in the studio. Her red marble eyes seemed to follow my every step. I was disgusted by her appearance, but fascinated at the same time. Although it was only a miniature sculpture, it looked real—and ugly.

Once more, they would take a model they had built and a small boy and turn them into a magnificent scene out of Tolkien's world. It never ceased to amaze me how they could transform anything they wanted to fit their vision.

As they painted, the vivid colors brought the scene to life. Shelob was taking shape. Beneath her, a small, lone figure lay sleeping, coiled tightly in her obscene cocoon. As the fearsome image of Shelob neared completion, so did the 1978 calendar.

My friend Joe met me in my loft. He wanted to see the finished painting. My father and uncle were out. Joe sat on the ladder, I sat several feet away on a pile of old books.

In mid-conversation, the ladder slid down the wall, its tip slamming against the top row of a bookcase. Joe bounced once and jumped off, unhurt. I leaped to his side. I looked up in startled silence. Shelob had been squashed beneath the twisted and mangled metal frame of the ladder.

In one swift blow, Joe had destroyed the mighty creature. Like Sam Gamgee in this classic scene, Joe had defeated the dreadful spider.

Shelob was dead. Long live the Fellowship!

*"This is the only existing photo of the model we made for Shelob. It was very crude, with coat-hanger wire for legs and marbles for eyes."-Greg*

November 1978 Calendar, Ballantine Books

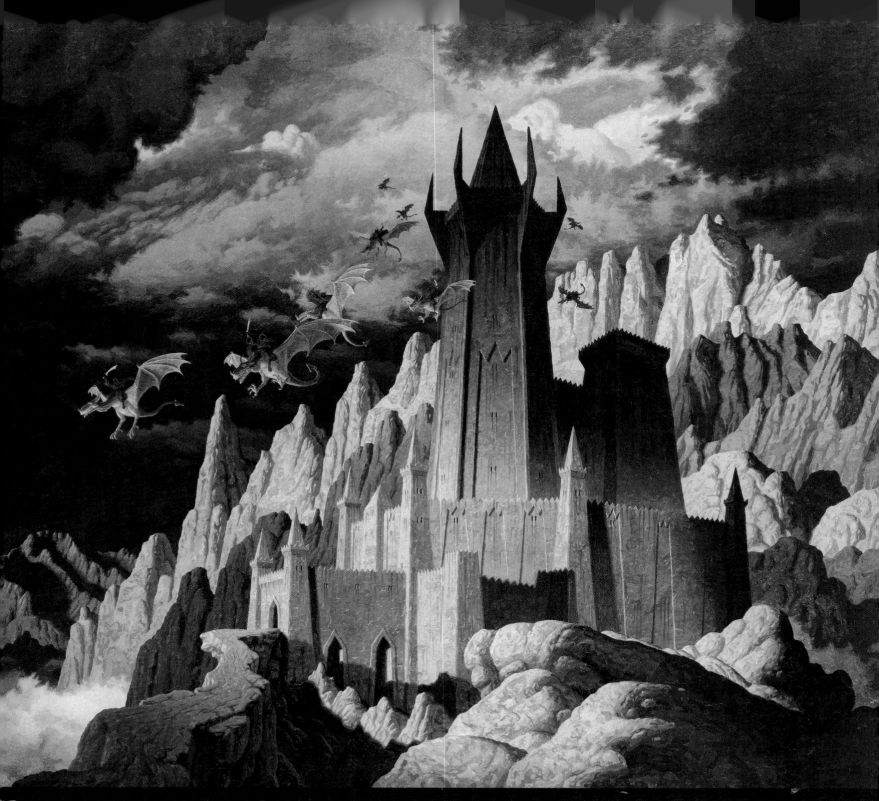

"This tower is totally my invention. Tolkien did not describe this scene. I remember struggling on this design. I knew at it had to look medieval and I wanted it to look sinister, too. I made it look like there were claws on the tower. I had

Andy, Joe, Tom, and I gathered together one last time to watch my dad and uncle complete the final painting in their calendar.

We watched as they painted the foreboding image of *The Dark Tower*. It was void of any friends or familiar places. The dark tower of Barad-dûr, the dwelling place of Sauron, could not be destroyed while the One Ring survived. Once the Ring was unmade, its ancient walls would crumble to the ground.

Tolkien's dark tower may have crumbled in his book, but my dad and uncle's painting is timeless. It will remain forever in the hearts and minds of their fans as an outstanding example of their vision of Middle-earth, along with their other calendar paintings.

*The Dark Tower* represented the end of a long, fruitful journey for the Brothers Hildebrandt. It was time to leave the land of the hobbits for new adventures, new characters, and new worlds.

With appreciation for their past projects and anticipation of projects not yet begun, the Hildebrandts walked away from the world of Middle-earth.

But they never shut the door behind them.

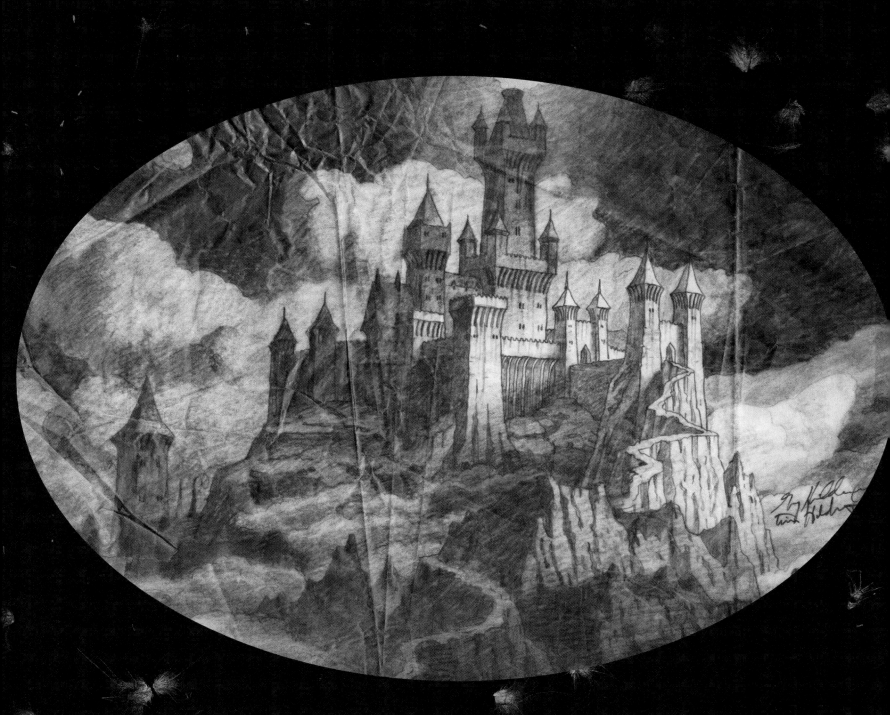

# Concept Sketches

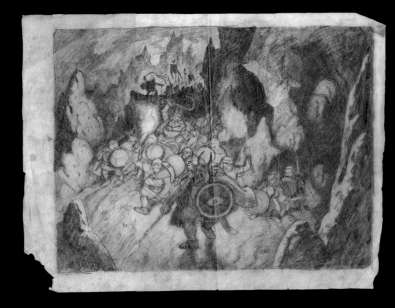

During the three years of the creation of the Hildebrandt's Tolkien calendars they drew many variations for each of the images. For the most part, those sketches were either damaged beyond repair or destroyed on the floor of their studio.

In the seventies, Greg and Tim focused only on the final painting. Everything that came before was only a means to an end. Very few of these sketches remain today, thirty-six years later. Most of them are wrinkled, torn and some even have Greg and Tim's coffee stains on them.

The sketches that you see in this book are all that survived from literally hundreds of pieces of art, having been saved thirty-three years ago by chance.

Road to Minas Tirith, *1975*

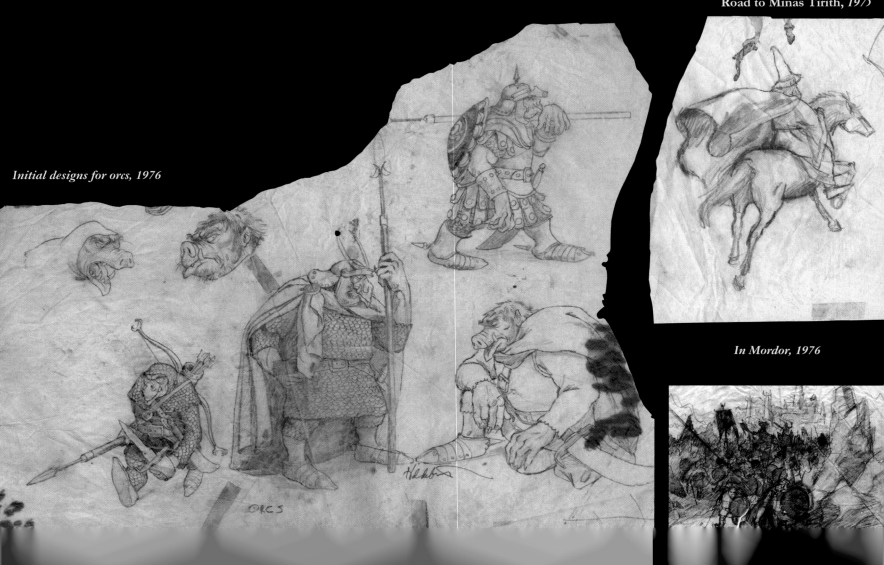

*Initial designs for orcs, 1976*

ORCS

*In Mordor, 1976*

Each sketch represents an integral part of one of the great periods in Greg and Tim Hildebrandt's careers.

Each of these is a treasure, because the initial artist concepts are the heart of the art. It is here that every possible decision has to be made: What is the correct composition? What should the light source be to create the desired mood? Where should the horizon line be in order to create the visual drama in the scene? Should it be a close-up, medium, or long shot?

These are but a few of the decisions that Greg and Tim Hildebrandt made on every piece of art they created.

Each decision they made was a learning process. Each time the decision they make was wrong it was a greater lesson. For over forty-four years, Greg and Tim constantly tried to reach out past what they already knew. For them, art was the continous, never-ending story of their lives.

This is what made their Tolkien art great. They had the ability to bring to life our fantasies and dreams. Their art is a pathway through the written word. We step into their world and it becomes ours.

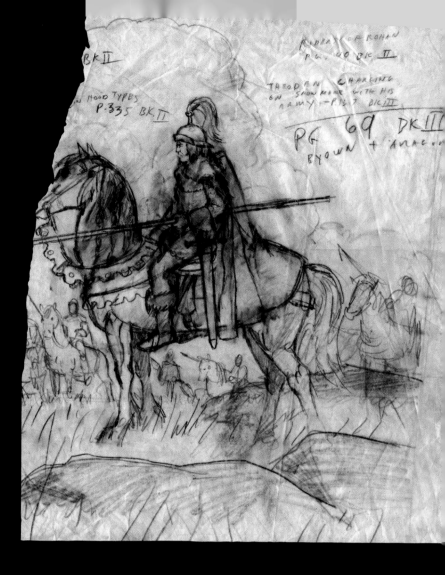

*First sketch of Strider and Frodo, 1974*

"Sometimes I have the feeling I failed on a project. That's just part of the process of creating art. Thomas Hart Benton said that there is no such thing as failure for an artist. The only time an artist fails is if he stops working. Ultimately, it's all about the process. It's about the journey and exploration. It's facing the blank piece of paper and transforming your fear into excitement. The point is not to let the fear make you stop or quit. There is a quote I love that is hanging on my studio wall by Miles Davis- 'Don't fear mistakes— there are none.'"—Greg

Ballantine Books allowed us to choose the scenes for each of the three calendars. First, we made a list of possibilities and developed each one with thumbnail sketches. This large sketch of the Crossing of the Ford of Bruinen is a good example of this initial phase. These small sketches helped us pin down a scene. For the fourteen calendar pieces, final decisions were based on achieving a contrast and balance of the following: interiors and exteriors, light and dark, good and evil, medium and long shots, and cool or warm light. Our final choices were also based on how long a painting would take."-Greg

*One page of many of the initial concept sketches for the* Crossing of the Ford of Bruinen, *1977*

"What we paint is representational. The subject matter you choose becomes a part of your style. Tolkien's *Lord of the Rings* was so realistically written that we had to paint it that way. We tried to make fantasy real."
—Tim

Seige of Minas Tirith *troll concept sketch, 1977*

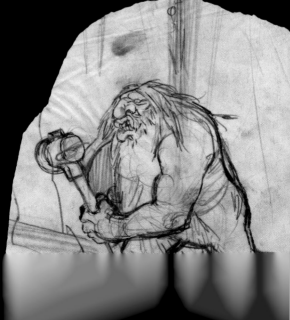

Greg and Tim both do their own takes on each scene in the rough sketch phase. Then they combine what they like from each other's versions for the finished rough. Once they tranfer the finished sketch to the board, they each take turns working on the painting. Many of the Tolkien pieces were large enough so they could sit next to each other and paint at the same time. Too see this live is magical. They can actually switch seats back and forth and pick up where the other one

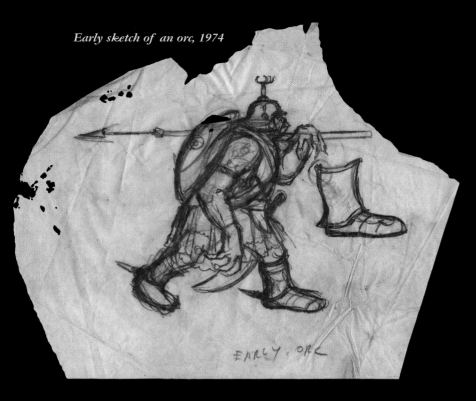

*Early sketch of an orc, 1974*

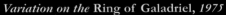

*Variation on the* Ring of Galadriel, *1975*

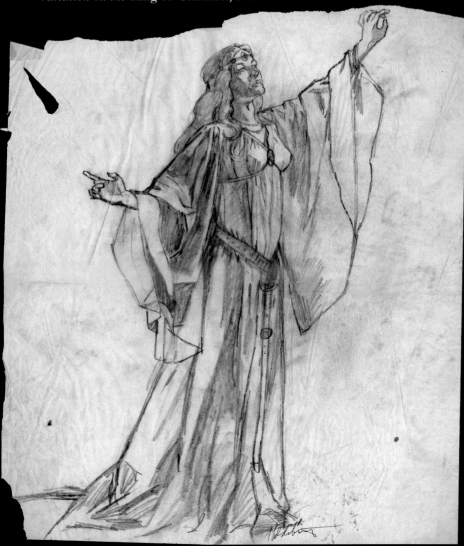

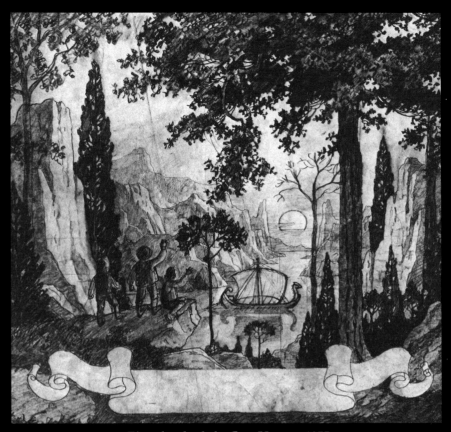

*First sketch of the Grey Havens, 1977*

"In the first calendar the paintings are simpler and have less detail. With the second and third calendars, we had twice the amount of time. The pictures got bigger and more detailed. Each calendar has a different style. If you have five minutes to do a drawing, you approach it differently than if you have twenty-five minutes." —Greg

113

# The Fourth Calendar and Beyond

With the end of the third calendar, the one that would eventually make a permanent mark on the world of fantasy, Greg and Tim Hildebrandt began to sketch images for their next Tolkien calendar. Unfortunately, it was not meant to be.

For several months, Greg and Tim worked on the initial concept sketches, poses and layouts for the next fourteen paintings. They worked on these ideas fully intending to paint them. Many of them went as far as the final sketch, and one was even painted as a preliminary color study.

But, at the same time, they had undertaken a personal quest to discover a new world of their own in the realm of fantasy. It was on this journey that they came across their land of Urshurak, a land that Greg and Tim created with friend Jerry Nichols. *Urshurak*, their first fully self-generated illustrated fantasy novel was published by Bantam in 1979.

The pull to create this world was too great for them to ignore. And so, they called Ian Summers and Judy-Lynn and Lester del Rey and gracefully ended their journey that had begun in 1975.

Needless to say, the Del Rey's were not happy about their decision. But being two of the great literary giants in science fiction and fantasy, they understood.

These next twelve pages are all that is left of what would have been the *1979 J.R.R. Tolkien Calendar*, illustrated by the Brothers Hildebrandt.

*A car tire makes the perfect throne, 1978*

*Cover concept of Sauron in Mordor, 1978*

*Celeborn and Galadriel, 1978*

"THE WHITE HAND"

"The decision not to go on to a fourth calendar was a struggle. We had the contract in hand and, given the success of the other calendars, we knew it was a sure thing. We had to decide whether or not to stay with the sure thing or take a giant risk on the unknown." —Greg

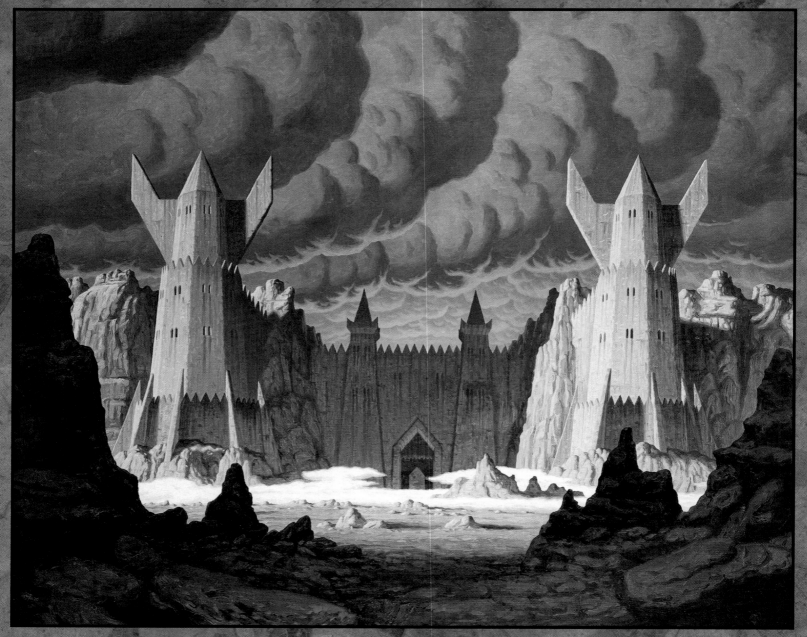

This color study of the gates of Mordor is a very unusual piece of Hildebrandt
history since Greg and Tim almost never do this interim step.

# *The Fall of Mordor, 1978*

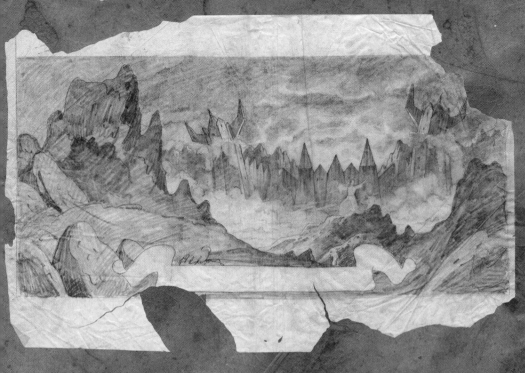

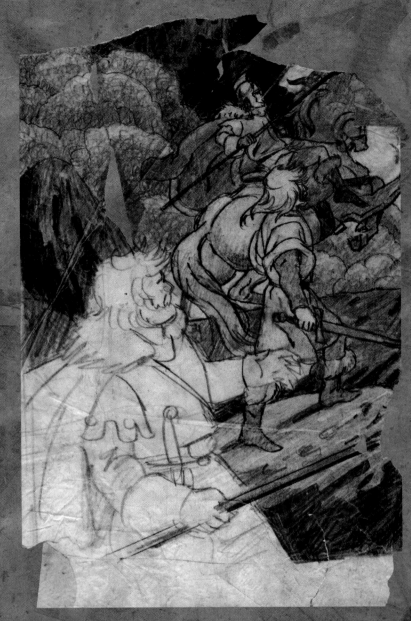

*"This was the first centerfold possibility for the fourth calendar. Once we took a look and realized that all the figures were seen from the back, we changed our minds."* —Greg

As you can see, there were many variations on this idea. Greg and Tim tried long shots and medium shots for this scene. In the end, they never did paint the gates of Mordor.

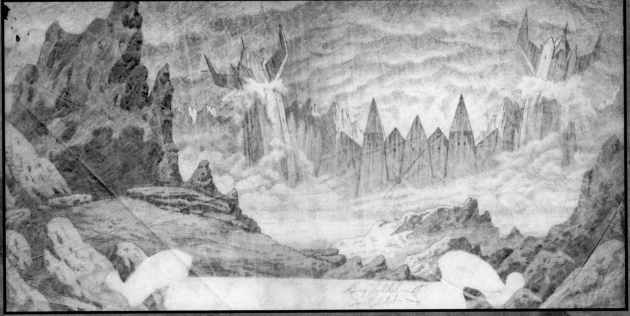

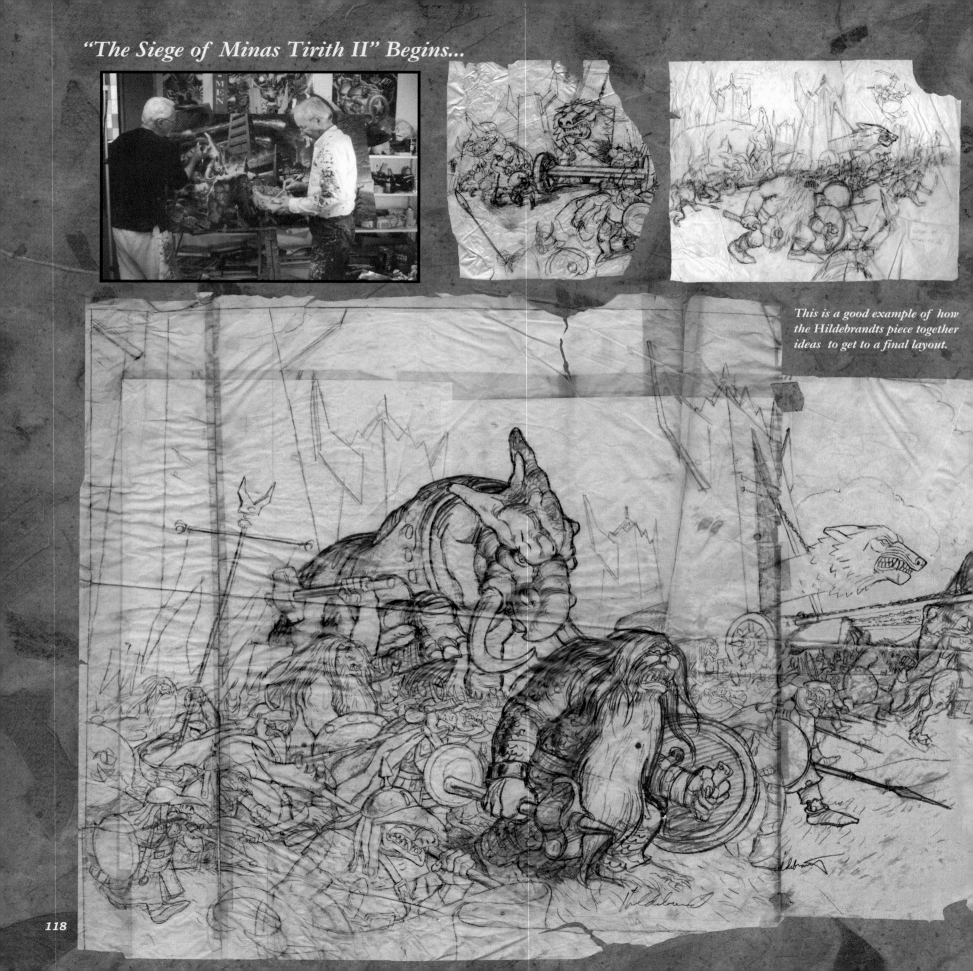

*This is a good example of how the Hildebrandts piece together ideas to get to a final layout.*

*Greg puts the final touches on the troll's face.*

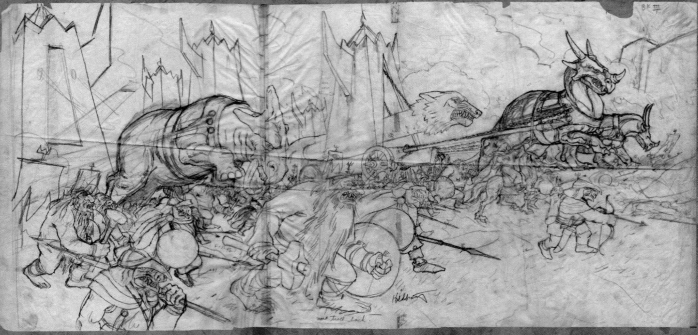

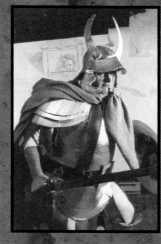

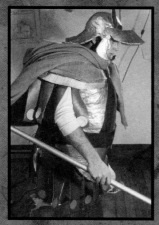

This painting of the *Siege of Minas Tirith II* was originally designed in 1978, but painted in the year 2000. Many of the old posing photos were too damaged to use, so Greg and Tim reshot the poses. Friend and artist, Mark Romanoski, posed for the troll and black rider, while Tim Hildebrandt dies valiantly below as a soldier.

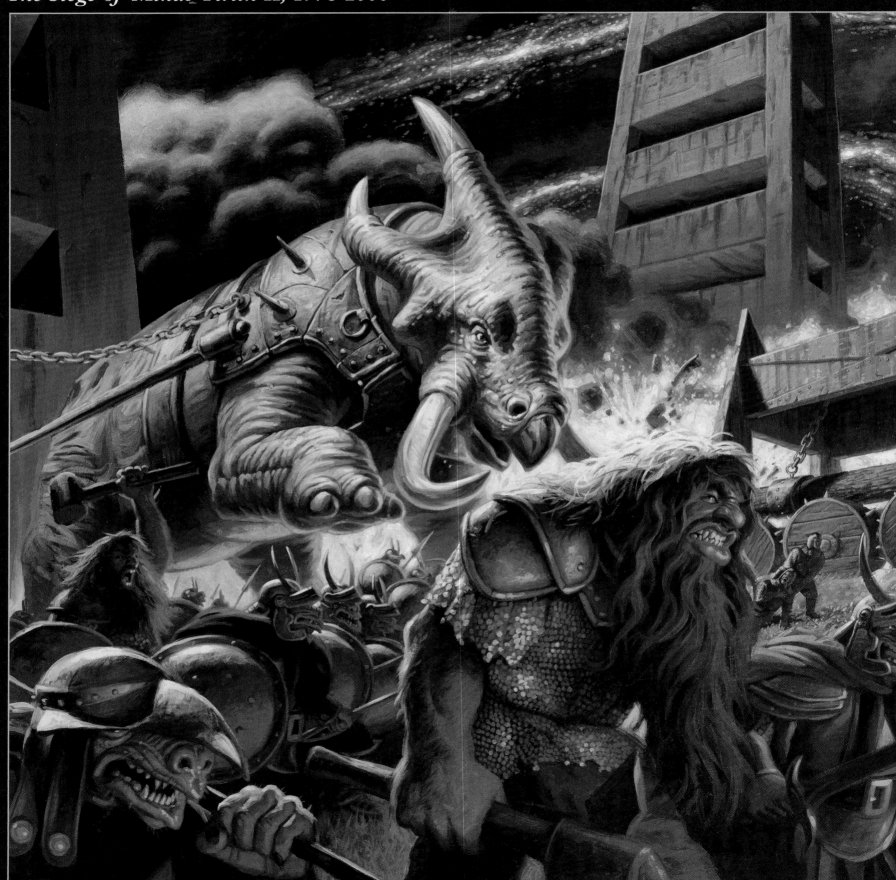

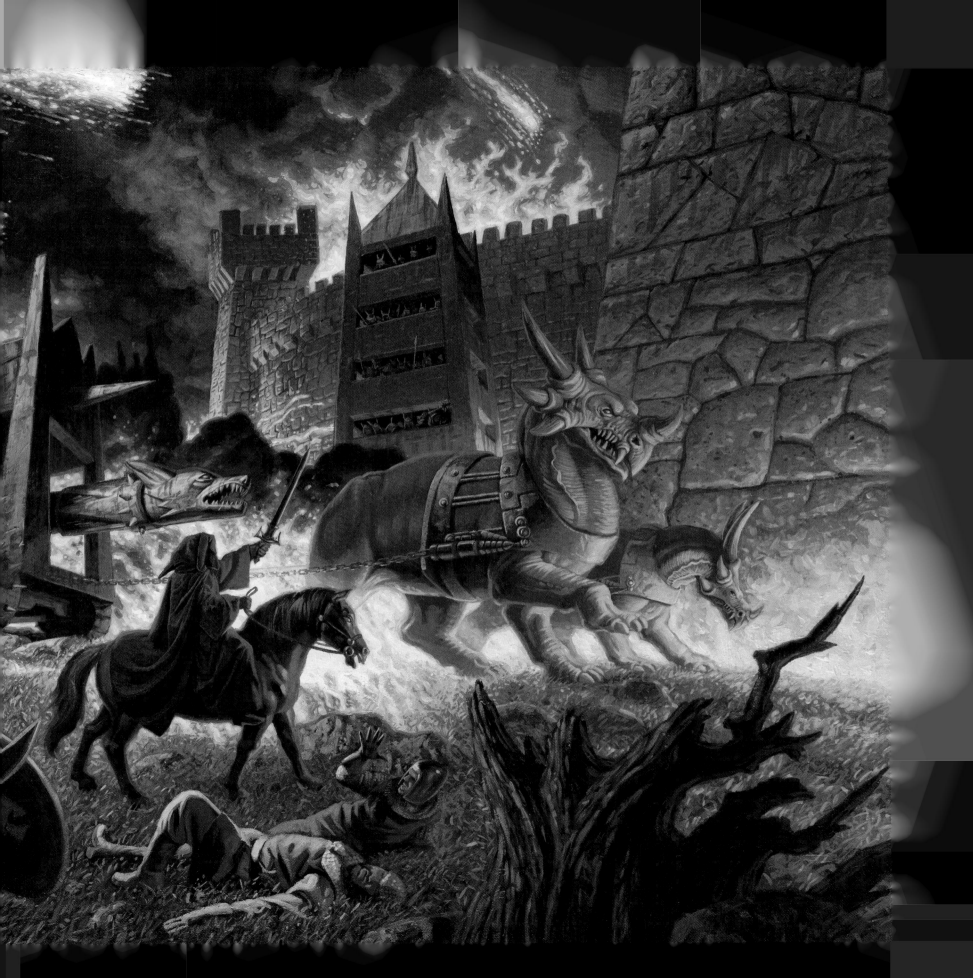

# "Journey in the Dark" Begins...

*"Journey in the Dark is based on old photos that we had taken in 1978. The first sketch and photos were damaged beyond repair. We took these new shots based on the original sketch. This scene had wolves attacking. We eliminated them for the sake of the composition."-Greg*

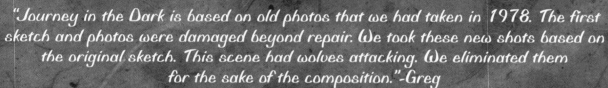

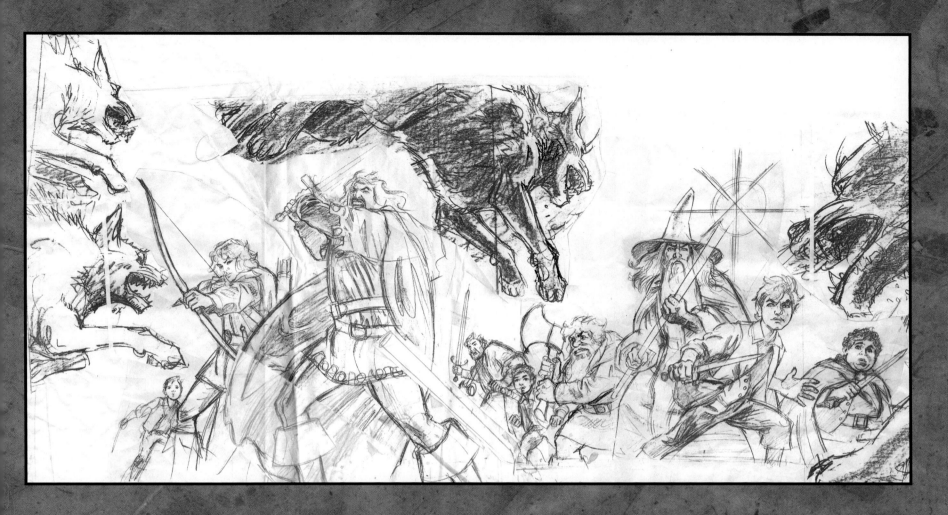

To capture this scene, Greg and Tim used their artist friends Alex Horley, Bob Petillo, and Mark Romanoski—and once more, of course, Gregory posed for the hobbits.

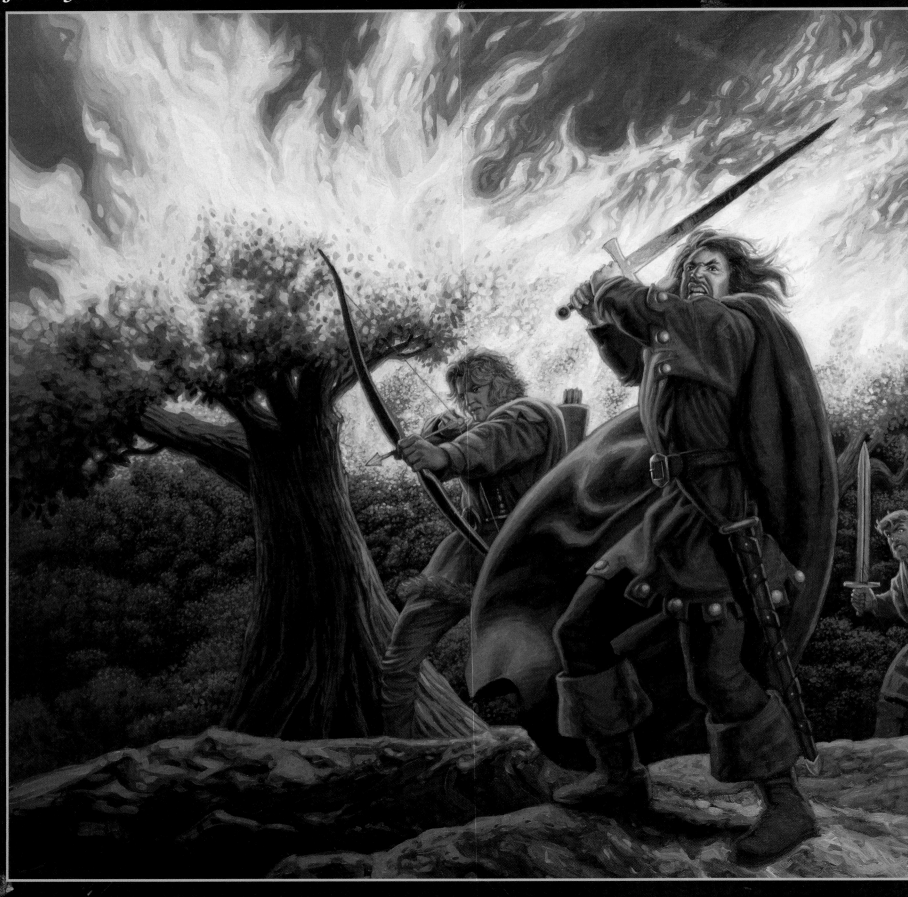

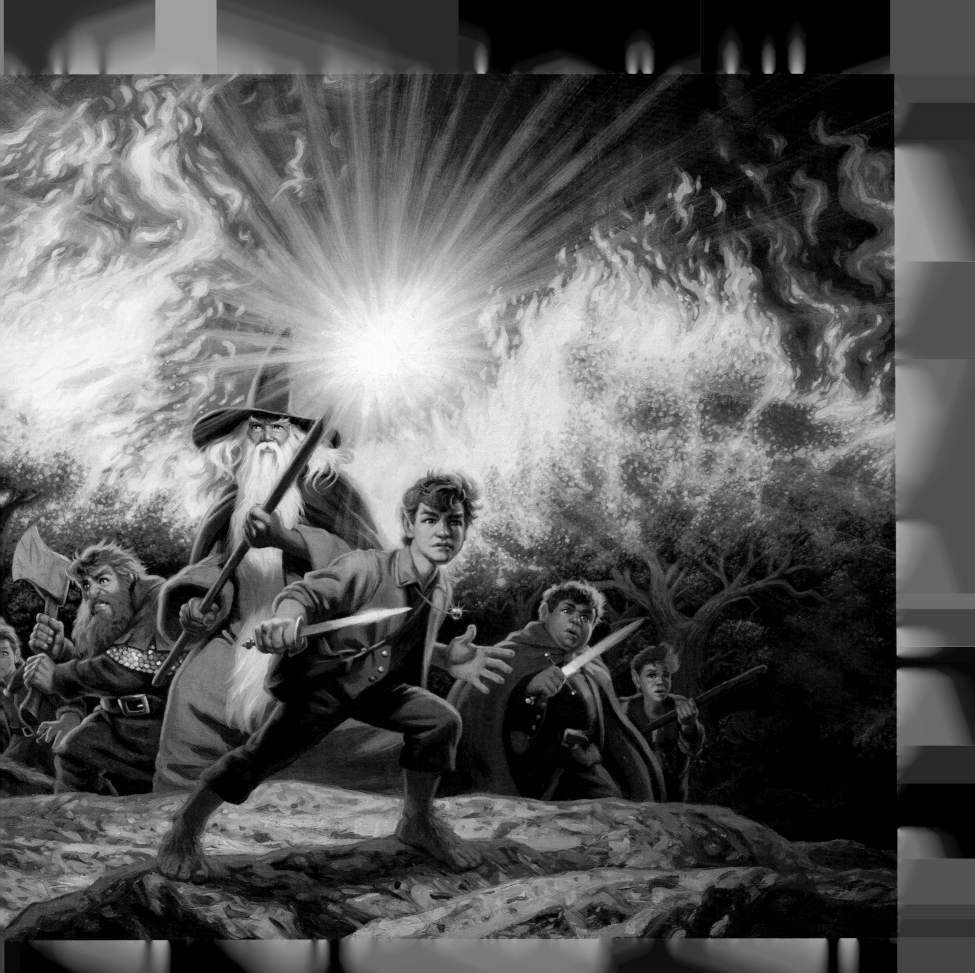

# Commissioned Artwork

I n the thirty-four years since the last Ballantine Tolkien calendar by the Brothers Hildebrandt was published, Greg and Tim were approached many times by licensees of the Tolkien estate and private collectors to create new *Lord of the Rings* art. The next ten pages represent most of their Tolkien commissions.

Whether it was a licensee or a private collector who requested Greg and Tim to return to Tolkien's Middle-earth, their enthusiasm for each new journey was as vibrant as the first day they walked into Ian Summers' office at Ballantine Books in 1975.

*In 1991 Greg painted these new versions of the* Ring of Galadriel *and the* Gift of Galadriel *for private collectors. By the time the paintings were completed he had become extremely good friends with these collectors who share a love of fantasy, nature, and art.*

## *Ring of Galadriel*

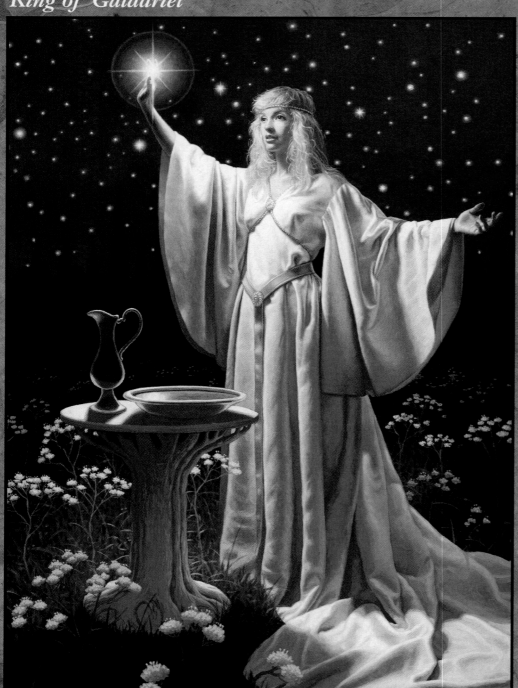

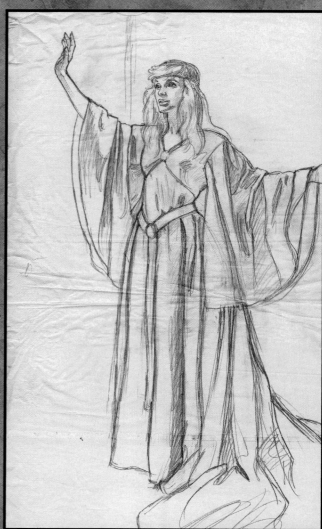

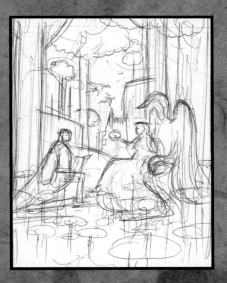

"When Terry and Dale, collectors of my art, came to me to paint these pieces, I saw it as a challenge. I never want to copy myself, so I had to create the same scenes I had painted before with my brother in a new way. I decided to use a vertical format instead of square and go with a completely different color of light. In the end, Terry and Dale were very happy, which made me happy." —Greg

## Gift of Galadriel

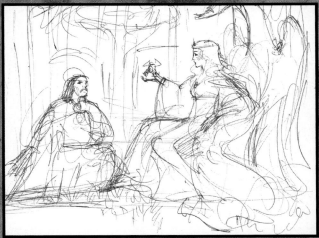

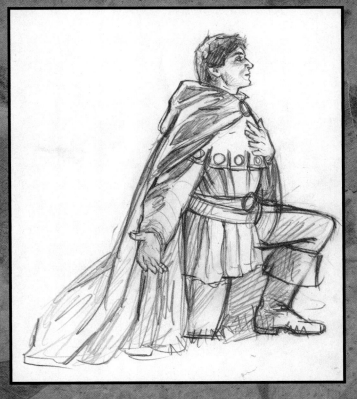

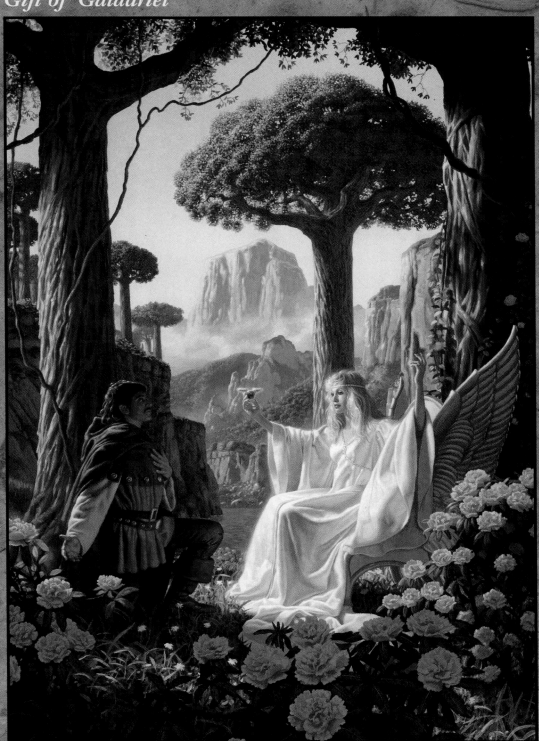

Over the years, Greg designed a number of collectibles for the Franklin Mint. To the right is his version of the Gift of Galadriel, which was painted for a lithograph. At the bottom left are two roughs for chess pieces of Galadriel and Gandalf, and at the bottom right are the final sketch and the front and back color designs for his Galadriel doll.

*Initial concept sketches for the King and Queen chess set pieces.*

*Concept sketch and watercolor designs for Galadriel Doll.*

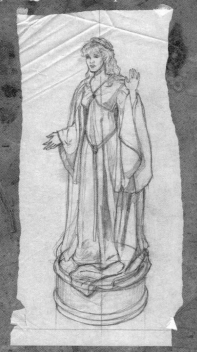

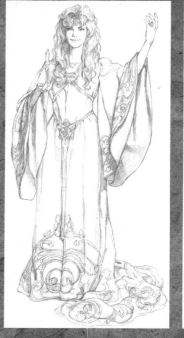

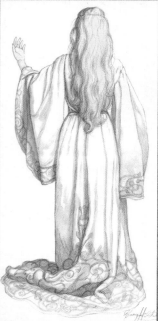

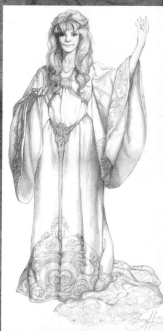

## Arwen Joins the Quest

In 1999 Greg and Tim ceated this cover for Inquest Magazine. Inquest was doing a piece on the new Lord of the Rings movie coming in fall 2001 and wanted Tolkien art for their cover. The only problem was that Inquest had no reference from the movie to give to Greg and Tim. So they gave them photos of the actors who were playing the characters in the film and told them to paint the rest of the art as they had on the calendars in the '70s.

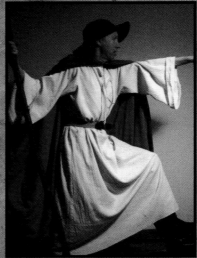

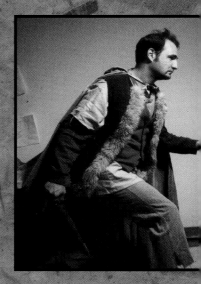

This finished drawing was created in January 2001. It was commissioned by a private collector. Greg and Tim chose to use white and gray pencils on colored paper to create this piece. This technique gives a completely different look to the art.

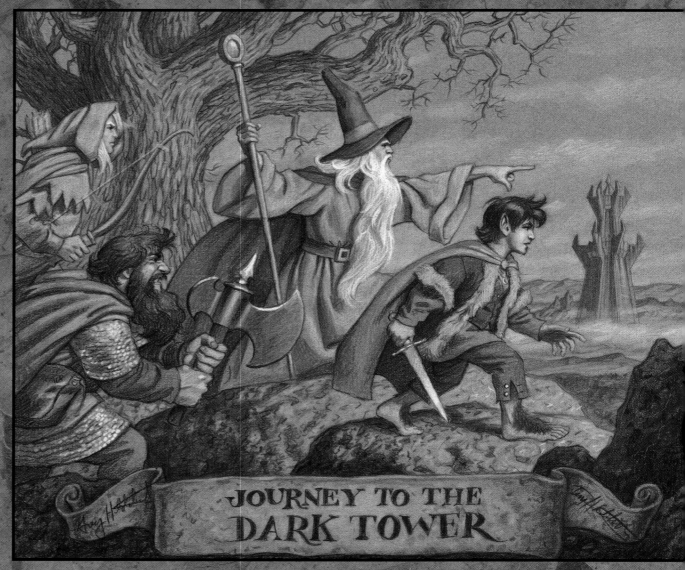

JOURNEY TO THE DARK TOWER

This painting was finished on February 7, 2001. It was commissioned by a private collector in New York. It was painted very large so it would be very impressive hanging over the fireplace. A fireplace which we believe resembles the one in the painting.

## The One Ring

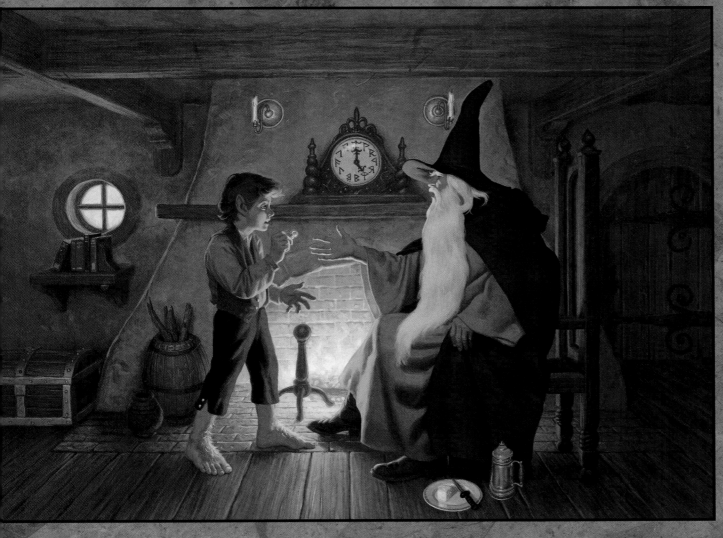

As long as there are Tolkien fans, Greg and Tim will continue to create their magic for all to enjoy.

When you come face-to-face with an original Hildebrandt painting you are transformed. As with Alice and the Looking Glass, it feels as if you can step into their paintings, walk through the hills and valleys, speak with the characters in them. Their world of pure imagination and reality become one.

*"This scene occurs in a pitch black cave. We had to take liberties to make it visible, so we created a light source coming from an opening in the ceiling."* —Tim

Every Tolkien fan has their favorite scenes or characters. The next four pieces were private commissions done exclusively for collectors, representing their favorite scenes in The Hobbit and The Lord of the Rings.

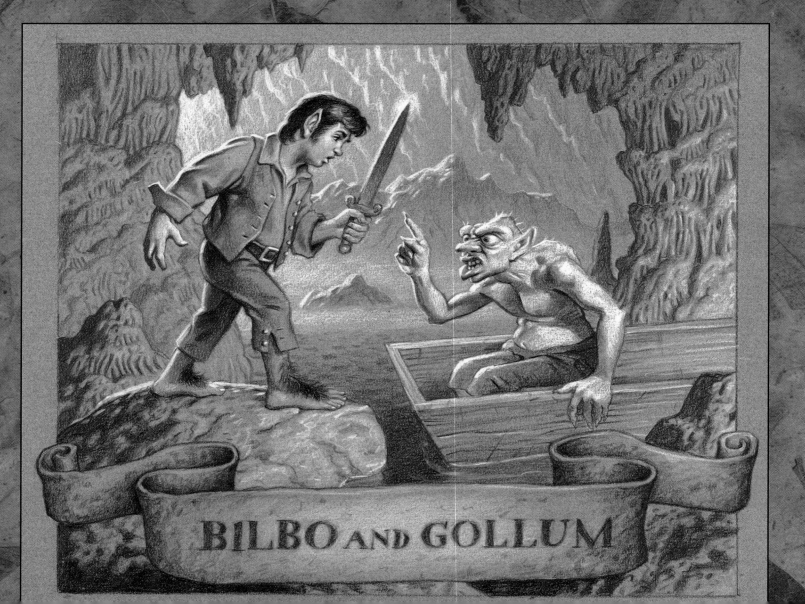

BILBO AND GOLLUM

"In this commissioned piece, we changed our original composition of the Balrog and added his sword. In the 1977 calendar painting, we took out the sword in order to have his open hand grasping for Gandalf. The original decision was made to achieve the look we wanted at the time." —Greg

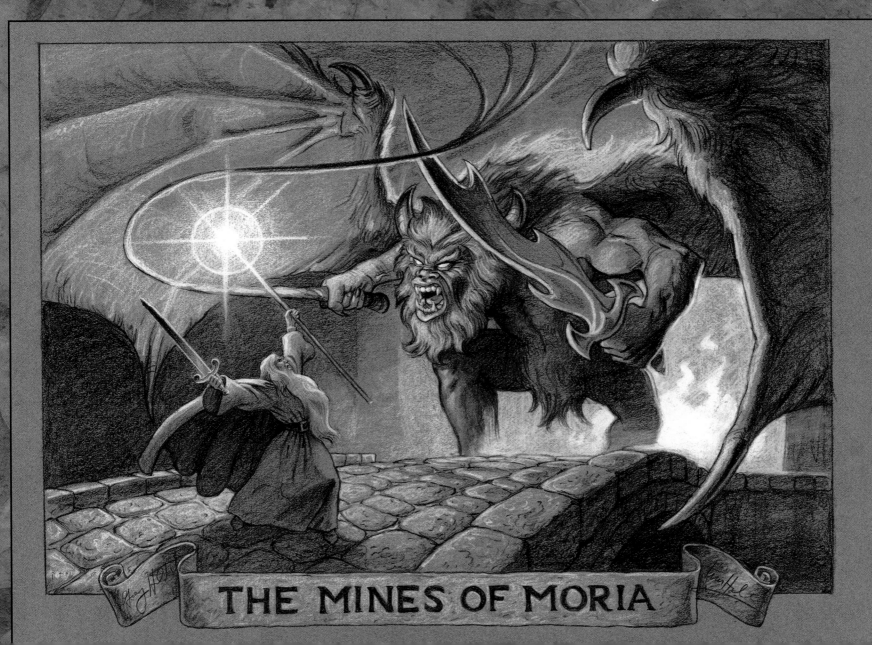

## THE MINES OF MORIA

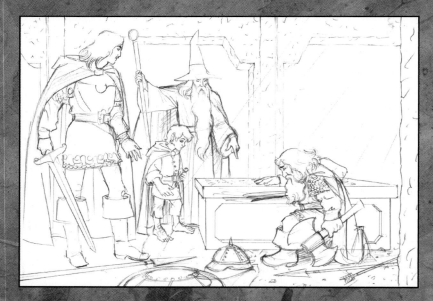

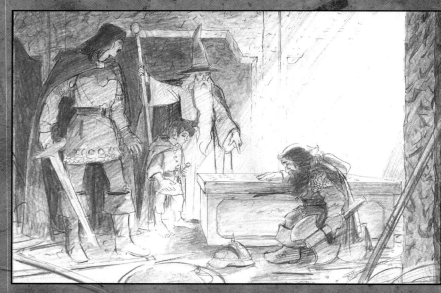

*Balin's Tomb*

"*A collector wanted a fully rendered sketch of Gimli, Gandalf, Frodo, and Strider together in a scene that included dramatic rays of light, so we chose this one in the Mines of Moria.*" —Tim

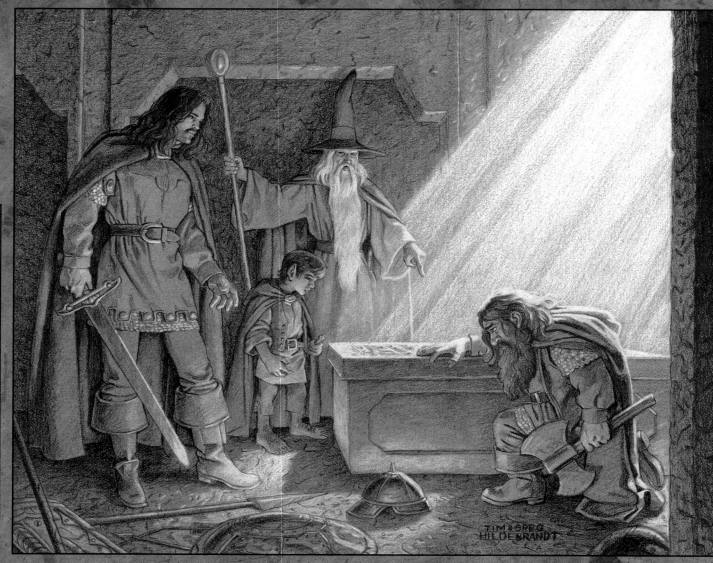

TIM & GREG
HILDEBRANDT

## The Hall of Fire

"We were approached by a husband and wife who wanted to be characters in a Lord of the Rings painting. They chose to pose as Arwen and Strider. This is what we call a true collector's fantasy. After they approved the rough sketch, they came to my house and I photographed them in costume. People really have fun and get into the characters' personalities when they pose for their own paintings." —Greg

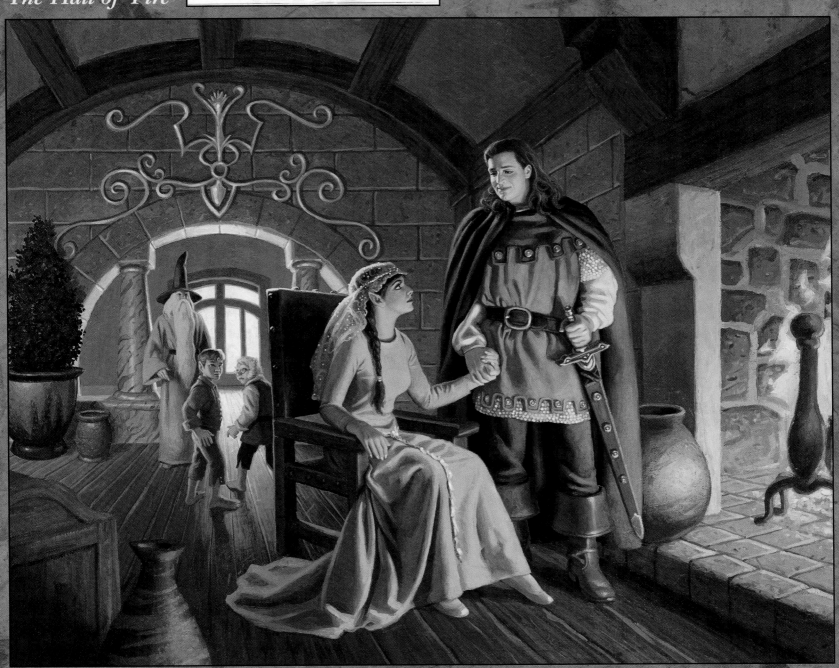

135

# Treasures in the Attic

**J**ust as Greg and Tim thought they had uncovered every single piece of Tolkien art from the past, they discovered a lost treasure. When Tim opened a box in his attic, he found these precious Tolkien pieces stuffed between lots of dusty children's book artwork. They are preliminary sketches-one of *Treebeard* for the 1976 calendar, and two designs that eventually led to the painting entitled *Beorn the Berserker* for the 1978 calendar.

*"Initially, I played with the idea of adding lots of branches and twigs to Treebeard. I was trying to give him a more tree-like feel. But in the end he became more beard than tree."—Tim*

*"These interior designs were done for Beorn's house. But since we had already painted a fireplace scene in Farmer Maggot's Hospitality, we opted for an exterior longshot of his lodge."—Greg*

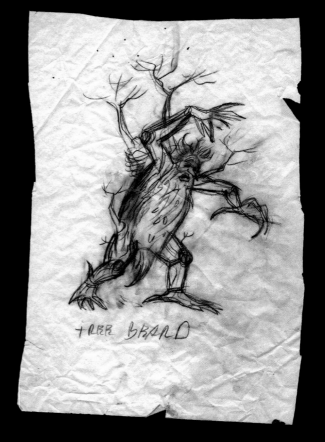

TREE BEARD

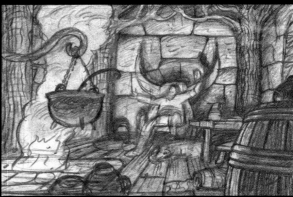

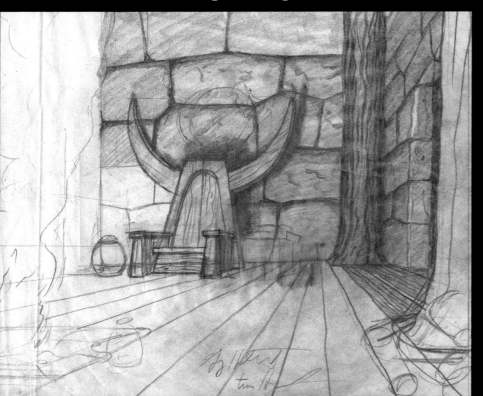

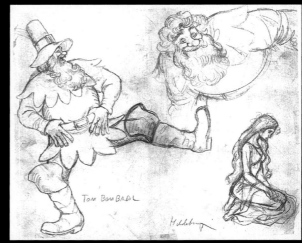

TOM BOMBADIL

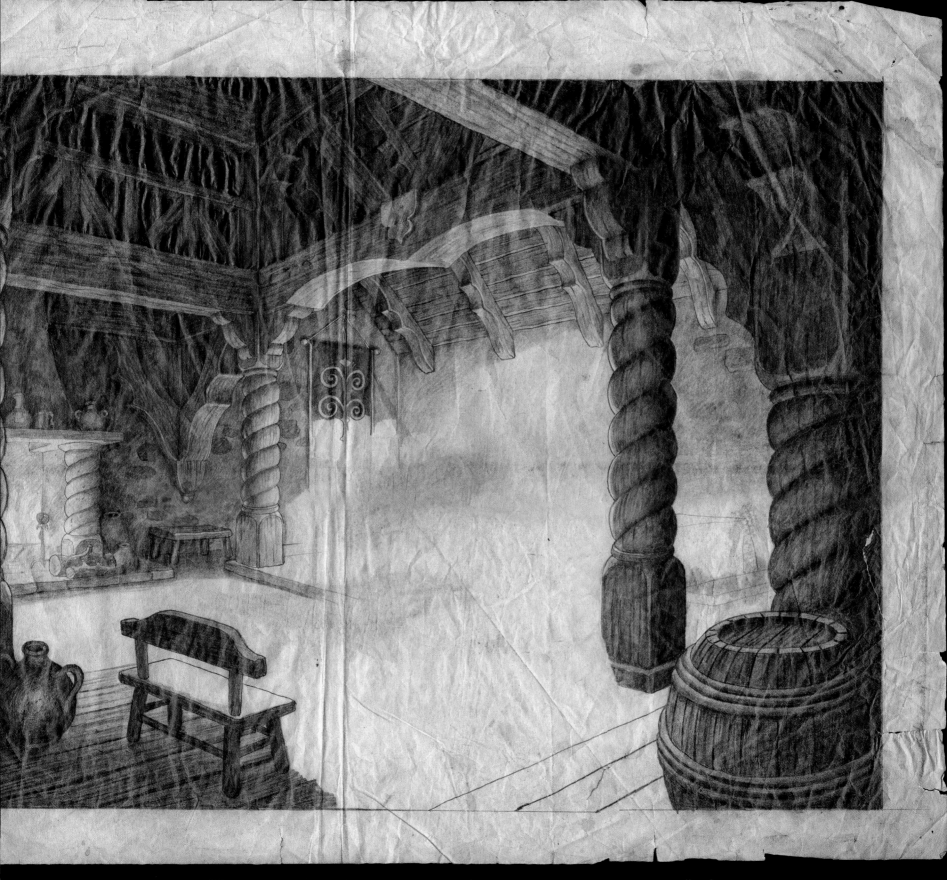

"We rendered all of our sketches with such detail in the seventies."—Greg

## The White Hand

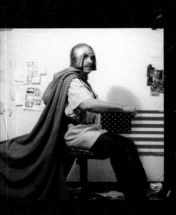

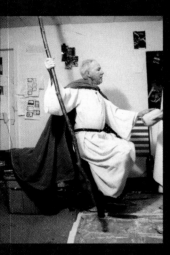

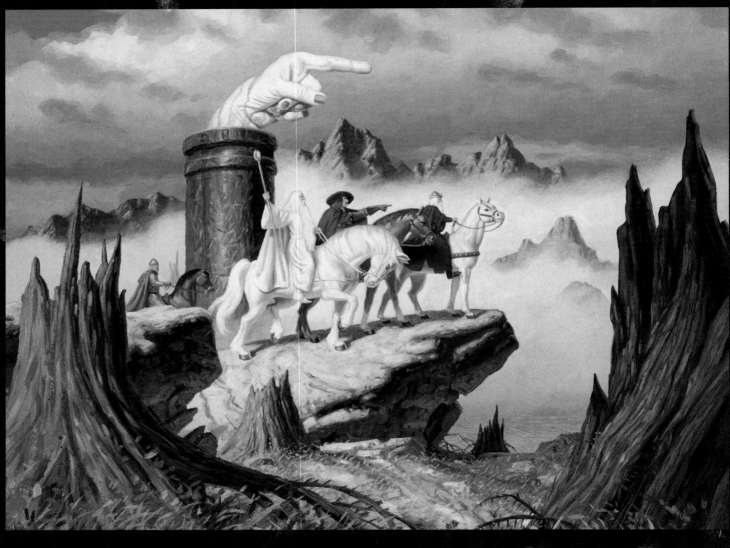

So, what did the Hildebrandt brothers do in their spare time? They painted of course. And what did they paint? Whatever was most important to them, because they almost never had spare time. And what was important to them was painting the sketches they originally designed for a **1979 Tolkien Calendar** that they never finished. These three Tolkien paintings were not for a new calendar they are simply for their love of art.

"When we finally painted this scene, I really enjoyed it. The fog and mist hanging over the landscape combine with the ravaged trees in the foreground to create a feeling of desolation. Unlike our original concept for lighting in 1978, Greg and I decided to use a direct frontal light in this piece. This allowed us to paint the hand a pure white, giving it a cold feeling."—Tim

"There is no question that the lighting setup in this painting was always a favorite of ours. The fire light and dark shadows create an ominous sense of terror. The hobbits cowering in this painting are actually my son, Gregory, at seven years old. He loved being a hobbit. All kids love to play act, and what better play can you perform in than *The Lord of the Rings.*" —Greg

**Deceiving the Orcs**

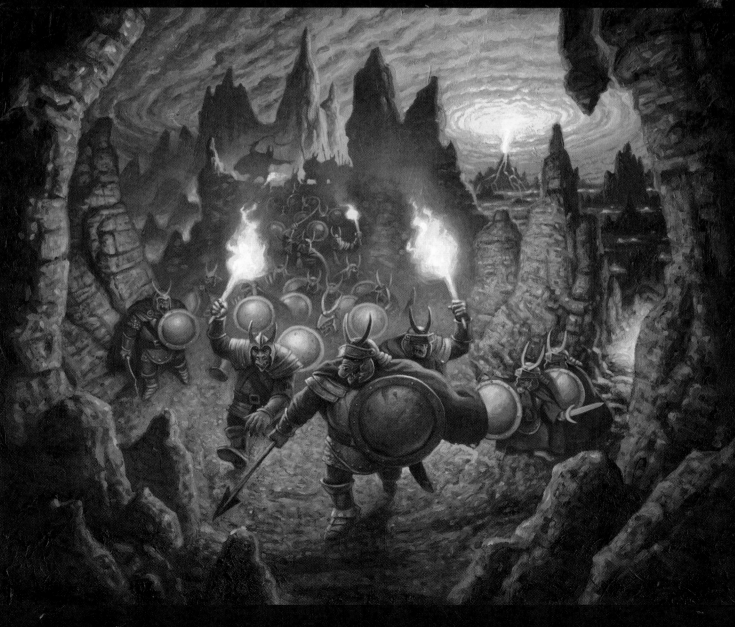

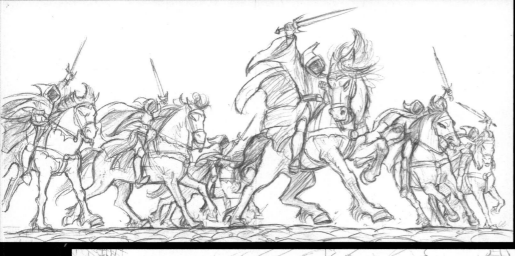

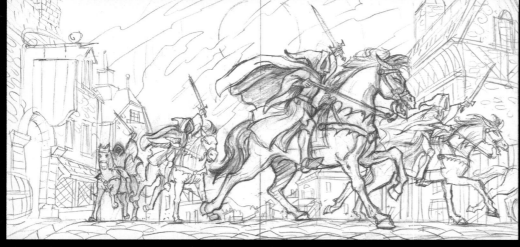

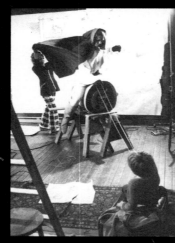

*"We really wanted to do this painting of the Black Riders. Our original sketches were destroyed and all we had to work with were the black-and-white photos we shot in 1978. Greg and I both remembered our original layout, so it was easy for us to reconstruct it. But we still had to shoot new photos to get the detail in the costumes, and the lighting for the scene."—Tim*

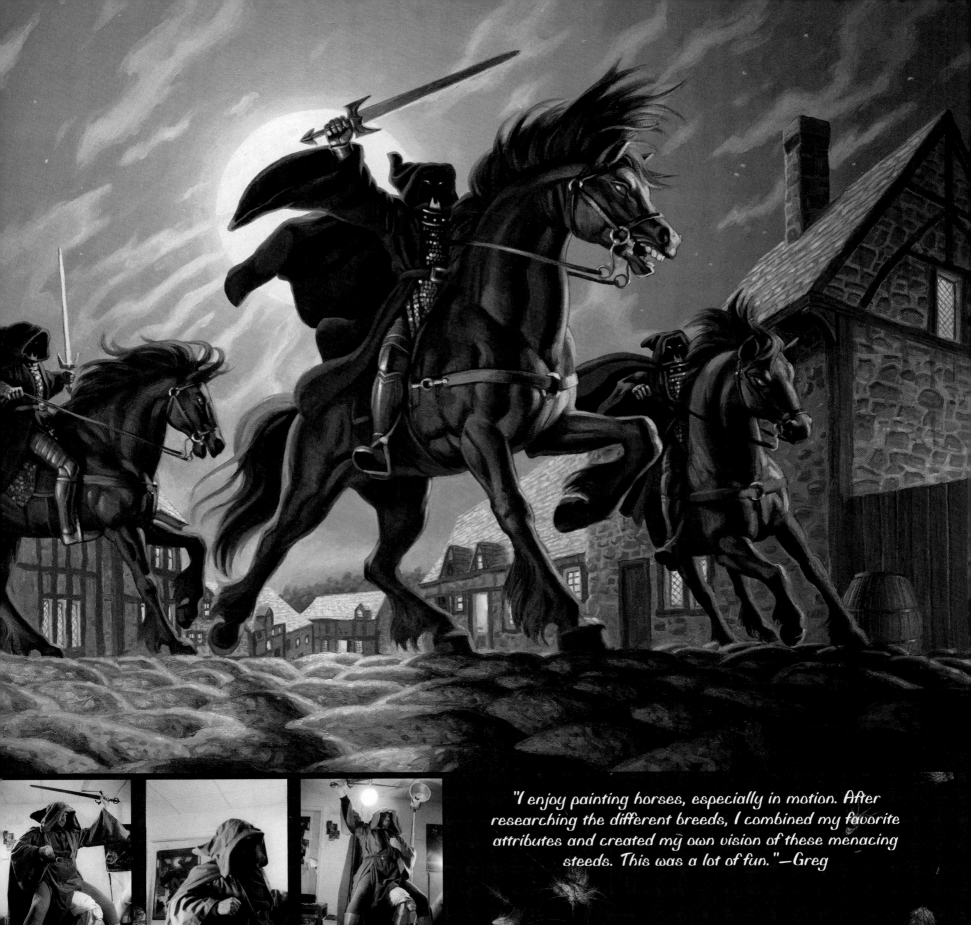

"I enjoy painting horses, especially in motion. After researching the different breeds, I combined my favorite attributes and created my own vision of these menacing steeds. This was a lot of fun." —Greg

# Miniature Paintings

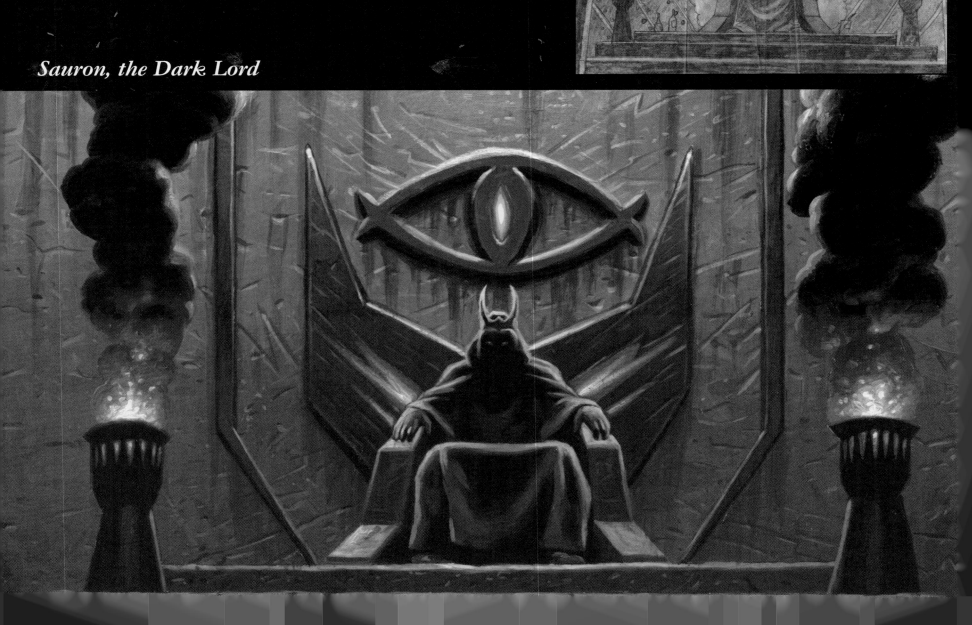

**G**reg and Tim did these paintings for a gallery show in Utah, called "Relatively Speaking" which featured miniature paintings. Each piece in the show was created by at least two artists that were blood relatives. They are much smaller than any of the original calendar paintings. *The Journey*, from a commissioned drawing, is 10 x 8 inches. *Sauron the Dark Lord*, from a sketch that was created for the 1979 calendar is 12 x 8 inches. Compared with the calendar paintings, which ranged from four to seven feet wide, these pieces are miniatures.

*Sauron, the Dark Lord*

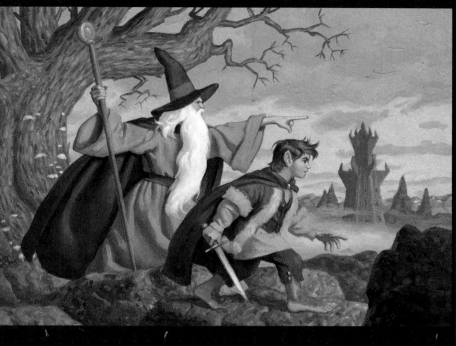

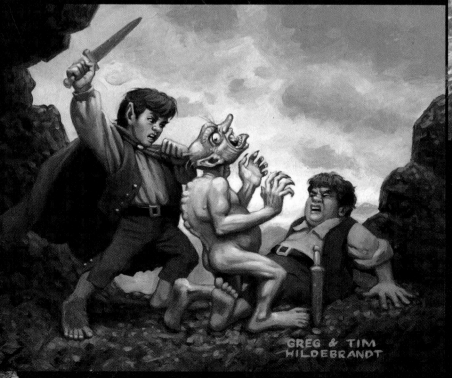

*"I liked the concept of an art show completely based on artists who are related to each other. It was a really unique idea."—Greg*

## Aragorn and Frodo

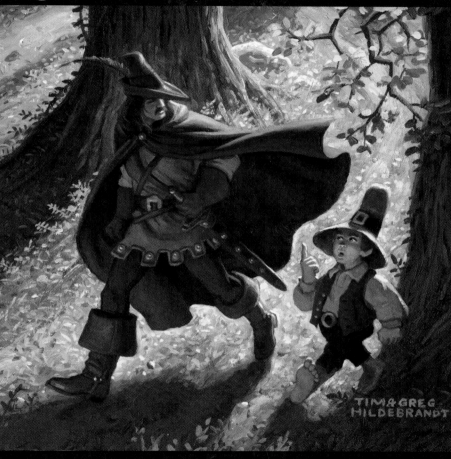

*"After the gallery show, we were once again asked to create new miniatures. The two pieces, on the left and above, were actually done from sketches that Tim and I did in the 1970s. Since the composition of each was very simple, they worked really well for the little paintings."—Greg*

**B**y now, most people know that Tim Hildebrandt passed away in 2006. It was a sad day and a great loss, not only to Tim and Greg's families, but to the world of art. As with life, art goes on. In 2010, Greg was asked by a collector to create an image of The Healing of Éowyn.

For the past seven years, Greg had been focusing mainly on his American Beauties pinup art, and his art for the Trans-Siberian Orchestra. He had done a number of pinup pieces on black board with Prismacolor pencils, which had a unique look and style. He suggested to the collector that the Éowyn piece be done that way. This is the result of that commission.

Greg likes creating black board pieces. He says he has to think in reverse while he is doing them. They are a challenge, and he loves the contrast.

## The Healing of Éowyn

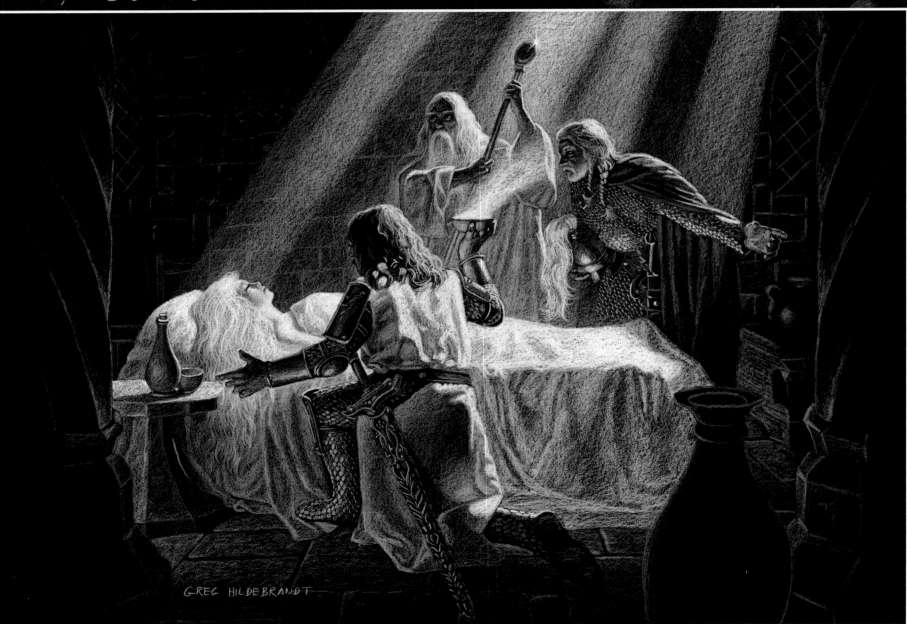

GREG HILDEBRANDT

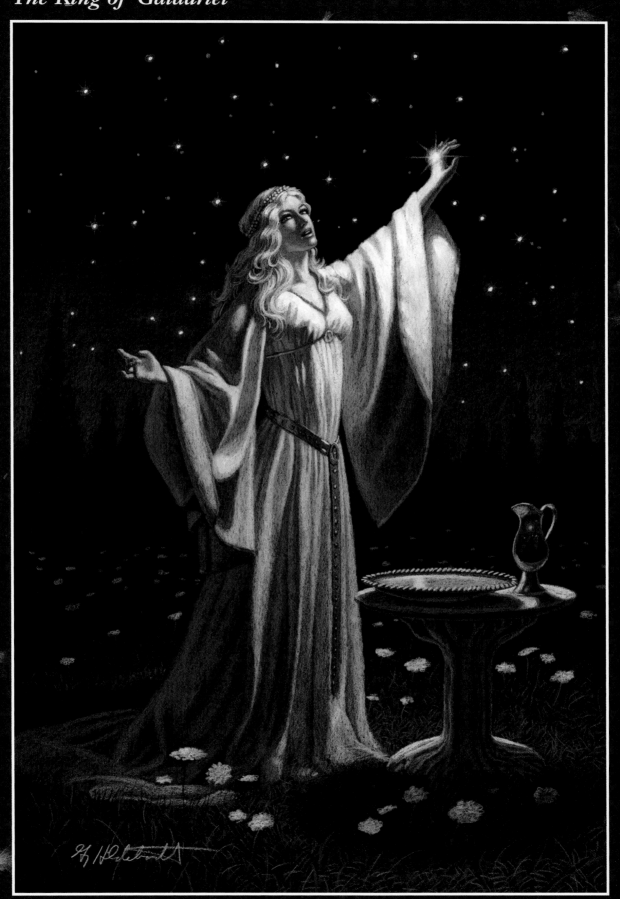

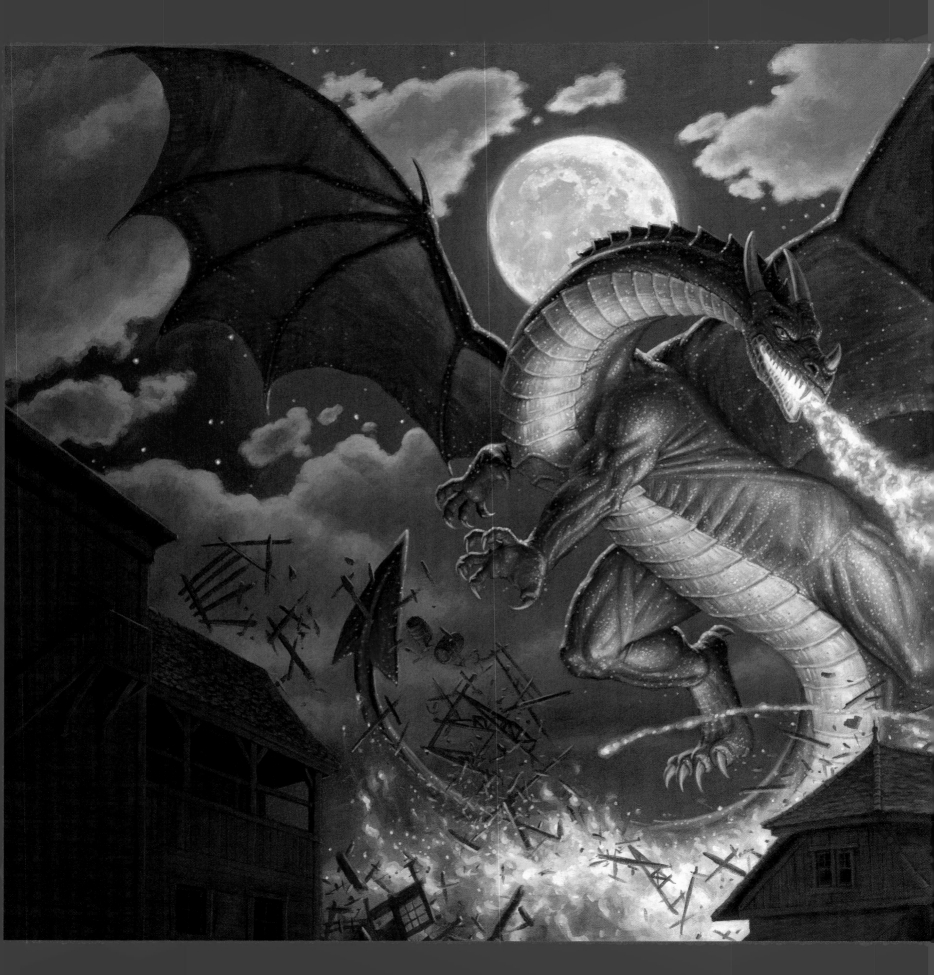

## Smaug Destroys Laketown

"In 2010, I had a booth at the Illuxcon Fantasy Art Show in Altoona, PA. I had never painted live at this show. I was trying to decide what I wanted to paint when Jean, my agent, suggested that I paint Smaug. I laughed and reminded her that I hadn't painted that dragon since 1976. Actually, I haven't painted very many dragons at all, so I went back to the books to pick a scene. Pretty much what I realized is that Smaug appears twice in The Hobbit; Once, sitting on the treasure, and once blowing up Laketown. Here he is, blowing up Laketown. Now, the real reason Jean requested that I do Smaug is because she's a dragon lady, born in the year of the dragon, and she just loves this dragon. It was my pleasure to paint it for her." —Greg

## The Black Riders

"The Black Riders were always sinister and cool. Everybody loves a villain, and certainly these are among some of the greatest villains ever created. The black board medium really lends itself to the dark side of art." —Greg

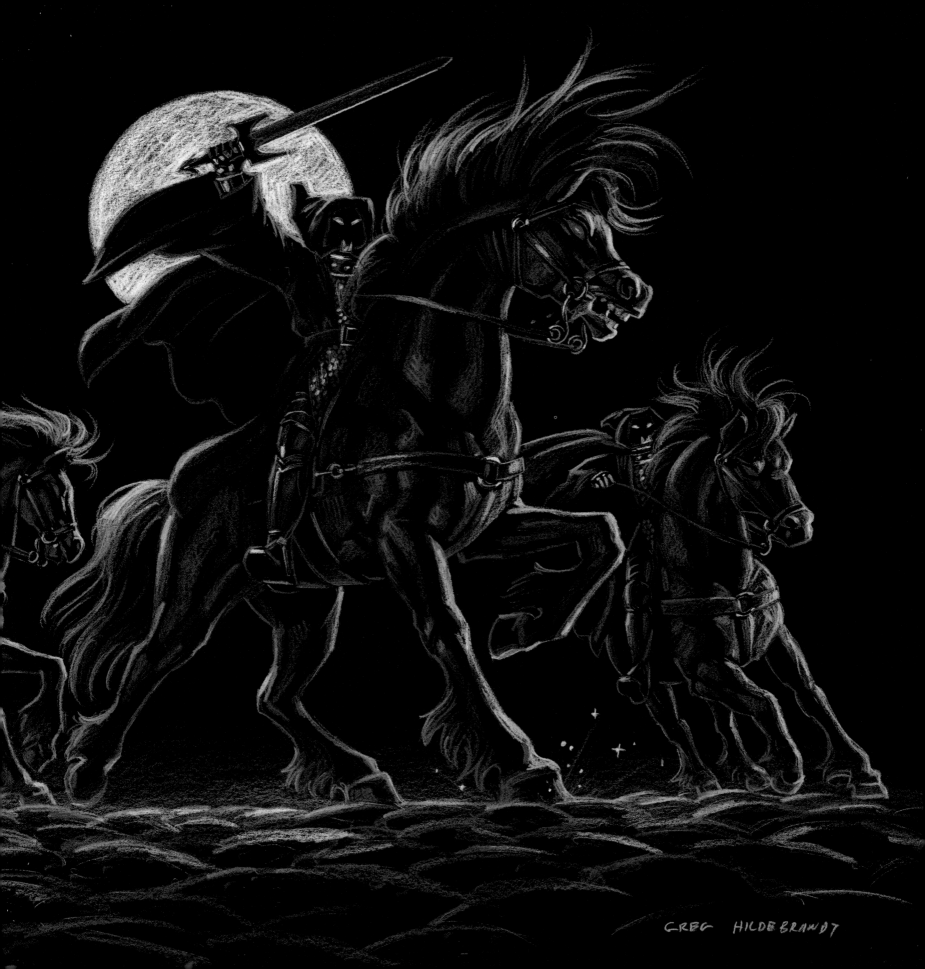

GREG HILDEBRANDT

"Both of these pieces were just a continuation of evil, once more proving my point that collectors love the bad guys. I guess at 73 years old, I can say I still enjoy the world of fantasy as much as I did when I began working professionally in 1959. I hope that you will continue to enjoy my art for many years to come. I appreciate all of my fans, and the support and acknowledgement they have given me and my brother all of these years." -Greg

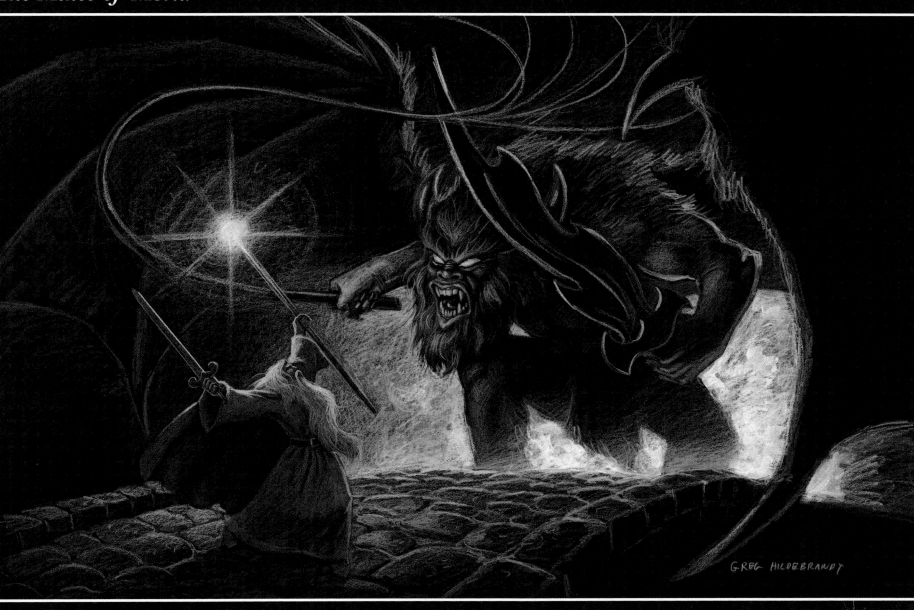

GREG HILDEBRANDT

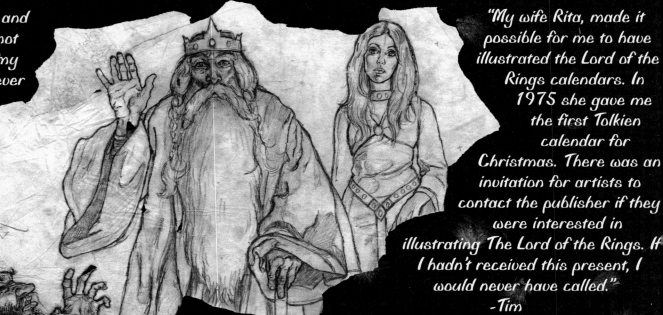

"Jean Scrocco has been my guide and inspiration for over thirty years, not only in art but in every aspect of my life. Without her, this book would never have been done. It is solely because of her commitment, love, dedication, and perseverance that it has seen the light of day. I thank her for this book, with a love, respect, and admiration that knows no bounds."-Greg

"My wife Rita, made it possible for me to have illustrated the Lord of the Rings calendars. In 1975 she gave me the first Tolkien calendar for Christmas. There was an invitation for artists to contact the publisher if they were interested in illustrating The Lord of the Rings. If I hadn't received this present, I would never have called."
-Tim

To all our Tolkien fans from the seventies and to all our new Tolkien fans, you have just seen our vision of The Lord of the Rings!

I sincerely hope you enjoyed this nostalgic trip through our past. This book represents a period of our lives that will remain in my heart as an exceptional journey, forever.

I would like to acknowledge the following people for their help and support in making this art book a reality:

Jean Scrocco
Gregory Hildebrandt, Jr.
Glenn Herdling, Ian Summers
Kevin Dobler, Keith Garletts
Mark Romanoski, Bob Petillo
Thomas Bonvillain
—and anyone else I forgot!

For information regarding print editions
and original Hildebrandt art, please contact:
The Spiderwebart Gallery
5 Waterloo Road, Hopatcong, New Jersey 07843

Phone: 973-770-8189   Fax: 973-770-8626
Or visit the gallery at http://www.spiderwebart.com
E-mail Spiderwebart at jean@spiderwebart.com
E-mail Greg Hildebrandt at greg@spiderwebart.com